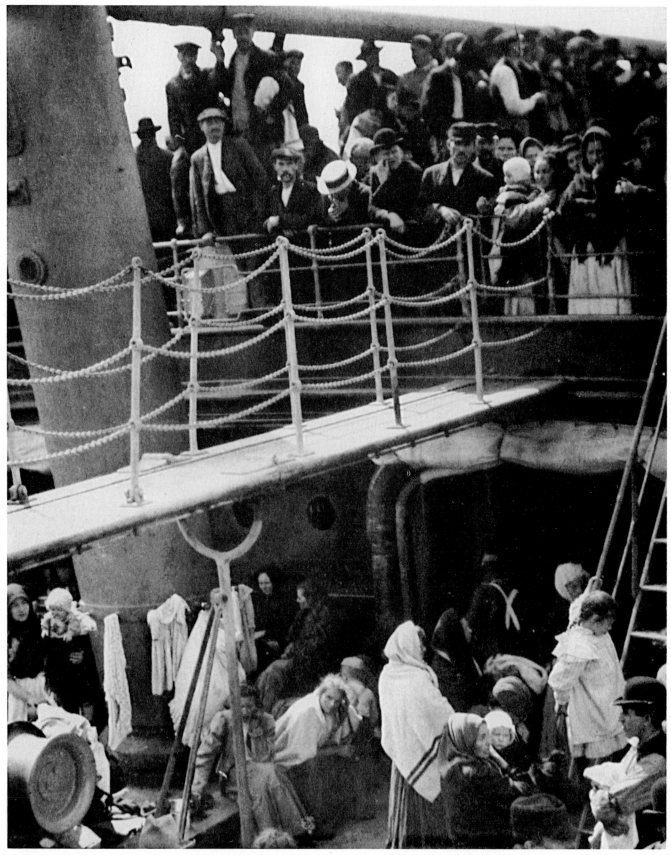

1 Alfred Stieglitz. The steerage. Photogravure, 1907.

A Concise History
of Photography

THIRD REVISED EDITION

Helmut Gernsheim

DOVER PUBLICATIONS, INC.
NEW YORK

Copyright © 1965, 1971, 1986 by Helmut Gernsheim.
All rights reserved under Pan American and International Copyright Conventions.

Published in Canada by General Publishing Company, Ltd., 30 Lesmill Road, Don Mills, Toronto, Ontario.
Published in the United Kingdom by Constable and Company, Ltd., 10 Orange Street, London WC2H 7EG.

This Dover edition, first published in 1986, is the third, further revised edition of the work first published by Thames and Hudson, London (and Grosset and Dunlap in New York), in 1965 and revised in 1971. The 1965 and 1971 editions appeared "in collaboration with Alison Gernsheim." The present edition contains a new foreword, additional black-and-white photographs, a partially different selection of color photographs, and supplementary text in a redesigned format. The original bibliography has been omitted.

BOOK DESIGN BY DEBBY JAY

Manufactured in the United States of America
Dover Publications, Inc., 31 East 2nd Street, Mineola, N.Y. 11501

Library of Congress Cataloging-in-Publication Data

Gernsheim, Helmut, 1913-
 A concise history of photography.

 Includes index.
 1. Photography—History. I. Gernsheim, Alison. II. Title.
TR15.G36 1986 770'.9 86-4516
ISBN 0-486-25128-4 (pbk.)

Of what use are lens and light
To those who lack in mind and sight?

TRANSLATION OF LATIN INSCRIPTION
ON A BRUNSWICK THALER IN 1589

Foreword to the Dover Edition

Now that this book is available again in a new and enlarged edition, a few words about past editions and the changes made in this one may be called for.

Originally published by Thames and Hudson in 1965, the *Concise History* established itself as an important extension of my comprehensive *History* of the nineteenth century by covering the vital half-century that had gone by since the outbreak of World War I. It turned out to be a popular textbook with students at my Photo-History courses at a number of universities and seminars, was translated into eight languages and sold a total of 115,000 copies including a second edition, published in 1971.

The Dover edition has been enlarged both in format and in text. The number of black and white photographs has been increased from 258 to 281, and the majority of the 26 colour photographs are also new in this edition. Additions to the text were mainly called for in the period between the two great wars, which saw such a tremendous rise in artistic photography in Germany and the U.S.A.

A future edition may be able to trace the effect that trends now recent will have had on the current scene, for whatever has any permanence becomes automatically part of history. Yet at the moment we are still too close to the evolution to attempt a forecast.

It should be the aim of every historian of photography—and in particular of the compiler of a *Concise History*—to find the correct balance between the great technical inventions that extended the field of the art or improved its practice and the achievements of leading artists of each period. Yet according to inclination of the author the result can turn into a technical evolution of the medium or manifest the aesthetic power of its language. For me photography is the art medium *par excellence* of our times and I will be happy if I can infect the reader with the enthusiasm that great pictures merit.

Many famous photographers can unfortunately receive only a brief mention and some perhaps none at all. If you look in vain for your favourite creator of images, please remember that a *Concise History* cannot assume the functions of a biographical dictionary.

In a history of this kind which brings photography as an art form to the general public in many countries, the inclusion of pictures which the experts recognize as classics seems obvious. Just as it would be difficult in a general history of European painting to dispense with the most famous masterpieces, so in the history of photography there are certain pictures that have established themselves as classics. In addition, there are many excellent unknown photographs, and quite a number of contemporary works are reproduced here for the first time.

Helmut Gernsheim
Castagnola, Switzerland, February 1986

Contents

The Technical Evolution
of Photography

The Pre-History of Photography

The Camera Obscura

That window, that vast horizon, those black clouds, that raging sea, are all but a picture . . . You know that the rays of light, reflected from different bodies, form a picture, and paint the image reflected on all polished surfaces, for instance, on the retina of the eye, on water, and on glass. The elemental spirits have sought to fix these fleeting images; they have composed a subtle matter, very viscous and quick to harden and dry, by means of which a picture is formed in the twinkling of an eye. They coat a piece of canvas with this matter, and hold it in front of the objects they wish to paint. The first effect of this canvas is similar to that of a mirror; one sees there all objects, near and far, the image of which light can transmit. But what a glass cannot do, the canvas, by means of its viscous matter, retains the images. The mirror represents the objects faithfully, but retains them not; our canvas shows them with the same exactness, and retains them all. This impression of the image is instantaneous, and the canvas is immediately carried away into some dark place. An hour later the impression is dry, and you have a picture the more valuable in that it cannot be imitated by art or destroyed by time . . . The correctness of the drawing, the truth of the expression, the stronger or weaker strokes, the gradation of the shades, the rules of perspective, all these we leave to Nature, who with a sure and never-erring hand, draws upon our canvasses images which deceive the eye.

In this episode from his science-fiction *Giphantie* (1760) Tiphaigne de la Roche recounts a long-cherished dream of humanity: to fix the reflections of the mirror and make pictures without the aid of the artist's pencil. The fact that light affects various substances—fading of textiles, and suntanning of the skin—had of course long been observed. The picture-making activities of Tiphaigne de la Roche's elemental spirits might be ascribed to photochemistry, but without the formation of a clear optical image in the *camera obscura*, which plays an equally essential role in photography, recording nature automatically would never have become possible.

Knowledge of the optical principle of the *camera obscura* images can be traced back to Aristotle; its use as an aid in drawing, to Giovanni Battista della Porta. The photographic camera derives directly from the *camera obscura*, which was originally, as its Latin name implies, a dark room, with a small hole in the wall or window-shutter through which an inverted image of the view outside is projected on to the opposite wall or a white screen. In southern climates where people darken their rooms in hot weather, this phenomenon may well have been noticed even before its underlying optical principle was described by Aristotle. He observed the crescent shape of the partially eclipsed sun projected on the ground through the holes of a strainer and the gaps between the leaves of a plane tree. He also noticed that the smaller the hole, the sharper the image.

A clearer description was given early in the eleventh century by the Arabian scholar Alhazen in his work on optics, which later became the main source-book of Roger Bacon and other European scholars.

If the image of the sun at the time of an eclipse—provided it is not a total one—passes through a small round hole on to a plane surface opposite,

it will be crescent-shaped . . . The image of the sun only shows this property when the hole is very small.

It may be assumed that knowledge of the *camera obscura* effect was widespread amongst Arab scholars, who preserved Aristotelian learning throughout the Dark Ages in Europe.

During the next five centuries the use of the *camera obscura* for the observation of solar eclipses without harming the eyes by looking directly at the sun was referred to by a number of scholars including Roger Bacon. The first published illustration [*Ill. 2*] of it is contained in *De radio astronomico et geometrico liber* (1545) by a Dutch physician and mathematician, Reiner Gemma Frisius. The earliest printed account antedates this by twenty-four years. Cesare Cesariano, a pupil of Leonardo da Vinci, described in an annotation in his 1521 edition of Vitruvius's *De architectura* the *camera obscura* in which the image of everything outside the room can be seen. Leonardo had already written two descriptions of the *camera obscura* in his notebooks, which however were not published until 1797.

The fullest and best description of the *camera obscura* was published by a Neapolitan scientist, Giovanni Battista della Porta, in *Magiae naturalis* (1558), in which for the first time it was recommended as an aid in drawing.

> If you cannot paint, you can by this arrangement draw [the outline of the images] with a pencil. You have then only to lay on the colours. This is done by reflecting the image downwards on to a drawing-board with paper. And for a person who is skilful this is a very easy matter.

In the second greatly enlarged edition which appeared thirty-one years later Porta extended the practical application of the camera to portraiture, the sitter being posed in direct sunshine outside the room and in front of the aperture in the window-shutter. *Magiae naturalis* was one of the best-known works on popular science published during the sixteenth century, appearing in many editions and languages. For this reason its author was for a long time believed to be the inventor of the *camera obscura*.

The first significant improvement to the *camera obscura* was the insertion of a biconvex lens in the aperture to form a brighter image. Its use was recommended by Girolamo Cardano, a Milanese physician, in *De subtilitate* (1550).

Danielo Barbaro, a Venetian nobleman, in *La Pratica della perspettiva* (1568) mentioned that by adding lens diaphragms of various sizes the image could be sharpened. Egnatio Danti, a Florentine mathematician and astronomer, in *La prospettiva di Euclide* (1573) made known a further improvement of adding a concave mirror to redress the hitherto inverted image.

Daniel Schwenter, professor of mathematics at Altdorf University, described in *Deliciae physico-mathematicae* (1636) an elaborate lens-system combining three different focal lengths. The scioptric ball or 'ox-eye' consisted of a hollow, revolvable wooden sphere with a hole bored through its axis and a lens fitted at either end, each of different focal length. Combined, they gave a shorter focus than either separately. Screwed into the window-shutter of a darkened room, the scioptric ball projected on to the opposite white wall or screen pictures from all directions in which the ball was turned, instead of only the view directly in front of the window. Schwenter mentioned that the artist Hans Hauer used the instrument for drawing a large panoramic view of Nuremberg and obtained excellent perspective with its aid.

The *camera obscura* in its original form as a darkened room in a house restricted the artist to the view outside, or to portraits of people posed in front of the hole, but in the seventeenth century portable cameras, which had first been suggested before 1580 by Friedrich Risner and pub-

2 First published illustration of the *camera obscura*, 1545.

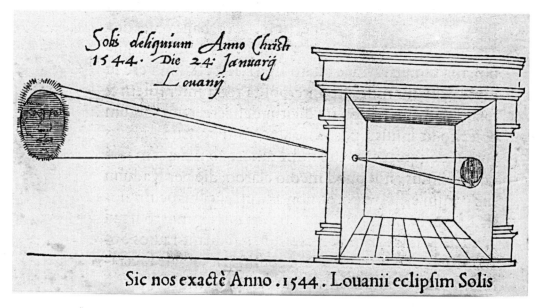

lished posthumously in his *Optics* (1606), were constructed.

Fourteen years later the astronomer Johannes Kepler, while making a survey of Upper Austria in his capacity as Imperial Mathematician, sketched in a small black tent, through the top of which projected a rotatable tube containing a biconvex lens, and a mirror to reflect the image down on to the drawing-board. The tent-type *camera obscura* was still in use in the early nineteenth century [*Ill. 3*].

Athanasius Kircher, a Jesuit scholar and professor in Rome, described and illustrated in *Ars magna lucis et umbrae* (1646) a *camera obscura* light enough to be carried on poles by two men. It consisted of an outer cube made of lightweight but strong material, with a lens in the centre of each wall, and an inner cube of transparent paper for drawing on. The artist entered through a trapdoor in the floor [*Ill. 4*].

Kircher's pupil Kaspar Schott, professor of mathematics at Würzburg, realized that it was not necessary for the artist to get inside the camera; it would perfectly suffice to look through a small hole in its side. In *Magia Optica* (1657) Schott mentioned that a traveller returned from Spain told him about a *camera obscura* small enough to be carried under the arm. He then constructed one in the form of two boxes, one slightly smaller so that it could slide within the other to adjust the focus. Two convex lenses were fitted in an adjustable tube and erect images were obtained.

The earliest reflex camera was described and illustrated by Johann Christoph Sturm, professor of mathematics at Altdorf, in *Collegium experimentale, sive curiosum* (1676). A plane mirror at 45° to the lens reflected the image the right way up on to a piece of oiled paper stretched across the opening in the top of the camera, which was shaded by a hood for improved visibility of the image. Nine years later Johann Zahn, a Premonstratensian monk at Würzburg, illustrated in *Oculus artificialis teledioptricus* (1685–86) several types of box *camera obscura* small enough to be taken anywhere. The reflex type [*Ill. 5*] was only about 9 inches in height and width and about 2 feet long. For the first time such refinements are described as an opal-glass focussing screen with the interior of the box and lens-tube painted black to avoid reflections. In

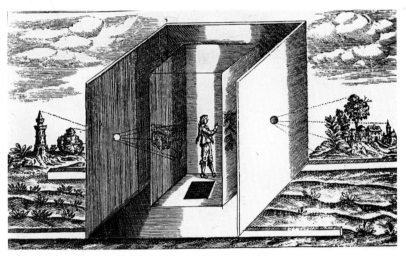

4 Athanasius Kircher. Portable *camera obscura*, 1646.

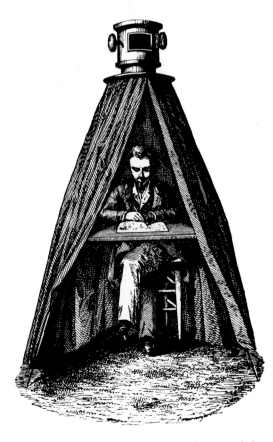

3 Nineteenth-century tent *camera obscura*, of the type used by Johannes Kepler in 1620.

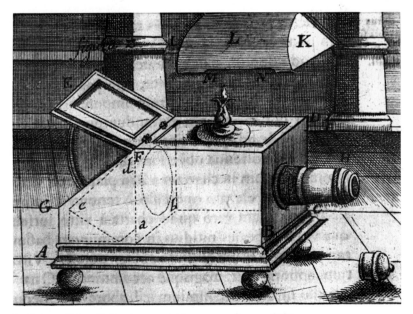

5 Johann Zahn. Reflex type portable *camera obscura*, 1685.

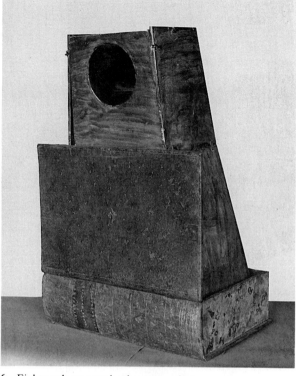

6 Eighteenth-century book *camera obscura*.

size and design Zahn's cameras were prototypes of nineteenth-century photographic box and reflex cameras.

By the eighteenth century the use of the *camera obscura* was common knowledge among educated people; long descriptions of the apparatus were contained in most works on optics, treatises on painting, and books of popular recreation. Cameras were constructed in innumerable types and sizes, from the original darkened room—now usually in a tower, to give an extensive panorama of the surroundings—to pocket cameras only 6 to 8 inches long and 2 or 3 inches wide. Some were in the form of a book [*Ill. 6*], others were concealed in the head of a walking-stick. To aid the artist in portraiture, still-life, and interiors, there were table cameras [*Ill. 7*], while for landscapes, portable box cameras and sedan-chair cameras [*Ill. 8*] were employed. Sometimes carriages were adapted by lining the interior with dark material and having well-fitting curtains and a table to draw on. As in the sedan-chair type, the rotatable lens was fixed in the roof and the image reflected on to the table by a mirror, so that the traveller could make sketches whenever he came to a beauty-spot without bothering to leave his vehicle.

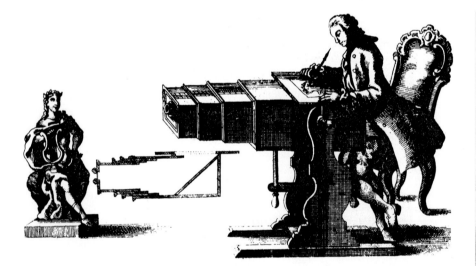

7 Georg Brander. Table *camera obscura*, 1769.

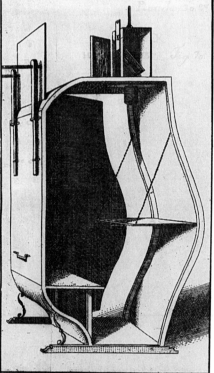

8 s'Gravesande. Sedan-chair *camera obscura*, 1711.

Photochemistry

Whereas since the middle of the seventeenth century the existing optical apparatus could have been used for photography, from the chemical point of view it was not until 1725 that Johann Heinrich Schulze, professor of anatomy at the University of Altdorf near Nuremberg, observed that the darkening of silver salts (on which most photographic processes depend) was not due—as previously believed—to the sun's heat or to air, but to light alone. While trying to make phosphorus, Schulze saturated chalk with nitric acid which happened to contain some silver. He performed the experiment near an open window in sunshine, and was surprised to see that the mixture on the side of the flask facing the light turned purple, while the portion away from the light remained white. Tests by the fire proved that the colour change was not due to heat. Using a mixture containing more silver, the discoloration took place much more rapidly. Finally, Schulze covered the flask with paper from which he had cut out letters. 'Before long I found that the sun's rays on the side on which they had touched the glass through the apertures in the paper, wrote the words or sentences so accurately and distinctly on the chalk sediment, that many people . . . were led to attribute the result to all kinds of artifices.' Beyond making evanescent stencil images Schulze did not carry his experiments towards photography. He published his observations in 1727 in the Transactions of the Imperial Academy at Nuremberg, entitling his paper jokingly *Scotophorus pro Phosphoro In-ventus*, for he had been trying to make phosphorus, 'bringer of light', and discovered instead 'Scotophorus', 'bringer of darkness'.

Schulze's experiment became widely known not only in scientific circles, being also published in many popular books of 'rational recreations' as a parlour-trick.

Extending Schulze's observations, the Swedish chemist Carl Wilhelm Scheele proved that the violet rays of the solar spectrum have a more rapid darkening effect on silver chloride than the other wavelengths—a fact which later on proved a disadvantage in photography until the introduction of panchromatic emulsions, as it caused an incorrect translation of the colours of nature into the monochrome tone scale. Scheele also published in *Chemische Abhandlung von der Luft und dem Feuer* (1777) that silver chloride acted on by light becomes insoluble in ammonia.

Jean Senebier, a librarian in Geneva, carried Scheele's photometric observations further, and published in *Mémoires physico-chymiques sur l'influence de la lumière solaire* (1782) his experiments on the relative speed with which the different spectrum colours darken silver chloride: from 15 seconds for violet light to 20 minutes for red. Senebier also made important investigations of the effect of light on resins, finding that some lose their solubility in turpentine after exposure to light: i.e. they harden—a phenomenon later used by Nicéphore Niépce in his photographic experiments.

The Invention of Photography

The Earliest Attempts at Photography

The first to try to fix the images of the *camera obscura* by chemical means were the brothers Joseph-Nicéphore and Claude Niépce, officers in the French army and navy respectively, while stationed at Cagliari, capital of Sardinia, in 1798. Beyond the fact that they made some experiments together, referred to in a letter from Nicéphore to Claude on 16th September 1824, nothing is known.

Towards the close of the eighteenth century Thomas Wedgwood, son of the potter Josiah Wedgwood, and an amateur scientist, conceived independently the same idea. Tom Wedgwood was familiar with the *camera obscura* used for sketching great country houses to ornament dinner and tea services made at the Etruria pottery works. His knowledge of the light-sensitivity of silver nitrate was acquired from his tutor Alexander Chisholm, formerly chemical assistant of Dr. William Lewis, the first person in England to publish (in 1763) Schulze's investigations.

Wedgwood's attempts at photography were published in the *Journal of the Royal Institution*, London, in June 1802 by his friend (Sir) Humphry Davy. Wedgwood's main object was to fix the images of the *camera obscura* on silver nitrate, but he failed to do so 'in any moderate time'—without stating what he considered moderate. Wedgwood and Davy both succeeded in making copies of leaves, insects' wings, and the then fashionable paintings on glass by simply laying them on paper or white leather sensitized with silver nitrate or silver chloride, which Davy found more light-sensitive. Davy also made photomicrographs. However, the pictures were unfixed and could only be viewed by candlelight; otherwise they darkened all over. It is astonishing that such a distinguished scientist as Humphry Davy, who referred to Scheele's experiments, failed to notice his statement that ammonia dissolves the silver chloride unaffected by light, and could therefore have been used to fix the image.

It was left to later experimenters to complete the invention of photography of which Thomas Wedgwood laid the foundation, but he has the honour of being the first to demonstrate the possibility of photography—a great step forward from Schulze.

In 1813, eight years after Wedgwood's early

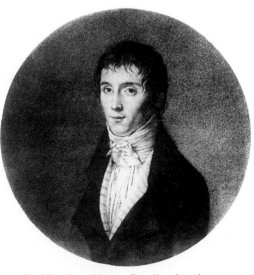

9 Nicéphore Niépce. Pencil and wash portrait by C. Laguiche, *c.* 1795.

death, Nicéphore Niépce [*Ill. 9*], now living in retirement at his country estate Gras near Châlon-sur-Saône, revived his earlier ambition through his interest in lithography, which began to become popular in France that year. Lacking artistic skill, Niépce tried to obtain images by photochemical methods. He laid engravings, made transparent with wax, on lithographic stones coated with an unspecified light-sensitive varnish and exposed them to sunlight. From this he progressed to attempts to fix the images of the *camera obscura*, in April 1816. He succeeded in taking pictures of the courtyard of his house on paper sensitized with silver chloride, but only partially fixed with nitric acid. As the parts which were light in reality appeared dark in the photographs—they were negatives—Niépce tried to print through one of them, and though unsuccessful in making a positive copy, his knowledge of this possibility forestalled Talbot.

For many years Niépce experimented with different light-sensitive materials and eventually turned to substances mentioned by Senebier which harden, instead of darken, under the influence of sunlight. In July 1822 he made his first successful photo-copy of a copperplate engraving by laying it on a glass plate coated with bitumen of Judea, a kind of asphalt used in engraving on account of its resistance to etching fluids. In the following years Niépce copied several engravings by superposition on metal plates (usually zinc or pewter) instead of glass, for he intended them to be etched and printed from. The best is a portrait of Cardinal d'Amboise [*Ill. 10*] which Niépce made in 1826 and had printed by the Parisian engraver Lemaître the following February.

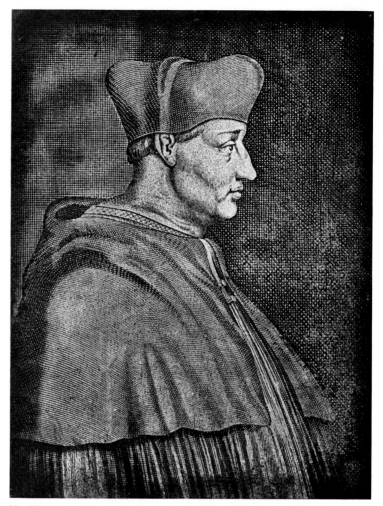

10 Nicéphore Niépce. Heliograph of Cardinal d'Amboise, 1826–27.

The Introduction of Photography on Metal

The world's first successful photograph was taken by Nicéphore Niépce on a pewter plate in 1826 [*Ill. 11*], using his first professionally-made camera supplied by the Parisian optician Charles Chevalier. It shows the view from Niépce's workroom window, with the pigeon-house on the left, a pear-tree with a patch of sky showing through the branches, in the centre the slanting roof of the barn, and on the right another wing of the house. The appearance of sunshine on both sides of the courtyard is due to the long exposure of about eight hours on a summer's day. The coating of bitumen of Judea dissolved in oil of lavender became hard in the parts affected by light, whilst that in the dark parts of the picture remained soluble and was washed away with a solvent consisting of oil of lavender and white petroleum (turpentine). The result was a permanent positive picture in which the lights are represented by bitumen and the shades by bare pewter.

Niépce gave the name *Héliographie* (sun drawing) both to photographs made in the camera and to engravings copied by superposition.

In September 1827 Niépce came to Kew near London to visit his brother Claude, bringing with him this camera view, the photo-engraving of Cardinal d'Amboise, and several other heliographic reproductions. At Kew he made the acquaintance of the botanical painter Francis Bauer, who recognizing the importance of the invention persuaded Niépce to address a memoir on the subject to King George IV and to the Royal Society. However, as the cautious inventor refused to disclose the details of his process, the Royal Society would not take cognizance of it. Before returning home, Niépce gave Bauer all these photographic *incunabula*,

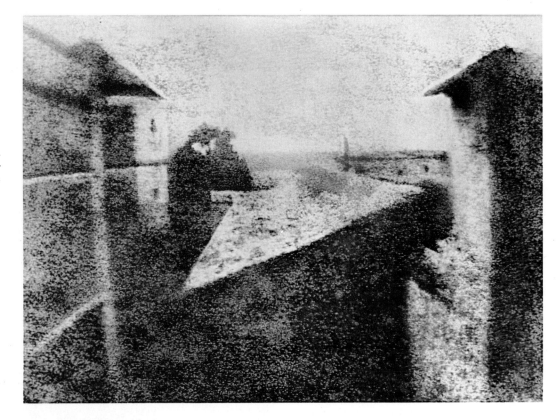

11 Nicéphore Niépce. First successful photograph from nature, 1826/7. 16.5 × 20.5 cm.

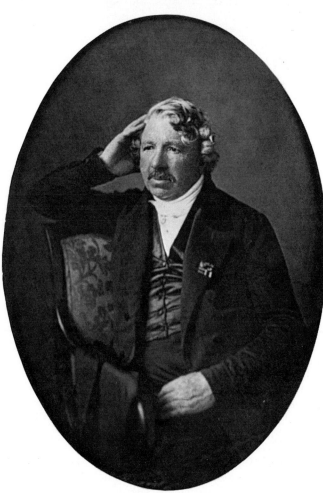

12 J. E. Mayall. Daguerreotype of L.-J.-M. Daguerre, 1846.

and after several years' 'detective work' by the author, *Ills. 9* and *12* and both memoirs came to light in 1952.

Giving up pewter, which is too soft a material to form a satisfactory printing plate—always Niépce's final aim—he changed to silverplated sheets of copper, improving the contrast of his pictures by blackening the bare parts of the silvered plate with iodine vapour. The exposure, however, remained impractically long.

In December 1829 Niépce signed a partnership agreement with Louis-Jacques-Mandé Daguerre [*Ill. 12*], theatrical designer and co-inventor with Charles-Marie Bouton of the Diorama. This was a popular show of enormous views painted on semi-transparent canvas, with changing effects according to whether the pictures were illuminated by reflected or transmitted light. In order to achieve perfect perspective and realistic detail Daguerre made preliminary sketches with the *camera obscura*, and had for many years been trying to fix its images automatically instead of tracing them by hand—but in vain. All Daguerre could contribute to the partnership was an improved model of *camera obscura* and his talents, and it was formed explicitly for the purpose of perfecting Heliography. Two years after Niépce's death Daguerre discovered that an almost invisible or latent image could be brought out or developed with mercury vapour, thus reducing the exposure time from at least eight hours to 20–30 minutes. It was not until May 1837, however, that he found a way of fixing the pictures with a solution of common salt.

Believing his new process to be distinct from that of Niépce (though founded to a large extent on his late partner's knowledge), Daguerre called it *Daguerréotypie*. After unsuccessful attempts during 1838 to get it taken up commercially by subscription, Daguerre secured the patronage of the astronomer and Deputy François Arago, who was instrumental in the French Government's acquiring the invention. The scientist Gay-Lussac, a Member of the Upper House, strengthened Arago's plea for the purchase of the invention by an argument so obvious that it is surprising that other important discoveries have not been helped similarly by governments: if the invention remains in the hands of an individual there is danger that it will remain stationary for a long time; made public, however, it will soon be perfected by the ideas of others. In July 1839 the Government acquired the daguerreotype in order to give it free to the world in return for pensions to Daguerre and Niépce's son, and the Legion of Honour for the former. Nevertheless, Daguerre took out a patent in England five days before details of the process were made public in Paris.

Speculation ran high [*Ill. 13*] after Arago's much publicized statement in the Chamber of Deputies that the daguerreotype 'requires no knowledge of drawing and is not dependent upon any manual dexterity. Anyone may succeed with the same certainty and perform as well as the author of the invention'. Details of this first practicable method of photography were not revealed by Arago until 19th August 1839, at a joint meeting of the Académies des Sciences and Beaux-Arts at the Institut de France [*Ill. 14*]. On this date, which counts as the official birthday of photography, a vast and curious crowd over-flowed into the courtyard of the Institut and 'there was as much excitement as after a victorious battle'. Nowadays photography is so completely taken for granted that it is difficult to realize how magical the idea seemed to Daguerre's contemporaries that Nature could be made to produce a picture spontaneously [*Ill. 15*]. Though realistic representation of the everyday world had been the aim of many painters from the time of Van Eyck and even much earlier in the Hellenistic period, the sudden achievement of their hopes without the need for an artist was so startling that Paul Delaroche exclaimed in bewilderment: 'From today, painting is dead!' Miniature painters and engravers feared for their livelihood, and in reactionary circles the daguerreotype was even disapproved of on religious grounds. The *Leipziger Stadtanzeiger* thundered indignantly:

> The wish to capture evanescent reflections is not only impossible, as has been shown by thorough German investigation, but the mere desire alone, the will to do so, is blasphemy. God created man in His own image, and no man-made machine may fix the image of God. Is it possible that God should have abandoned His eternal

13 Title-page of the first photographic manual in the world, July 1839, by 'F–n' (probably Karl von Frankenstein, Graz).

14 Arago's official report on the daguerreotype, August 1839.

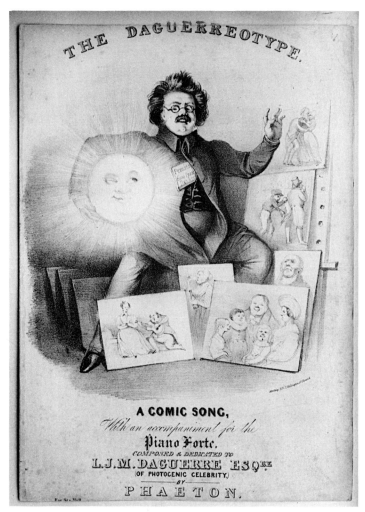

15 The Daguerreotype Song, 1839.

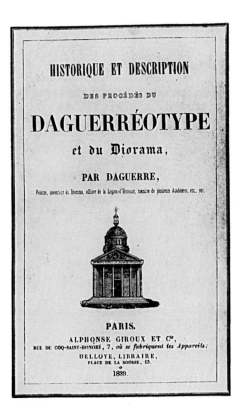

16 Title-page of the edition of Daguerre's manual, supplied with the Daguerre camera, published in September 1839.

principles, and allowed a Frenchman in Paris to give to the world an invention of the Devil? . . . The ideal of the Revolution—fraternity, and Napoleon's ambition to turn Europe into one realm—all these crazy ideas Monsieur Daguerre now claims to surpass because he wants to outdo the Creator of the world. If this thing were at all possible, then something similar would have been done a long time ago in antiquity by men like Archimedes or Moses. But if these wise men knew nothing of mirror pictures made permanent, then one can straightway call the Frenchman Daguerre, who boasts of such unheard of things, the fool of fools.*

The manipulation published in Daguerre's manual *Historique et Description des Procédés du Daguerréotype et du Diorama* [*Ill. 16*] immediately after the historic meeting at the Institut de France was briefly as follows:

A silvered copper plate, bought ready-made, was sensitized with iodine vapour which formed silver iodide on the plate. After exposure in the camera the latent image was developed by vapour of mercury heated over a spirit-lamp, the mercury attaching itself to those parts of the silver iodide which had been affected by light. The picture was fixed with hyposulphite of soda and rinsed with distilled water. The result was a finely detailed positive picture with a delicate surface which had to be protected by a cover-glass against abrasion, and sealed to prevent tarnishing through contact with air.

From August 1840 onward daguerreotypes were generally toned with chloride of gold, an important improvement due to Hippolyte Fizeau. This increased the contrast of the image and made the mercury adhere more strongly to the silvered plate.

Owing to the length of the exposure (20–30 minutes) the daguerreotype could not be used for portraiture—its most desired application—until after considerable improvements had been made to Daguerre's process and apparatus by experimenters in America, England, and Austria.

*On investigation, the newspaper and text quoted have proved to be an invention of the author Max Dauthendey in a fanciful book on his father, *Der Geist meines Vaters*, published in 1912. His father, Carl Dauthendey, had learned to daguerreotype in Leipzig in 1839 and had probably heard a similar diatribe against the French invention.

The Introduction of Photography on Paper

Immediately after Arago's announcement of Daguerre's invention on 7th January 1839 several independent inventors came forward with claims to have also made pictures by the action of light. The majority of them do not bear investigation, but a few were genuine and should be briefly recorded, if only to show how ripe the time was for the invention of photography.

Friedrich Gerber, a veterinary surgeon and professor at Berne University, announced in the *Schweizerischer Beobachter* on 2nd February 1839 that since 1836 he had been able to fix the images of the *camera obscura* on paper coated with silver salts. From his description it is evident that Gerber had independently achieved the production of direct positives, and a negative process which allowed him to make any number of positive copies; also, enlarged photographic images of microscopic objects. However, his achievements with the camera had obviously not yet reached any degree of perfection, and his success seems to have been mainly in photographic images of objects laid on prepared paper. At any rate, only the latter were seen by a critic, and none of Gerber's photographic *incunabula* has survived.

The Rev. J. B. Reade was a distinguished scientist in the astronomical and microscopical fields. Reade had followed up the photographic experiments of Wedgwood and made photomicrographs on white leather and on silver chloride paper washed over with a solution of gallic acid which he knew to be used in the tanning of leather. Reade considered gallic acid to be merely an accelerator and did not realize that it was in fact developing a latent image. He fixed his pictures with hyposulphite of soda, which he found listed in Brande's manual of chemistry on Herschel's authority as a solvent of silver salts. Apart from 'solar mezzotints', as he called his photomicrographs made with a solar microscope, Reade also made contact copies of botanical specimens and lace by superposition on sensitive paper, and took some photographs in the *camera obscura*. They were shown at the Royal Society, London, in April 1839, and in comparing notes with William Henry Fox Talbot on their methods, Reade mentioned that he had been speeding up his photographs with an infusion of galls. A recently discovered letter from Reade to his brother dated 1st April 1839 contradicts Reade's claim, made many years later, that his experiments began in 1837.

On hearing of Daguerre's discovery, the great English astronomer Sir John Herschel set himself the task of solving the problem of photography independently. Within a week he achieved what had taken others years to accomplish. His first photograph, of his father's big telescope at Slough near London, was taken on 29th January 1839 on paper sensitized with carbonate of silver and fixed with hyposulphite of soda. On 14th March Herschel read a paper to the Royal Society 'On the Art of Photography' which was accompanied by twenty-three photographs on paper, some of them negatives, others positives. Apart from the photograph of the telescope they were all copies of engravings or drawings by superposition. Out of consideration for Talbot, whose achievement Herschel did not want to belittle by his own independent discovery, Herschel withdrew his communication from publication in the Royal Society's Transactions, and only an abstract was printed in the Society's Proceedings.

Photography owes Herschel many valuable contributions, not least as regards nomenclature. In his notebook the verb 'to photograph' and the adjective 'photographic' appear three weeks before the German astronomer Mädler first published the noun 'Photographie' in the *Vossische Zeitung* on 25th February 1839; and Herschel used the term 'photography' in his paper to the Royal Society of 14th March. Furthermore, he introduced 'negative' and 'positive' in his second communication on photography to the Royal Society in January 1840 and the term 'snap shot' twenty years later.

On the practical side, the earliest extant photograph on glass, taken in September 1839, is due to Herschel, as is the cyanotype or blueprint first made in June 1842. It is impossible to enumerate all his invaluable and frequently prophetic suggestions. The most striking is undoubtedly his forecast in 1853 of microfilm documentation of public records and works of reference and their subsequent enlargement of public records and works of reference and their subsequent enlargement on a readable scale—a scheme which had to wait eighty-five years for realization.

Hippolyte Bayard, a French civil servant, had been making photographic experiments since 1837, and after the announcement of the daguerreotype redoubled his efforts. By 5th February 1839 he was able to show some imperfect negative images on silver chloride paper—similar to Talbot's but made before details of Photogenic Drawing were published. Learning that Daguerre's pictures were positives, Bayard, thinking that this constituted an advantage over negatives, set to work to do the same. It is a curious fact that in the first years of photography the direct positive process was by most people regarded as superior to the negative/positive pro-

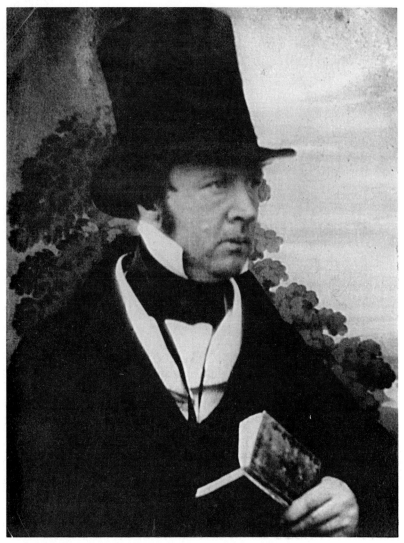

17 W. H. Fox Talbot. Daguerreotype by A. Claudet, 1844 (detail).

19 Portable *camera obscura*, *c*. 1810, of the type used by Talbot and Daguerre for drawing.

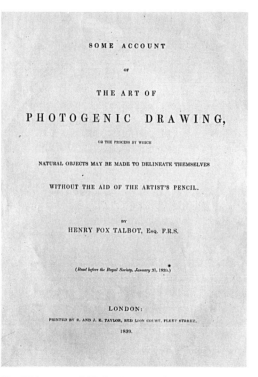

SOME ACCOUNT

OF

THE ART OF

PHOTOGENIC DRAWING,

OR THE PROCESS BY WHICH

NATURAL OBJECTS MAY BE MADE TO DELINEATE THEMSELVES

WITHOUT THE AID OF THE ARTIST'S PENCIL.

BY

HENRY FOX TALBOT, Esq. F.R.S.

(*Read before the Royal Society, January 31, 1839.*)

LONDON:
PRINTED BY R. AND J. E. TAYLOR, RED LION COURT, FLEET STREET.
1839.

18 Title-page of Talbot's privately published brochure, constituting the world's first separate publication on photography, February 1839.

cess, which required two manipulations in order to get a picture instead of one—without considering the convenience of being able to make any number of copies.

On 20th March Bayard obtained his first direct positives on paper in the camera. The exposure was stated to have been about an hour. In June he showed thirty photographs of still-life, sculpture, and architecture at a miscellaneous exhibition in Paris. Arago, to avoid prejudicing his negotiations with the Government on behalf of his *protégé* Daguerre, persuaded Bayard, by a grant of Fr. 600 for better equipment, not to publish his method at present. For this trifling consideration Bayard did not divulge his meanwhile improved manipulation to the Académie des Sciences until 24th February 1840, thus losing his right to a more prominent position as an independent inventor of photography, which would undoubtedly have been accorded to him had he published prior to Daguerre.

Two German scientists, Franz von Kobell, professor of mineralogy, and Carl August von Steinheil, professor of mathematics, both at Munich University, have occasionally been stated in German source-books to be independent inventors of photography in 1837. My research published in 1959 proves, however, that their photographic experiments did not begin until March 1839 when they drew up a joint report on Talbot's invention for the Bavarian Academy of Sciences. They presented their report on 13th April, together with three paper negatives $1\frac{5}{8}$ inches square which they had re-

cently taken of buildings in Munich with an exposure of several hours. Though fixed with ammonia, the negatives were apparently too dense for printing positives. Ten of these pictures are preserved at the Deutsches Museum in Munich, together with an autograph note of Kobell describing them as 'Photographic experiments by me and Steinheil, 1839,' which should put all speculation as to date at rest.

The only process that eventually established itself to some extent as a rival to the daguerreotype was the Calotype, the improved version of Photogenic Drawing invented by William Henry Fox Talbot [*Ill. 17*], an English landowner, scholar, and scientist. On hearing of Daguerre's success in fixing the images of the *camera obscura* Talbot hastened to put forward his priority claim by submitting a paper to the Royal Society, London, on 31st January 1839, entitled: 'Some account of the Art of Photogenic Drawing, or the process by which natural objects may be made to delineate themselves without the aid of the artist's pencil' [*Ill. 18*].

Like Wedgwood, Niépce, and Daguerre—and doubtless other, unknown, users of the *camera obscura*—it occurred to Talbot: 'How charming it would be if it were possible to cause these natural images to imprint themselves durably and remain fixed upon the paper!' This idea came to him while sketching at Bellagio on Lake Como in October 1833 with the aid of a *camera lucida*. Finding this optical device difficult to use, he remembered having previously been more successful with a *camera obscura* [*Ill. 19*]. Talbot began his photographic experiments by making contact copies of plants, lace, and feathers [*Ill. 20*], on silver nitrate and silver chloride paper, fixed imperfectly with ammonia and sometimes potassium iodide. In the summer of 1835 he had a number of cameras made, only 2½ inches square, and took tiny views of his house, Lacock Abbey in Wiltshire, on silver chloride paper with an exposure of half an hour. They were fixed with common salt. The earliest extant paper negative was taken in August 1835 and shows the window of the library at Lacock Abbey. Compared with Niépce's 8 × 6½ inch view taken nine years earlier, Talbot's 1 inch square picture is rather poor. No wonder that Photogenic Drawing completely failed to capture the imagination of the public. Pictures taken in the camera were too slow, too small, and not good enough technically compared with the brilliant detail of the daguerreotype, and contact copies of botanical specimens were of interest to comparatively few people. Talbot continued trying to improve his invention and in September 1840 discovered the possibility of developing the latent image formed during a much shorter exposure, by using gallo-nitrate of silver—having been informed of the accelerating properties of gallic acid, which had been used by the Rev. J. B. Reade.

Talbot patented his improved process, which

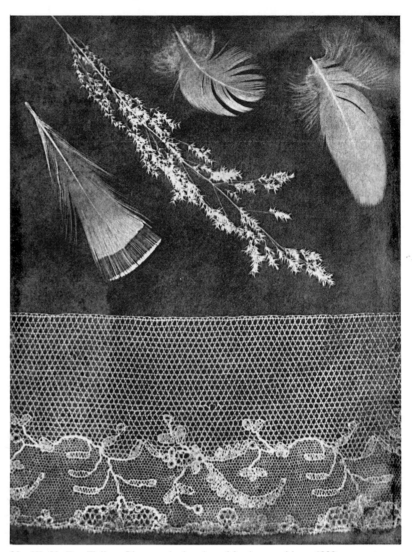

20 W. H. Fox Talbot. Photogenic drawing of feathers and lace, 1839.

he called Calotype, on 8th February 1841. Later it also became known as Talbotype.

Good quality writing paper was coated successively with solutions of silver nitrate and potassium iodide, forming silver iodide, then further sensitized with solutions of gallic acid and silver nitrate. After exposure the latent image was developed with a further application of gallo-nitrate of silver solution—which had the same function as the mercury developer in the daguerreotype—and the picture became visible when the paper was warmed by the fire for one or two minutes. The negative was fixed with potassium bromide (later hyposulphite of soda) and then rinsed with water. The positive print was made on Photogenic Drawing paper (not developed).

Talbot's process had now (1841) reached the same speed as Daguerre's had with chemical acceleration, and offered the great advantage that any number of positive prints could be made. It is this negative/positive principle on which modern photography is based, whereas the daguerreotype, which produced a single picture, was a *cul-de-sac* in photography.

The Introduction of Photography on Glass

Niépce had used glass for Heliography as early as 1822. Sir John Herschel on 9th September 1839 took a photograph of his father's telescope on glass coated with carbonate of silver. This earliest surviving photograph on glass 2½ inches in diameter was considered by Talbot 'the step of a giant'.

Albumen-on-Glass Process

The first practicable method of photography on glass was the albumen process of Abel Niépce de Saint-Victor, a cousin of Nicéphore Niépce, published in June 1848. A glass plate was coated with white of egg sensitized with potassium iodide, washed with an acid solution of silver nitrate, developed with gallic acid, and fixed in the usual way. Very fine detail was achieved, and the prepared plates could be kept for a fortnight, and development postponed for a week or two. The exposure, however, lasted 5 to 15 minutes, according to circumstances, which ruled out portraiture, but slowness was no great drawback for landscapes, architecture, and art reproductions.

Positives printed on albumen glass plates were excellent for magic-lantern slides and stereoscopic pictures on account of their perfect transparency. The former were introduced by William and Frederick Langenheim of Philadelphia in 1849 under the name Hyalotype; the latter by C.-M. Ferrier of Paris in 1851.

Collodion Process

1851 marks the beginning of a new era in photography. The invention which in a short time supplanted all existing methods was Frederick Scott Archer's wet collodion process published in the March issue of *The Chemist* that year. Before this, Robert J. Bingham and Gustave Le Gray had alluded, independently, to the possible use of collodion in photography, but neither published a workable manipulation.

An English sculptor who learned calotyping in order to have portraits of his sitters as studies, Archer endeavoured to improve Calotype paper by spreading various substances on it, including the recently discovered collodion. This led him to the idea of using collodion as a substitute for paper.

In Archer's process collodion containing potassium iodide was poured on to a glass plate, which was carefully tilted until an even coating was formed all over it. Sensitizing followed immediately by dipping the plate in a bath of silver nitrate solution. It then had to be exposed while still moist, because the sensitivity deteriorated rapidly as the collodion dried. Development had to follow directly after exposure, with either pyrogallic acid or ferrous sulphate. The picture was fixed with hyposulphite of soda or potassium cyanide.

The manipulation was much more complicated than with the daguerreotype or Calotype, and since all the operations had to be done on the spot, the outdoor photographer was burdened with a complete darkroom outfit [*Ill. 21*]. These disadvantages were, however, compensated for by the greatly increased sensitivity. Exposures with the collodion process varied from 10 seconds to 1½ minutes for landscapes and architecture on plates of moderate size. Small portraits (Ambrotypes) could be taken in 2 to 20 seconds. It was the fastest photographic process so far devised, and the first to be free from patent restrictions in England. Collodion remained in general use for over thirty years and is still employed in block-making.

A variation worked out by Archer in collaboration with Peter Wickens Fry was the direct

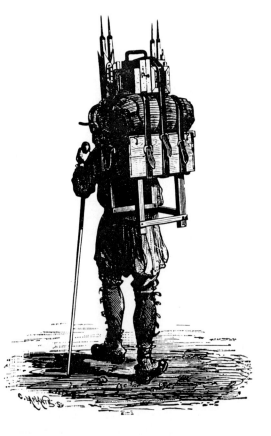

21 Landscape photographer, *c*. 1859.

positive on glass, obtained by bleaching an underexposed collodion negative and transforming it into a seemingly positive picture when viewed by reflected light against a black background. When seen by transmitted light, or without a dark background, the picture retains its negative character [*Ill. 22*]. The name Ambrotype was suggested for collodion positives by Marcus A. Root, a Philadelphia daguerreotypist, and was also current in England. On the Continent they were usually called Melainotypes. Backed with dark-coloured velvet, paper, or varnish, and contained in decorative American 'Union' cases of moulded plastic material, or sometimes in gilded frames, Ambrotypes bear a superficial resemblance to daguerreotypes [*Ill. 23*], and were in the nature of a cheap substitute for them. The vast majority are small portraits, and were very popular with the cheaper kind of photographer from the early 'fifties until the mid-'sixties when the fashion for the *carte-de-visite* superseded them.

Collodion direct positives were also sometimes made on dark-coloured leather or on black paper (Atrographs). Ferrotype or tintype portraits on enamelled sheet iron originated with Adolphe-Alexandre Martin, a French teacher, in 1853. They enjoyed great popularity in the United States with the lower grade photographers from c. 1860 onward, but failed to establish themselves in Europe until the late 1870s when they were introduced as an American novelty by beach and street photographers. Better-class photographers had little demand for any of these direct positives, and made mostly contact copies on albumen paper. This positive paper introduced by E. Blanquart-Evrard in May 1850 was coated with white of egg (albumen) to give it a glossy surface, and sensitized with silver nitrate. As the process of albumenising was rather troublesome, the paper was later on manufactured commercially, but the photographer had still to sensitize it before use. The printed-out picture was usually toned with chloride of gold to improve its colour and permanence. Albumen paper remained the most popular until the turn of the century. The consumption of eggs for albumenising was tremendous; the Dresden Albuminpapier Fabrik, the largest producer of albumen paper in Europe in the 1890s, used 60,000 eggs daily—about 18 million a year.

The inconvenience of the wet collodion process for the landscape photographer led to the demand for dry plates. Various methods were devised for keeping the collodion in a sticky sensitive state for several days or even weeks, so that the entire chemical manipulation could be carried out in the photographer's darkroom at home. All these preservative processes, however, were many times slower than wet collodion.

In September 1871 Dr Richard Leach Maddox, an English medical doctor and well-known microscopist, published experiments on gelatine silver bromide emulsion as a substitute for collo-

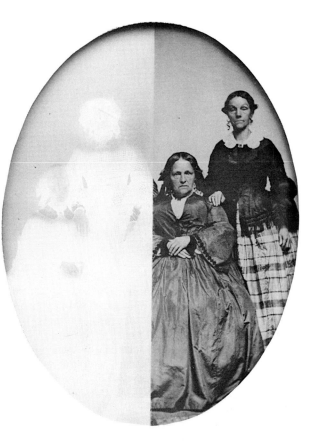

22 Ambrotype with half the backing removed to show positive and negative effect, *c.* 1858.

23 Ambrotype of Mrs William Blake, *c.* 1854.

dion. This turned out to be an epoch-making invention, though as initially published it was 180 times *slower* than wet collodion. Improved and speeded up by John Burgess, Richard Kennett, and Charles Bennett, the rapid gelatine dry plate ushered in the modern era of factory-produced photographic material, freeing the photographer from the necessity of preparing his own plates. By April 1878 four British firms were mass-producing gelatine dry plates, which could be stored for long periods, and made possible truly instantaneous photographs with exposures of a fraction of a second. The following year factories in several other countries started production. With certain improvements, it is still gelatine emulsion which is used in modern photography.

The Introduction of Photography on Film

The gelatine dry plates still had the disadvantages of weight and fragility, and photographers had long been desirous of replacing glass plates by a less heavy and fragile support. From time to time methods had been devised to peel off the emulsion from a paper backing. In the 1880s a number of flexible film supports were introduced but proved unreliable. Celluloid, invented by Alexander Parkes in 1861, provided the answer to the problem after John Carbutt, an English photographer who had emigrated to America, persuaded a celluloid manufacturer to produce sufficiently thin sheets in 1888. Coated with gelatine emulsion, it was used in the form of cut film. The following year The Eastman Co., manufacturers of the Kodak, went into production with much thinner nitro-cellulose roll-film, and by 1902 were producing 80%–90% of the world's output. The film had been independently invented and patent applied for in 1887 by the Rev. Hannibal Goodwin, whose successors eventually were awarded five million dollars after a twelve-year lawsuit against the Eastman Kodak Company. The highly inflammable nitro-cellulose film began to be replaced by non-inflammable cellulose acetate about 1930, and since then the emulsion has been frequently increased in sensitivity.

The Evolution of Equipment

The pioneers of photography made their first experiments with simple box *camera obscuras*, often home-made. Niépce's cameras at the Museum named after him at Châlon-sur-Saône seem unnecessarily bulky considering that the plate size was 6½ × 8 inches. All but one are wooden, but a camera sent to him by Daguerre under the 1829 partnership contract is of zinc, and measures 14 × 14 × 25½ inches. One camera has an accordion-like square leather bellows, and two others are fitted with a variable iris diaphragm behind the lens to sharpen the image—features that had been incorporated in certain eighteenth-century *camera obscuras* and telescopes, respectively, but were used by Niépce for the first time in photography.

The first photographic camera on sale to the public was advertised in June 1839 by a London optician, Francis West, for Photogenic Drawing.

The daguerreotype cameras put on the market by Alphonse Giroux of Paris at the time of publication of the process in August 1839 consisted of two wooden boxes, the rear part with the ground-glass for focussing sliding within the front part containing the lens [*Ill. 24*]. The complete outfit with plate box, iodising and mercury boxes, spirit-lamp, bottles of chemicals, and other paraphernalia, weighed 110 lbs. and cost 400 francs (then £16—by today's value about £120) [*Ill. 25*]. Soon smaller models and folding cameras were designed for travelling. In December Baron

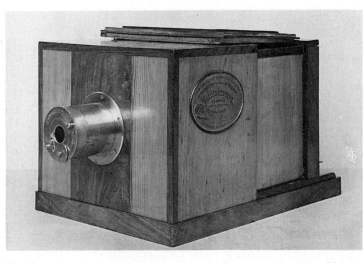

24 Daguerreotype camera with the seal of the manufacturer Giroux and Daguerre's signature, 1839.

Séguier introduced a lightweight bellows camera, and with it three 'firsts' in photographic equipment: the darkroom tent, the photographic tripod, and the ball-and-socket head. Previously, the camera was simply placed on a table or other solid stand.

The same month, Carl August von Steinheil constructed a pocket camera taking 8 × 11 mm daguerrotypes, which had to be viewed through a magnifying glass. This proved a stumbling-block to the introduction of the miniature camera—an invention that had come long before its time.

The lenses made by Lerebours and Chevalier for the early French apparatus were of poor quality, the effective aperture at which a sharp image was obtained being F 14 or even F 16, with the result that the necessary long exposure ruled out portraiture. To overcome this grave disadvantage Alexander S. Wolcott of New York in May 1840 patented a mirror camera: a wooden box which had instead of a lens an open front through which the image of the sitter was received on a concave mirror and reflected on to the 2 × 2 inch daguerreotype plate [Ill. 26]. By this ingenious arrangement much more light was received on the plate than if it had passed through a lens.

The need for a rapid portrait lens prompted the Viennese mathematician Josef Max Petzval to calculate one for Friedrich Voigtländer, who designed an original conical-shaped brass camera for it [Ill. 27]. The apparatus put on the market on 1st January 1841 took circular pictures 3½ inches in diameter in 1½ to 2 minutes on a sunny day in the shade. It made portraiture possible even before the introduction of chemical acceleration of the daguerreotype plate, for Petzval's double combination lens gave excellent definition even at full aperture F 3.5, and was thirty times faster than any other lens of the period. Indeed this lens—the first designed specifically for photographic portraits—remained the most widely used lens-design for portraiture all over the world until the introduction of Paul Rudolph's anastigmat by Carl Zeiss in 1889.

Wolcott's and Voigtländer's cameras were, however, exceptions and only used for a short period until chemical acceleration made possible the taking of larger pictures with ordinary cameras.

Cameras for taking Calotypes were similar to those for daguerreotypes.

In 1850 Marcus Sparling, Roger Fenton's assistant during the Crimean War, designed the first magazine camera for the travelling photographer. Ten sheets of Calotype paper were stored in separate holders inside the camera, each sheet being dropped after exposure into a receptacle beneath the instrument.

Pride of place for ingenuity must go to A. J. Melhuish and J. B. Spencer for the first 'roll-film' arrangement in May 1854. Sensitized waxed paper was rolled up on a spool and the exposed part rewound on to a receiving spool. The roll-

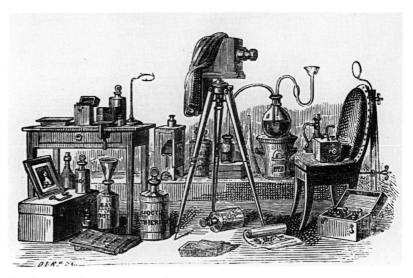

25 Complete daguerreotype outfit.

26 Wolcott's mirror camera, 1840.

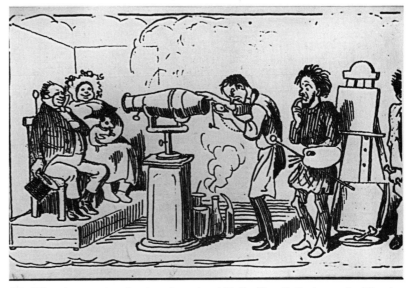

27 'The photographer deprives the artist of his livelihood'. Caricature by Theodor Hosemann showing the Voigtländer camera, 1843.

holder was made in several sizes suitable for attachment to any camera.

The landscape photographer using wet collodion had to take with him an enormous amount of equipment as the plates had to be prepared, exposed, and developed while the collodion was still moist. In addition to camera and tripod, and a choice of several lenses, he needed a chest full of bottles containing chemicals for coating, sensitizing, developing, and fixing the negatives; a supply of glass plates; a number of dishes, scales, and weights; glass measures and funnels; a pail to fetch rinsing water (and where none was likely to be found, the water itself); and a portable dark-tent in which the chemical operations took place [*Ill. 28*]. An amateur's equipment for a day's outing weighed 100–120 lbs. Since it was both undignified and uncomfortable to stagger

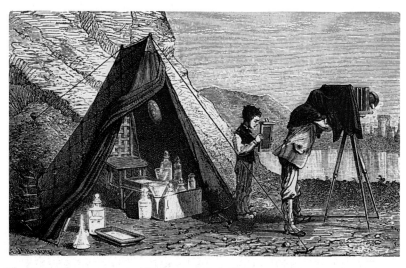

28 Dark-room tent in wet collodion period, *c.* 1875.

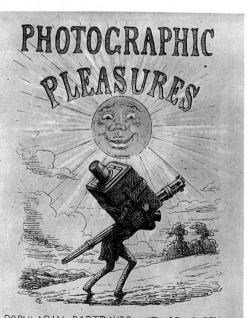

29 Title-page of *Photographic Pleasures* by Cuthbert Bede, 1855. The first book caricaturing photography.

along bent double beneath the weight of cumbersome apparatus [*Ill. 29*], many photographers employed a porter. The less affluent pushed a wheelbarrow or small hand-cart containing all the equipment. The more successful could afford a carriage, which in some cases simply served to convey the photographer and his equipment to the scene, and in others was fitted up as a travelling darkroom. Roger Fenton took with him to the Crimean War a horse-drawn van rigged up as a darkroom and sleeping quarters [*Ill. 30*].

Many inventive minds worked towards methods of avoiding the need for a dark-tent. This could be effected either by chemical methods allowing preparation of the plate in advance, and delayed development, or by constructing cameras fitted with a compartment in which the chemical manipulation could be performed. Neither of these two methods was, however, really satisfactory in practice. The so-called dry collodion plates were far too slow, and manipulating chemicals inside the camera was a messy business.

Paradoxically, during the collodion period (1851–c. 1880) the camera became both larger and smaller—according to the purpose for which it was intended. Realizing the possibilities of photography as an independent art medium—a feeling which had hardly existed in the 1840s when photography was largely in the hands of professional portraitists—many amateurs took up the art and competed with each other and with professionals in exhibitions. Naturally, the bigger pictures were the more imposing [*Ill. 31*], and as enlarging was not yet practicable on account of the extreme slowness of the positive printing-out paper, the photographer had to use big plates from which he made contact prints. 10 × 12 inch and 12 × 16 inch were quite ordinary plate sizes, and some hardy spirits felt that nothing smaller than a 20 × 16 inch plate would do justice to their subject. Keen photographers laboured under the most trying conditions with their huge equipment, but these difficulties caused them to be particularly careful in the choice of viewpoint and lighting in order to ensure success at the first exposure.

The largest camera made during the nineteenth century was constructed in 1860 for John Kibble, a Glasgow amateur. It was so big that it had to be mounted on wheels and drawn by a horse. The glass plates measured 44 × 36 inches and each one weighed about 44 lbs. Fortunately Kibble was used to handling large panes of glass, being by trade a builder of conservatories and greenhouses.

In contrast to this monster camera were the stereoscopic cameras introduced in the 'fifties when a great demand arose for photographs to be viewed in Sir David Brewster's lenticular stereoscope, commercially introduced by Louis-Jules Duboscq in 1851. To enable two pictures of the same object to be taken from slightly

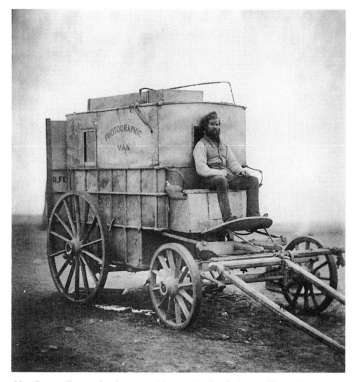

30 Roger Fenton's photographic van in the Crimean War, 1855.

31 Disdéri's life-size portraits. Caricature by 'Cham', 1861.

A L'EXPOSITION DU BOULEVARD DES ITALIENS.
— Ah! mon Dieu! c'est la photographie de mon petit bébé?
— Je puis le faire encore plus grand, si madame le désire.

different viewpoints, giving an impression of relief and astonishing reality when viewed in the stereoscope, special cameras were constructed. In the single-lens type, necessary for Sir Charles Wheatstone's mirror stereoscope, after the first picture had been taken on one half of the plate, the whole camera was moved along a rail on the carrying-box on which it stood, and the other half of the plate was then exposed. Of course only still objects could be photographed in this way [*Ill. 32*]. The binocular or twin-lens type, proposed by Brewster in 1849 and constructed in 1853 by John Benjamin Dancer of Manchester [*Ill. 33*] and A. Quinet of Paris, took both pictures simultaneously, and soon superseded the slow single-lens type. Owing to the small size of each picture (3 × 3¼ inches) and the short focal length of the lenses (5 inches) it was possible with binocular stereoscopic cameras to obtain lively instantaneous pictures of moving objects in a fraction of a second: street scenes with traffic [*Ill. 34*], seascapes with rolling waves, public ceremonies. The extreme popularity of stereoscopic pictures began in the mid-'fifties and affected the whole of the so-called civilized world for about fifteen years. It was claimed there was 'no home without a stereoscope'.

Realization of the new possibilities opened up by the binocular camera led to the construction of small cameras for taking single pictures. Thomas Skaife's metal 'Pistolgraph' (1858) had a spring shutter worked by rubber bands released by a trigger, hence 'pistol'. It was fitted with one of the fastest lenses ever made, a Dallmeyer combination with effective aperture F 1.1, taking snapshots about 1½ inches in diameter. Rather

32 T. R. Williams. Stereoscopic daguerreotype including stereoscopic viewer, *c.* 1852.

incongruously Skaife particularly recommended his pistol camera for photographing pet animals and babies. He once aimed his 'Pistolgraph' at Queen Victoria and was nearly arrested for an attempt on her life. Unfortunately this interesting photograph was lost forever when Skaife had to open his 'pistol' to convince the police that his 'shots' were harmless snapshots. It may well have

been the 'Pistolgraph' that led Sir John Herschel to write in 1860 of 'the possibility of taking a photograph as it were by a snap shot'—the first use of this term.

Probably the smallest nineteenth-century camera was introduced by T. Morris of Birmingham in 1859. It measured only 1½ × 1½ × 2 inches, took ¾ inch square pictures suitable for locket portraits or for enlargement, and was called a miniature camera.

The best known of these small cameras was Adolphe Bertsch's 'automatic camera' (1860). The 4 inch square metal box camera had a fixed-focus lens (hence automatic) rendering sharp all objects beyond a distance of 40 feet. Instead of the usual ground-glass it was provided with a frame viewfinder and spirit-level. Whilst the comparatively long exposures with the large cameras of the period rendered a shutter mechanism unnecessary, it is surprising that in Bertsch's camera the short exposures were made simply by removing the lens cap by hand. The 'chambre noire automatique' was an early example of the modern system of a miniature camera producing negatives for enlargement. Tenfold magnification could be achieved from the 2¼ × 2¼ inch negatives with Bertsch's improved solar enlarger with double condensor. The best known enlarger was D. A. Woodward's 'solar camera' of 1857 [*Ill. 35*], but enlarging was little practised because it depended on hours of sunshine with the slow printing-out paper.

33 J. B. Dancer's binocular stereoscopic camera (improved model), September 1856.

The cameras just described, and a number of other pocket cameras introduced in the 1860s, were, therefore, exceptions. Most serious photographers worked, as already mentioned, with big plate cameras.

Carte-de-visite photographers used a camera fitted with four identical lenses of short focus; the interior was divided into four compartments, one for each lens. By exposing first one half of the plate and then the other by means of a sliding plate-holder, eight small portraits could be taken on a plate 10 × 8 inches. For a variety of poses the lenses could be uncapped separately and a new pose taken each time [*Ill. 36*]. The advantage of this method, patented by André-Adolphe Disdéri in November 1854, was that eight photographs were obtained on one negative. The resulting contact print, somewhat resembling a set of Polyphotos, was then cut up and each portrait, trimmed to 2¼ × 3½ inches, mounted on a card 2½ × 4 inches—the usual visiting-card size. This was naturally much cheaper than taking eight separate photographs. An additional saving was achieved because in these tiny full-length portraits the sitter's head was so small that retouching was unnecessary.

The rapid gelatine dry plate which began to come into general use in 1879–80 not only greatly simplified photographic technique but also revolutionized equipment. Cameras for outdoor work were now small, and provided with an instantaneous shutter. Quarter-plate and 4 × 5

34 Adolphe Braun. The Boulevard Poissonnier, Paris, *c*. 1860. The dark pattern in the road is due to water-sprinkling.

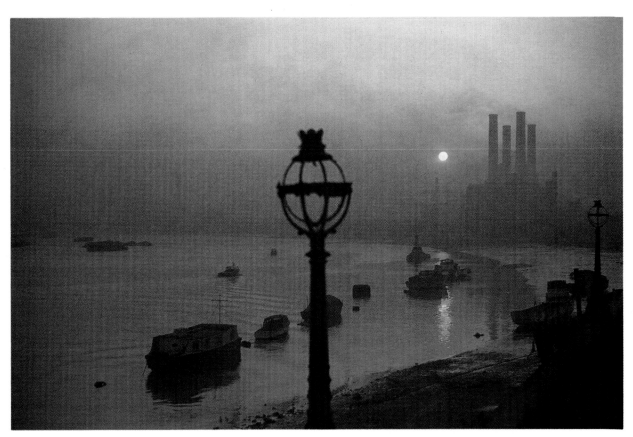

i Felix H. Man. The Thames at Chelsea, 1949.

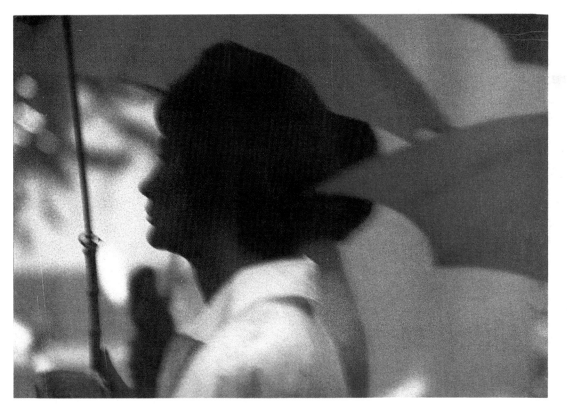

ii Erwin Fieger. Oxford Street, London, in rain, 1959.

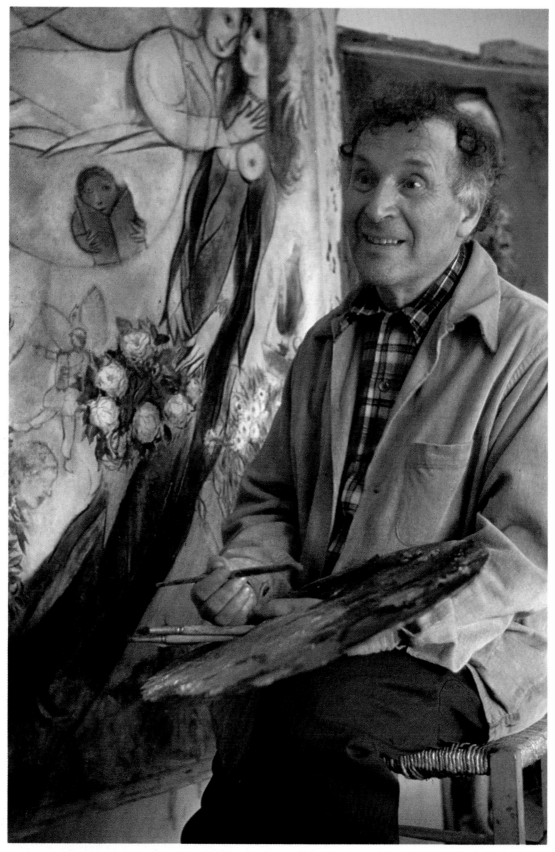

iii Felix H. Man. Marc Chagall at Vence, 1950.

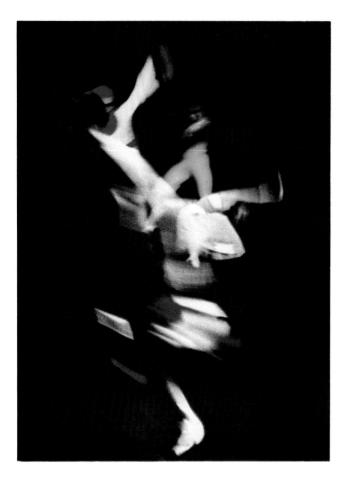

iv Walter Boje. 'The Tides',
ballet with music by Stravinsky,
1958.

v Brian Blake. Indian women
on a swing, 1962.

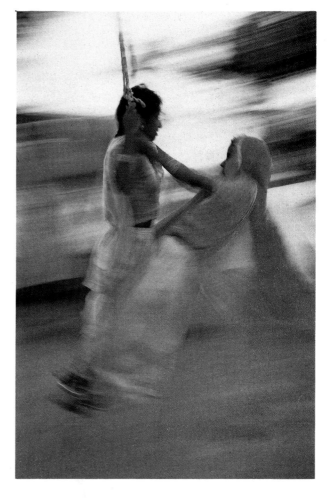

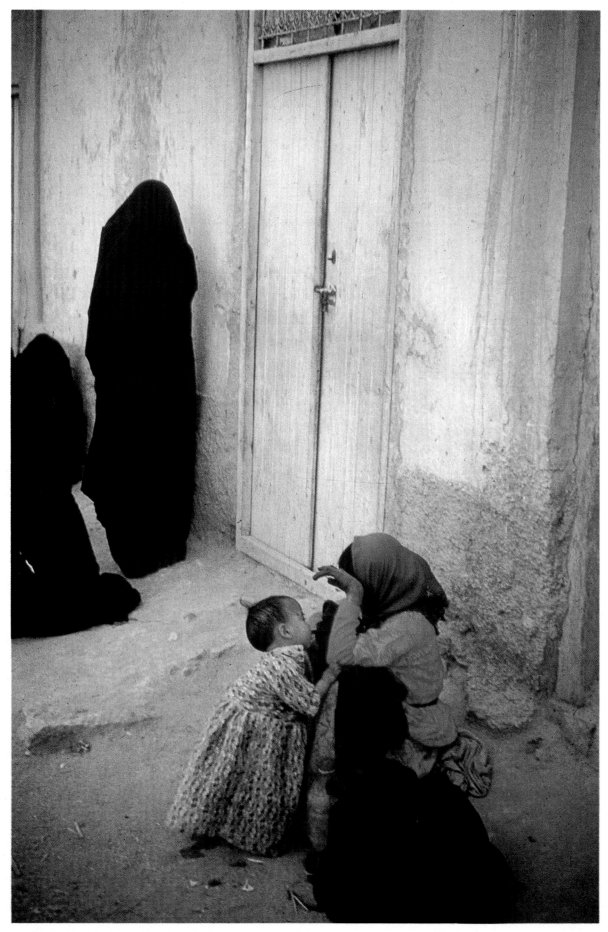

vi Ferenc Berko. Quarazaze, Morocco, 1971.

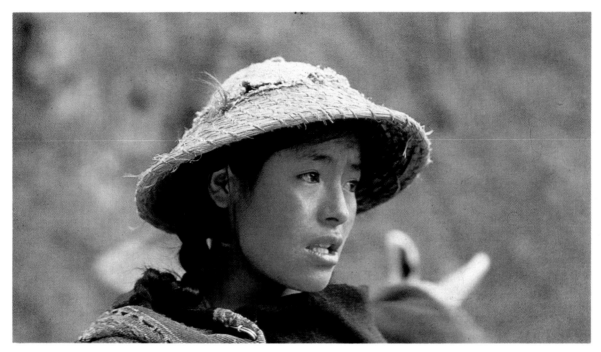

vii Werner Bischof. Bolivian boy, 1954.

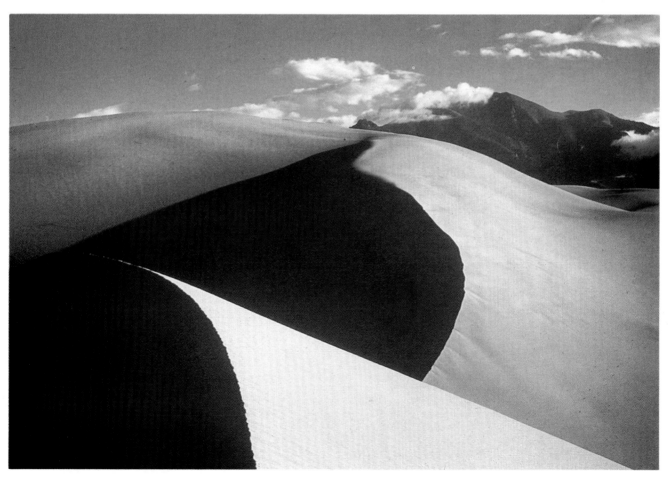

viii Ferenc Berko. Great National sand dunes, 1952.

ix Franco Fontana. City landscape, 1979.

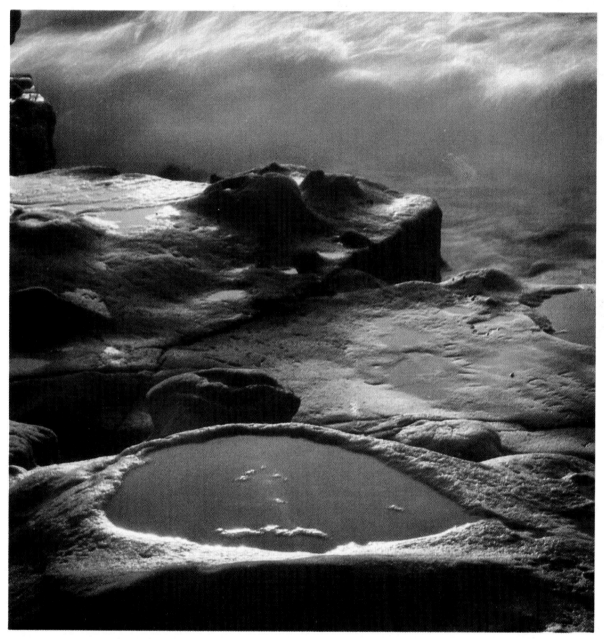

x Jack Stuler. Californian coast, 1966.

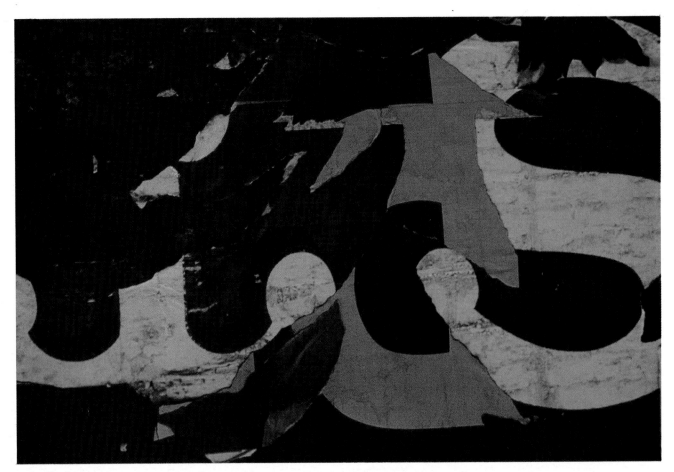

xi Ernst Haas. Poster, 1959.

xii Sir George Pollock. Vitrograph, 1964.

inch hand cameras established themselves as the most popular sizes for amateurs in the Anglo-Saxon countries, the Continental equivalent being 9 × 12 cm.

During the 1880s and '90s a variety of cameras were produced for use with dry plates, cut film, and roll-film. They fall into four main categories:

(1) *Change-box cameras* with a plate-changing box attached, similar to a modern film-pack cassette. They usually held a dozen plates (sometimes cut film), each in a separate plate-holder, permitting daylight changing. In most cases an automatic counter indicated the number of exposures made.

(2) *Magazine cameras* with twelve plates or forty sheets of cut film stored in a magazine or chamber inside the camera body, the plate being changed after each exposure by various mechanisms. In the simplest form the exposed plate was dropped into the bottom of the camera and the next plate pushed into the focal plane by a spring [*Ill. 37*]. An automatic counter was provided.

(3) *Reflex cameras*. Single and twin-lens reflex cameras are classed as a separate group, for although they were variously made with change-box, magazine, or roll-film attachment, they are basically of different construction, incorporating a mirror fixed at 45° to the lens, reflecting the image on to a ground-glass in the top of the camera, allowing observation of the subject up to the moment of taking the picture.

The first to apply this centuries-old *camera obscura* construction to photography was Thomas Sutton, editor of *Photographic Notes*, who patented his single-lens reflex camera in August 1861. However, like the roll-holder of Melhuish and Spencer (1854), the focal-plane shutter of William England (1861), miniature cameras, and other inventions in advance of their time, there was no demand for the reflex camera until the mid-'eighties, when photography for the first time became the hobby of millions. The first of the twin-lens reflex cameras, a quarter-plate with a roller-blind shutter attached to the taking lens, was made by R. & J. Beck, London, in February 1880. Perhaps the most advanced in design was Ross & Co.'s 'Divided' (1891) [*Ill. 38*], of which the smallest model, for 3¼ × 3¼ inch negatives on 48-exposure Eastman roll-film, measured only 6 × 4½ × 7¼ inches.

(4) *Roller-slides* and *roll-film cameras*, which eventually superseded change-box and magazine cameras, used flexible films instead of glass plates or cut films, the film being wound on two spools. At first the film was in a separate box or roller-slide, made in many sizes for attachment to almost any camera. The first camera incorporating a roll-film was the Kodak introduced by George Eastman in August 1888. The apparatus was the embodiment of simplicity, being a wooden box 6½ × 3½ × 3½ inches with a rectilinear fixed-focus lens giving sharp definition of everything beyond 8 feet, and having only one speed and a fixed stop. With the Kodak anybody who could 'Pull the string—turn the key—press the button' could photograph. Its appeal to the unskilled amateur was further enhanced by Eastman's recommendation to return the camera to the factory for developing and printing of the film, according to his famous slogan 'You press the button—we do the rest'.

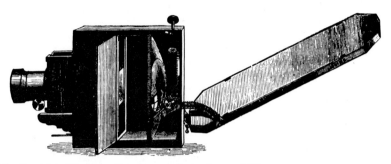

35 David A. Woodward's 'solar camera' enlarger, 1857.

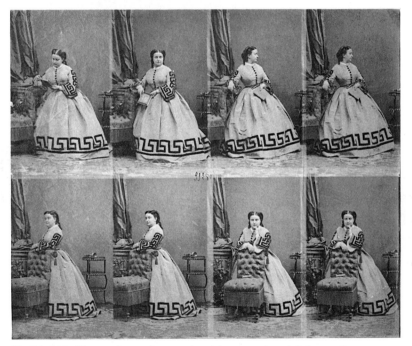

36 Disdéri. Uncut sheet of *carte-de-visite* portraits of Princess Buonaparte-Gabrielle, *c.* 1862.

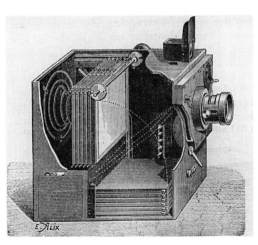

37 Magazine camera, *c.* 1885.

The rapid growth of the amateur movement after 1880 had made the mass-production of photographic equipment and materials feasible for the first time, and the Eastman Company in Rochester, N.Y., was the first of the great photographic manufacturing companies to cater to their needs and stimulate their demand with brilliant psychology applied to advertising. 'A collection of these pictures,' prospective buyers of the Kodak were informed, 'may be made to furnish a

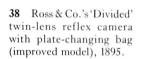

38 Ross & Co.'s 'Divided' twin-lens reflex camera with plate-changing bag (improved model), 1895.

39 'Ticka' detective camera taking 25 pictures on 16 mm film, 1906.

40 Sheet of 'postage stamp' photographs with portrait of George Washington Wilson, 1888. Withdrawn for lèse-majesté.

pictorial history of life as it is lived by the owner, that will grow more valuable every day that passes.' This was and still is, all that the average camera user wants to get out of photography.

While other manufacturers were discouraged from producing roll-film cameras by Eastman's virtual monopoly of nitro-cellulose roll-film, introduced in 1889, a large variety of hand-cameras for plates or cut film appeared. In the '80s and '90s some very small and compact cameras were designed, which were in the true sense pocket cameras. It was a status symbol for amateurs of both sexes to carry a camera about, and the market was inundated with small cheap models, which degenerated into toys of little practical value, rather like some transistor radios of today. A craze started for so-called detective cameras got up in the form of field-glasses, revolvers, books, watches [*Ill. 39*], and parcels, and concealed in purses, walking-sticks, hats, and cravats or beneath the waistcoat. The lenses of these cheap cameras were poor, the pictures too minute to be of any use. Only in one respect are they of interest, in that they show a steady trend towards the miniature camera which, as a scientific precision instrument, did not arrive until 1925.

Space does not permit more than a passing reference to the many cameras designed for special purposes, such as panoramic views, 'postage-stamp' photographs [*Ill. 40*], chronophotography, and various medical and other scientific purposes.

New cameras constantly appeared on the market, for the ranks of photographers swelled from week to week. By 1900 every tenth person in Britain—four million people—was reckoned to own a camera. The proportion was probably about the same in the U.S.A., but considerably lower on the Continent. Today the U.S.A. with over forty million amateur photographers is the largest camera-owning country, followed by Japan, the U.K., and Germany.

The vast majority of the small cameras were of the folding type and made of lightweight metal. Gaumont of Paris introduced in 1903 a well-designed vest pocket camera, as the 4½ × 6 cm plate size was generally called. This was the smallest size from which a contact print was considered acceptable for pasting in an amateur's album.

An interesting pointer to future development and a precursor of the Leica was designed and constructed by George P. Smith of Missouri in 1912. His 35 mm camera took 1 × 1½ inch pictures on cine-film. The mass-production of 35 mm film for the new cinema industry made it economical for still photography and it is natural that this idea should have occurred to more than one camera designer about the same time. The Minigraph introduced in 1914 by Levy-Roth of Berlin took 50 pictures 18 × 24 mm on 35 mm perforated cine-film. The external dimensions of the Minigraph, 5 × 6 × 13 cm, are very similar to the Leica's, the prototype of which was con-

structed in the same year by Oskar Barnack, a microscope designer at Leitz in Wetzlar. Owing to the first World War and the subsequent inflation in Germany it was ten years before the Leica went into production. The significance of the Leica lay in the fact that various features, such as a range-finder coupled with the excellent Elmar lens designed by Dr Max Berek to give first-rate definition at the full aperture of F 3.5, raised the miniature camera to a precision instrument.

Only six prototypes were produced of this revolutionary camera in 1924. The following year the Leica came on the market in an edition of 150, and ten years later it had sold over 150,000. Partly responsible for its phenomenal popularity was the superb work produced with it by Dr Paul Wolff—a Leica fan since 1925—who in a number of very successful publications and exhibitions became the leading exponent of its versatility and its ability to compete with the quality of the larger-format plate cameras. Thus *Formen des Lebens* (1931) shows the hidden beauty of flowers in a superb collection of macro close-ups. *My Experiences with the Leica* (1934) acted as an eye-opener to the last doubting Thomases though the high quality of the large-format reproductions. New viewpoints and a new range of subject matter were opened up by the 35 mm camera [*Ill. 41*], and above all, a breath of life pervaded every picture.

With the Leica the era of miniature photography began, and enlarging on fast, developed gelatine bromide paper at last became standard practice. Nevertheless, the advantages of the Leica were not fully appreciated immediately. In particular, the high resolving power of the Elmar lens was far in advance of the resolving power of the films of that day, and until about 1932 when fine-grain developers reduced the graininess of fast films, and consequently ensured good enlargements, the small plate camera retained undoubted advantages over the miniature cameras.

It was in fact a plate camera, the Ermanox [*Ill. 42*] made by the Ernemann Works, Dresden, and put on the market in June 1924, one year before the Leica, that for a few years proved a more useful tool for photographers needing a fast instrument. Indeed the powerful F 1.8 and F 2 Ernostar lenses made snapshots possible by available light at political meetings, indoor social functions, the theatre, and so on. In conjunction with fast panchromatic plates 4½ × 6 cm, the Ermanox was the camera used by the pioneers of photo-journalism, Dr Erich Salomon, Felix H. Man, Alfred Eisenstaedt, and others, who had to work in poor lighting conditions.

The Rolleiflex, devised by Reinhold Heidecke in 1928 and put on the market the following year by Franke & Heidecke, Braunschweig, had its forerunners [*Ill. 38*] and was the precursor of numerous similar twin-lens reflex roll-film cameras in the 6 × 6 cm format. Like the Leica and the Zeiss Ikon Contax (1932), the Rolleiflex has undergone many revisions since its first ap-

41 Dr Paul Wolff. Times Square at night, 1930.

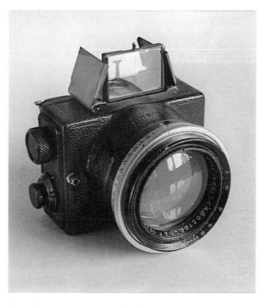

42 Ermanox camera with Ernostar lens F 2, 1924.

pearance, and its former disadvantage of being restricted to one focal length has been overcome by a modification of the construction to permit at least a limited interchangeability of lenses. The work of another leading German (now American) photographer—Fritz Henle—has become so closely linked with this camera since the early 'thirties that he is often dubbed 'Mr. Rollei'.

The best known of the pre-war single-lens reflex cameras in the 6 × 6 cm format, the Reflex Korrelle (1936), was also of German make. With amateurs wanting a slightly larger negative size, the Plaubel Makina 6 × 6 cm camera with Anticomar F 2.9/10 cm lens proved for many years a very popular instrument. It too came on the market in 1924, and could be used with plates or cut-film.

After World War II the 6 × 6 cm single-lens reflex camera of the Swedish manufacturer Hasselblad in Gothenburg, incorporating an interchangeable film back, came into prominence. It is popular among advertising, fashion, and portrait photographers.

In recent years the Japanese camera industry has produced precision instruments in the 35 mm and 6 × 6 cm sizes now almost universally favoured, with a range of excellent lenses, challenging for the first time the previous hegemony of the German camera and photographic optical industry. This had begun in 1889 with the introduction of Dr Paul Rudolph's anastigmat, and

was firmly established with his Tessar lens (1902) and other world-famous lenses and camera features such as Friedrich Deckel's Compur shutter (1912), and above all the Leica and the Rolleiflex.

The need for several lenses of different focal length has been partly superseded by the Zoom lens system giving variable focal length, introduced by Voigtländer, Braunschweig, in 1958.

With the latest fully automatic cameras, of which the prototype was the 1959 Optima of Agfa, the amateur has no longer to worry about diaphragm opening and length of exposure, which are controlled by built-in photocells.

The Polaroid camera invented by the American Edwin H. Land in 1947, with which a positive could be obtained in 60 seconds (now reduced to 10 seconds) after exposure, the paper negative and positive being developed in the camera, is by many people considered the ideal instrument for the amateur. Extremely simple in operation, it has the disadvantage of producing only one print, for the negative cannot be re-used unless a special film is used.

These refinements free the amateur from the need for any technical knowledge whatsoever, but

Of what use are lens and light
To those who lack in mind and sight?

The Evolution of Colour Photography

From the first announcement of the daguerreotype on 7th January 1839 a certain disappointment was felt at its inability to record colours, which were instead translated into varying shades of monochrome. Yet, having achieved the exact representation of Nature with all its details, it was realized that the attainment of colour was only a matter of time—though its advent came much later than expected.

Lack of colour was at first particularly felt in portraiture, for the public, accustomed to miniatures, preferred 'twopence coloured' to 'penny plain'. Miniature painters, finding themselves out of work through the popularity of the daguerreotype, soon fulfilled the demand by tinting daguerreotypes and occasionally painting over paper photographs.

(Sir) James Clerk Maxwell in a lecture on the Young/Helmholtz theory of colour vision at the Royal Institution, London, in May 1861 demonstrated that every possible shade of colour could be made up from the three colours, red, blue, and green. Thomas Sutton took for him three photographs of striped coloured ribbon through glass cells containing red, blue, and green solu-

tions of metallic salts (acting as filters). Diapositives of these were projected from three optical lanterns behind three identical coloured filters, and when superimposed on the screen, combined into a colour photograph. Though the result was far from perfect, Clerk Maxwell indicated the correct primary colours for three-colour photography by the additive process, whereas the suggestions put forward by Henry Collen in 1865 were not only impracticable but were moreover based on Sir David Brewster's theory of red, blue, and *yellow* as primary colours, which is erroneous for light, though valid for pigments.

Louis Ducos du Hauron made the greatest contribution to the evolution of colour photography in the nineteenth century. He proposed the subtractive method of colour photography in his book *Les Couleurs en Photographie, Solution du Problème* (1869), i.e. the pigments absorb or subtract from light all colours except their own, which they reflect. Ducos du Hauron took three separation negatives behind green, orange, and violet filters, and made positives on thin sheets of bichromated gelatine incorporating carbon pig-

ments of red, blue, and yellow colour respectively, i.e. the complementary colours to those by which the negatives were taken. When the red, blue, and yellow carbon prints were mounted superimposed, a Heliochrome or colour photograph was the result. Either colour transparencies or colour prints could be made, depending on whether the carbon prints were mounted on paper or on glass.

Charles Cros independently published the correct principle of the subtractive colour method two days after the granting of a patent to Ducos du Hauron on 23rd February 1869.

In his book Ducos du Hauron also made a correct forecast of the additive colour process by the line screen system, which was first put into practice by the Dublin professor of geology John Joly in 1895, using a screen plate with 200 lines per inch.

Like all other experimenters trying to solve the problem of colour photography, Ducos du Hauron was seriously impeded by the comparative insensitivity of photographic negative materials to colours other than blue and violet. Even the most correct theory was bound to lead to unbalanced colour pictures until good panchromatic material was available. Ducos du Hauron's earliest surviving colour photograph, a view of Agen, dates from 1877, and though taken after the introduction of certain dyestuffs which had the effect of increasing the sensitivity to other colours, the carbon print is far from perfect.

The discovery of the power of particular dyes to render the photographic emulsion sensitive to all colours was the one step needed to turn the theory of three colour photography into practice. In December 1873 Hermann Wilhelm Vogel, professor of photochemistry at the Technische Hochschule, Berlin, discovered that by bathing the collodion plate in particular aniline dyes its sensitivity to green was increased to some extent. Vogel's pioneer work in orthochromatism led a number of other investigators to experiment on similar lines, with the result that through new and better colour sensitizers the photographic plate was by degrees made more sensitive to green, yellow, and orange. Orthochromatic plates were, however, still comparatively insensitive to red and over-sensitive to blue. It was not until 1906 that the first truly panchromatic plates (i.e. sensitive to all colours of the spectrum) were commercially introduced by Wratten & Wainwright of London, after new I. G. Farben dyestuffs had extended the sensitivity of the photographic emulsion to red.

A pioneer in inventing equipment for three colour photography was Frederick Eugene Ives of Philadelphia, whose various apparatus first made the realization of colour photographs a commercial proposition. In Ives's Photochromoscope camera (1891) three separation negatives were taken in rapid succession on one plate by means of a repeating back containing red, green, and blue-violet filters. From these, black and white diapositives were made by contact printing. When laid on the Kromskop viewing instrument (1892), containing filters in the same colours, the Kromograms appear in perfect colour.

Ives also brought out stereo versions of these instruments, in which the colour pictures are seen in relief, and in 1895 introduced the Projection Kromskop for use with a magic lantern, which was followed a few years later by a one-shot colour camera, in which by means of built-in filters and mirrors the three separation negatives are obtained in one exposure.

Prof. Gabriel Lippmann's interference process (1891), based on the theory of Wilhelm Zenker, aroused much scientific speculation, for it produced a direct *natural* colour picture without the intervention of filters or dyes, which can only give close approximations. The phenomenon of colours produced by interference was described by Sir Isaac Newton, and can be seen in, for instance, soap bubbles, mother-of-pearl, or oil on a wet road, which appear coloured though consisting of colourless substances. In the Lippmann process a thin photographic plate coated with fine-grain silver bromide was placed with the emulsion side away from the lens and in contact with mercury. This formed a mirror-like surface, decomposing the white light into the spectrum colours by the interference of light rays reflected by this thin film of mercury, the colours being caused by the phenomenon of interference due to the structure which the mercury deposit has acquired. From the practical point of view Lippmann's process was too complicated, the exposure extremely long, the picture difficult to see and impossible to reproduce. Yet it received the Nobel Prize in 1908.

A turning point in practical colour photography was the colour screen process patented in 1904 by the brothers Auguste and Louis Lumière. The Autochrome plates manufactured at their factory at Lyons were not commercially introduced until 1907, after good panchromatic emulsion was available. The glass plates were coated with microscopically small grains of potato starch dyed green, red, and blue. Over them a thin film of panchromatic emulsion was applied. The exposure was made through the glass side of the plate, i.e. through the dyed starch grains acting as colour filters. After development the plate was re-exposed to light and re-developed (reversal process), resulting in a transparency composed of small specks of primary colours giving the effect of mixed colours, as in a *pointilliste* painting.

Although the Autochrome was the first colour process to enjoy considerable popularity, particularly among amateurs, it had the disadvantages that the exposure was about forty times longer than with black and white, and that the transparencies were rather dense.

In this *résumé* only brief mention can be made of the best-known of the other colour processes

invented before 1935. Though improvements on previous additive or subtractive processes, all were too complicated and expensive to find widespread application. *Additive processes*: Louis Dufay (1908), Agfa colour plate (1916) introduced in film form as Agfacolor (1932), Finlay Screen process (1929). *Subtractive processes*: Sanger-Shephard (1900), Pinatype (1904), Uvachrom invented by Arthur Traube (1916), Duxochrom invented by Herzog (1929), Autotype carbro process (1930), Vivex colour prints (1932), Kodak wash-off relief (1934).

Modern methods of colour photography are based on multi-layer film and coupling components. This principle was almost simultaneously introduced by Kodak and Agfa.

In Kodachrome film (1935), devised by two American musicians, Leopold Godowsky and Leopold Mannes, three layers of emulsion are coated on film support, the total thickness amounting to no more than an ordinary black and white film. The top layer is sensitive only to blue light, the middle layer to green and the bottom layer to red. (The idea of using substances sensitive to one colour only was first put forward by Henry Collen in 1865.) After development the residual silver bromide in each layer is re-exposed and independently developed in coupler developers which deposit dye of pre-determined colours wherever they develop silver bromide to silver. Different coupler developers are therefore used for each layer, and after dissolving away the positive silver image a subtractive colour photograph of yellow, magenta, and cyan (blue-green) dyes remains.

The Agfacolor film introduced in 1936 was based on a similar principle, and is not to be confused with the additive film of the same name introduced four years earlier. The chief difference between this new Agfacolor film and Kodachrome was that the three coupling components were incorporated in the three emulsion layers during manufacture. After developing to a negative and bleaching out the silver image, the reversal positive image was produced by a single colour-forming developer in the required subtractive colours. In America, the process was introduced as Anscocolor in 1941.

With both Kodachrome and Agfacolor, film transparencies were obtained, suitable for projection and for reproduction. The natural desire, especially of the amateur, was to have colour *prints*. Though the Agfacolor negative/positive process was published in 1937, development of the system for practical use was stopped by the war and the film did not become available until 1949. Meanwhile Kodak had brought out in 1942 the Kodacolor negative/positive film in which the first part of the process (the making of the transparency) is analogous to the procedure described above under Agfacolor. Instead, however, of converting the negative into a positive transparency, a negative dye image in the complementary colours was left; this negative was then printed on to paper coated with a similar set of emulsions to those on the original negative, and after similar processing a positive print in the primary colours was obtained.

The processing of all modern colour films is complicated and requires controlled laboratory conditions and for this reason is performed by the manufacturers or their authorized agents properly equipped for the work. Since about 1950 leading manufacturers of photographic materials in many parts of the world have marketed colour films under their own trade names. They are all more or less based on the Agfacolor patent which, as an enemy invention, became available to the allied powers. Only one American, British, and Japanese manufacturer brought out colour film on the Kodachrome principle. Another exception is the Polaroid colour film introduced by the Polaroid Corporation of Cambridge, Massachusetts, in 1963, for use in the Polaroid Land camera. It produces a direct colour positive print in one minute.

The Artistic Achievements
of Photography

Pictures and their Makers up to 1914

The Daguerreotype

America

Probably no other invention ever captured the imagination of the public to such an extent and conquered the world with such lightning rapidity as the daguerreotype. Within a month of the manipulation's being made public, D. W. Seager, an English resident in New York, on 16th September 1839 took the first successful daguerreotype in the New World—a view of St Paul's Church, New York. He was immediately followed by two professors of New York University, Samuel Morse, portrait painter and inventor of the electro-magnetic telegraph, and the scientist Dr John William Draper, who independently of one another experimented with portraiture. Alexander S. Wolcott, a New York manufacturer of dental supplies, on 7th October succeeded in taking a profile portrait the size of a signet-ring of his partner John Johnson. Nine days later Joseph Saxton, an official of the U.S. Mint, took the earliest surviving American daguerreotype, a view in Philadelphia.

When, therefore, François Gouraud, agent of Daguerre and Giroux, the manufacturer of his apparatus, arrived in New York on 23rd November with the intention of introducing the daguerreotype in the New World, he found he had been forestalled. However, the thirty daguerreotypes which Gouraud exhibited in a Broadway hotel were vastly superior to the experimental ones so far made in the United States. According to *The Knickerbocker*, the French daguerreotypes were 'the most remarkable objects of curiosity and admiration, in the arts, that we ever beheld. Their exquisite perfection almost transcends the

bounds of sober belief'. Gouraud gave demonstrations and lessons, sold daguerreotype outfits, and published an instruction manual in March 1840. Independently from this, there appeared almost simultaneously a brochure by Dr James Chilton, a Broadway chemist.

During the winter Wolcott, with the assistance of Henry Fitz, who possessed some knowledge of optics, had devised a novel camera in which a concave mirror was substituted for a lens [*Ill. 26*]. This shortened the exposure to 3–5 minutes, and allowed Wolcott and Johnson to open the world's first Daguerreian Parlor in New York at the beginning of March 1840. A contributory factor to success in 'sun-drawn miniatures' was Wolcott's ingenious lighting system. Two adjustable mirrors outside the window reflected the sunlight on to the sitter through a plateglass trough filled with a solution of copper sulphate, the blue colour of which made the light more actinic as well as protecting the sitter's eyes from the glare.

The following month Morse and Draper, considering their experiments sufficiently advanced, opened jointly a portrait studio on the roof of the University building, where they also gave lessons in daguerreotype manipulation. The earliest good portrait to survive until modern times was taken by Draper of his sister in June 1840 [*Ill. 43*]. It measured 3½ × 2¾ inches and the exposure was 65 seconds. A detailed description of the taking of photographic portraits was communicated by Draper to *The London & Edinburgh Philosophical Magazine* and published in September 1840.

By the early 'forties portrait studios abounded

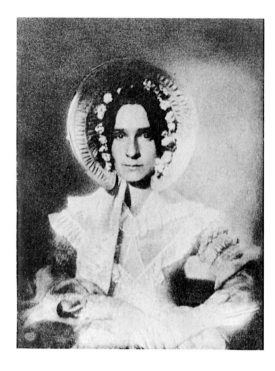

43 Dr J. W. Draper. Daguerreotype of his sister Dorothy Catherine Draper, June 1840.

in American cities, and itinerant daguerreotypists appeared in every small town.

Prominent early American daguerreotypists include Charles R. Meade, M. M. Lawrence, Jeremiah Gurney, and Mathew B. Brady, all in New York. The latter from 1844 onward photographed every American of distinction with the intention of forming a National Historical Portrait Gallery. Edward Anthony in partnership with J. M. Edwards opened a portrait studio in Washington, D.C. in 1842 and photographed all the members of Congress. Marcus A. Root of Philadelphia was from 1842 to 1846 in partnership with J. E. Mayall, later a leading photographer in London. John Adams Whipple of Boston is better known for a particularly successful daguerreotype of the moon in 1851 than for his portraits. Excellent views, as well as portraits, were taken by Albert Sands Southworth and his partner Josiah John Hawes in Boston, where John Plumbe, a Welsh immigrant, became in 1841 probably the first American manufacturer of daguerreotype apparatus and materials. He also had a photographic studio there, and during the next few years opened a chain of twelve other branches across the United States.

Most European daguerreotypes are small portraits, but in the United States the process was frequently also used for landscapes. In July 1845 the brothers William and Frederick Langenheim, portrait photographers in Philadelphia, made a number of large panoramic pictures of the Niagara Falls, each made up from five separate views. Charles Fontayne and W. S. Porter three years later produced a fine panorama of the Cincinnati waterfront no less than 8 feet long, made up from eight daguerreotypes each 12 × 9 inches. Platt D. Babbitt was granted in 1853 the monopoly for photography on the American side of the Niagara Falls. When visitors stood at the edge of the cliff to admire the Falls he would take them unawares [*Ill. 44*] and of course they were always glad to buy a picture as a souvenir. Babbitt was probably the first to specialize in this kind of tourist photography.

44 Platt D. Babbitt. Daguerreotype of the Niagara Falls, *c.* 1853.

The bright reflection from the water enabled him to give an almost instantaneous exposure showing the spray and clouds. The only European to have succeeded in photographing clouds by this date was Hippolyte Macaire of Le Havre.

In November 1850 there appeared in New York the first photographic journal in the world, *The Daguerreian Journal: devoted to the Daguerreian and Photogenic Arts*. On the banks of the Hudson River a town grew up round a large factory making daguerreotype supplies and was appropriately named Daguerreville.

At the Great Exhibition in London, 1851, American daguerreotypes won universal praise for their technical brilliance, due to special care in polishing the silvered plate—frequently by steam-machinery driving cleaning and buffing wheels.

The daguerreotype attained its greatest popularity in the States in 1853 when three million were estimated to be produced. In New York City alone there were about a hundred studios. The process remained popular in the United States until the mid-'sixties, several years longer than in Europe, where both the waxed-paper and collodion processes had long established themselves in preference to the daguerreotype.

Great Britain

England was the only country in which the daguerreotype had been patented. In February 1840 Daguerre and Isidore Niépce (Nicéphore's son) sent to England an agent, Elzeard-Désiré Létault, with the aim of selling the daguerreotype patent to the British Government or some public institution. However, Létault returned to Paris two months later without having accomplished his object.

About this time Richard Beard, coal-merchant and patent speculator, acquired from Alexander Wolcott the right to use his mirror camera, which was vital to Beard's plan to make photographic portraiture a commercial success. He engaged John Frederick Goddard, a science lecturer, with the object of accelerating the daguerreotype process with bromine (which he learned Wolcott had experimented with) in order to make it fast enough for portraiture. By 12th December Goddard had succeeded sufficiently to make an announcement in *The Literary Gazette* of his ability to take portraits, and Beard went ahead with his plan for a public studio. This was opened on 23rd March 1841 on the roof of the Royal Polytechnic Institution in London. It was the first public photographic portrait studio in Europe, and the novelty of having one's likeness taken 'by the sacred radiance of the Sun' caused immense excitement. Crowds flocked to Beard's establishment, and 'in the waiting rooms you would see the nobility and beauty of England, accommodating each other as well as the limited space would allow, during hours of tedious delay'. The average daily takings amounted to £150, the charge being one guinea for a 1½ × 2 inch portrait—the size to which the picture was limited by the mirror camera. The exposure varied in summer from 3 seconds to 2 minutes and in winter from 3 to 5 minutes according to the weather. For this reason the head-rest as employed by Sir Thomas Lawrence and other portrait painters was taken over by photographers, and remained in use to a certain extent up to the Great War.

Beard's studio was circular and glazed with blue glass casting a mysterious light which made people look like spectres. The arrangement was more convenient than Wolcott's liquid filters. The posing chair stood on a raised platform bringing the sitter closer to the light [*Ill. 45*]. Here

Apollo's agent on earth, when your attitude's right,
Your collar adjusted, your locks in their place,
Just seizes one moment of favouring light,
And utters three sentences: 'Now it's begun'—
'It's going on now, sir'—and 'Now it is done'.
And lo! as I live, there's the cut of your face
On a silvery plate
Unerring as fate,
Worked off in celestial and strange mezzotint
A little resembling an elderly print.
'Well, I *never*!' all cry: 'It is cruelly like you!'
But truth is unpleasant
To prince and to peasant.

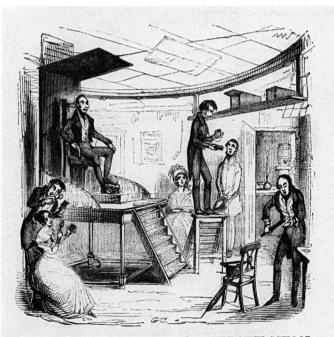

PHOTOGRAPHIC PHENOMENA, OR THE NEW SCHOOL OF PORTRAIT-PAINTING.

" Sit, cousin Percy ; sit, good cousin Hotspur !"—HENRY IV.
" My lords, be seated."—*Speech from the Throne.*

I.—INVITATION TO SIT.

Now sit, if ye have courage, cousins all !
Sit, all ye grandmamas, wives, aunts, and mothers ;
Daughters and sisters, widows, brides, and nieces ;
In bonnets, braids, caps, tippets, or pelisses,

45 Richard Beard's studio. Wood engraving by George Cruikshank, 1842.

The realization that the camera revealed the sitter with uncompromising truth, dispelling cherished illusions of youth and beauty, was disconcerting at first, particularly to women. The demands of the sitter for a good likeness and at the same time a beautiful portrait were—and still are—seldom compatible. Fashionable artists, especially miniaturists, had encouraged

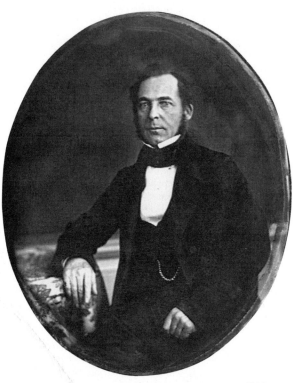

46 Daguerreotype of Sir Henry Bessemer, *c.* 1848.

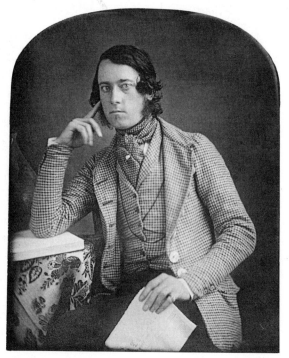

47 Daguerreotype of a gentleman, *c.* 1845.

their sitters' whims, and traded on deceit. Suspecting, perhaps, that Alfred Chalon had made her quite unrecognizable by excessive flattery, the young Queen Victoria asked her Court painter one day whether he were not afraid that photography would ruin his profession. Chalon's confident rejoinder, 'Ah non, Madame! photographie can't flattère' was characteristic. Nevertheless, the heyday of miniature painting was past. To all except the incurably vain the intimacy of the actual image of life was photography's strongest attraction [*Ill. 46*]. It was this quality that caused Elizabeth Barrett to write to her friend Mary Russell Mitford in 1843: 'It is not merely the likeness which is precious—but the association and the sense of nearness involved in the thing . . . the fact of the *very shadow of the person* lying there fixed for ever! . . . I would rather have such a memorial of one I dearly loved, than the noblest artist's work ever produced.'

The best daguerreotypists took such excellent portraits that even the great Ingres avowed: 'It is to this exactitude that I would like to attain. It is admirable—but one must not say so.' [*Ill. 47*].

Daguerreotype portraiture proving a lucrative business, in June 1841 Beard bought Daguerre's patent rights for the daguerreotype in England, Wales, and the Colonies. To overcome a frequent complaint against daguerreotypes by people used to miniatures, Beard in March of the following year patented a method of colouring daguerreotypes. Further studios were soon opened by him in London and the provinces, and he also sold licences for professional studios in certain towns and counties. For amateurs the fee was five guineas annually. Beard's quickly-earned fortune was lost, however, in several protracted lawsuits against infringers of his rights and he was declared bankrupt in June 1850—three years before the patent ran out.

The most distinguished daguerreotypist in Britain was Antoine Claudet, a Frenchman who had settled in London in 1827 as an importer of sheet glass and glass domes. In August 1839 he learned the daguerreotype process from the inventor himself and purchased from him a licence to practise it in Britain. He was also granted sole agency rights for the import and sale of French daguerreotypes and Daguerre's apparatus. Claudet's independent experimentation with an acceleration process led him to success slightly later than Goddard. After discovering that a combination of chlorine and iodine vapour greatly increased the sensitivity of the plate, Claudet began taking portraits professionally in June 1841 in a glass-house erected on the roof of the Royal Adelaide Gallery, a popular scientific recreation centre rivalling the Polytechnic. This was the second photographic portrait studio in Europe.

Claudet was a man of superior calibre to Beard, who was merely a promoter. He belonged to that rare species of being equally distinguished

in the scientific and artistic fields, and an inventor as well. For the first quality he was elected a Fellow of the Royal Society; his artistic merits were summed up by *The Athenaeum:* 'What Lawrence did with his brush, Monsieur Claudet appears to do with his lens.' [*Ill. 17, 48*]. Claudet introduced the red dark-room light, the use of painted backgrounds, and several instruments, especially in the field of stereoscopy. In 1851 he set up a 'Temple to Photography' in Regent Street—the most elegant establishment of its kind in Britain, designed by Sir Charles Barry, architect of the Houses of Parliament.

John Jabez Edwin Mayall, a daguerreotypist in Philadelphia, 1842–46, opened his 'American Daguerreotype Institution' in London early in 1847 under the pseudonym 'Professor Highschool'. Early daguerreotypists frequently called themselves 'Professor'. The technical excellence of Mayall's portraits soon brought him into prominence. A 24 × 20 inch daguerreotype portrait preserved at the Science Museum, London, was probably taken by him, for only Americans took daguerreotypes of such large dimensions.

Other noted London professional daguerreotypists include William Edward Kilburn, T. R. Williams, and William Telfer.

The Science Museum, London, possesses 158 wholeplate daguerreotypes of Italian architecture and views taken in 1840 and 1841 [*Ill. 49*]. Most of them are by Dr. Alexander John Ellis, philologist and mathematician, but some of the earlier ones were commissioned by him from Achille Morelli and Lorenzo Suscipi. Ellis's own pictures bear an exact description of subject, date, time of day, and exposure, which varied from 5 to 35 minutes. The photographs were intended for publication as steel engravings, which, however, for some unknown reason did not materialize. They are the only daguerreotype views known to have been taken by an Englishman, and the earliest surviving photographs of Italy.

The first professional portraitist in Scotland—where photography was free from patent restrictions—was a Mr. Howie who began taking portraits in Princes Street, Edinburgh, in autumn 1841. The sitter had to climb three flights of stairs and a ladder through a skylight on to the roof, where Howie would push him into a posing chair with the encouraging observation: 'There! Now sit as still as death!'

In Ireland the first Daguerreotype Portrait Institution was opened in Dublin by a Hungarian, 'Professor' Glückman, in 1842.

France

With Arago's revelation of the daguerreotype manipulation, all Paris was seized with daguerreotypomania. An eye-witness wrote: 'You could see in all the squares of Paris three-legged dark-boxes planted in front of churches and palaces

48 Antoine Claudet. Daguerreotype (tinted) of a lady, *c.* 1851.

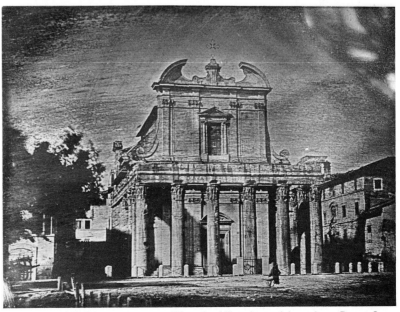

49 Dr A. J. Ellis. Daguerreotype of Temple of Faustina and Antoninus, Rome, June 1841.

50 'La patience est la vertu des ânes'. Caricature by Daumier from *Le Charivari*, July 1840.

51 L.-J.-M. Daguerre. Daguerreotype of still-life in his studio, 1837.

52 L.-J.-M. Daguerre. Daguerreotype of Notre Dame and the Île de la Cité, Paris, 1838.

[*Ill. 50*]. All the physicists, chemists, and learned men of the capital were polishing silvered plates, and even the better-class grocers found it impossible to deny themselves the pleasure of sacrificing some of their means on the altar of progress.' Edition after edition of Daguerre's official instruction booklet was quickly sold out. Altogether no fewer than twenty-nine editions were published in the next four months, in six languages, not counting a number of brochures by other people which appeared in that period.

Considering the tremendous impact the invention made, it is surprising that only seventeen daguerreotypes by the inventor himself, several of which he presented to heads of State, have survived. They are of still-lifes in his studio [*Ill. 51*], buildings and views in Paris [*Ill. 52*], and a few portraits taken in the mid-'forties at his country house at Bry-sur-Marne to which he retired in 1840.

In France, as elsewhere, attempts at portraiture were immediately made, by Dr Alfred Donné, head of the Charité clinic; Abel Rendu, a civil servant; Susse Frères; E.-T. and E. Montmiret; and others. As people had to sit imprisoned in a posing chair in direct sunshine for about a quarter of an hour they looked more dead than alive [*Ill. 53*]. The only people who could stand the ordeal with a reasonable measure of success were artists' models, but it was not until July 1840 that portraits of this kind were mentioned for the first time as being on view.

As architecture, sculpture, and landscapes do not depend for success on a short exposure, N.-P. Lerebours, an enterprising Parisian optical instrument maker, equipped a number of artists and writers with daguerreotype outfits of his own manufacture and commissioned them to take views in many countries. Early in November 1839 Horace Vernet, painter of his historical battle scenes, who travelled to Egypt with Frédéric Goupil Fesquet, reported from Alexandria: 'We keep daguerreotyping away like lions.' Under the title *Excursions Daguerriennes* (1841–42) Lerebours published fewer than one-tenth of the 1,200 daguerreotypes taken, copied as copperplate engravings, and enlivened in many cases by the addition of figures.

Nearly as many fine architectural and landscape daguerreotypes were taken by a single French amateur, Joseph-Philibert Girault de Prangey, during his travels through Italy [*Ill. 54*], Greece, and the Near East in 1842–44. Some of his close-ups—possibly the earliest taken—formed the basis of the illustrations in his book *Monuments arabes d'Egypte, de Syrie et d'Asie Mineure* (1846).

The daguerreotype was a veritable mirror of nature. Its marvellously clear rendering of detail and texture never ceased to arouse admiration. John Ruskin, comparing his daguerreotype of a Venetian palace with a painting by Canaletto of the same building, declared himself in favour of the photograph 'in which every figure, crack and

53 Caricature by Daumier published in *Les bons bourgeois*, 1847.

stain is given on the scale of an inch to Canaletto's three feet'. In 1843 he wrote enthusiastically to his father: 'Photography is a noble invention, say what they will of it. Anyone who has worked, blundered and stammered as I have done [for] four days, and then sees the thing he has been trying to do so long in vain, done perfectly and faultlessly in half a minute, won't abuse it afterwards.'

John Lloyd Stephens, an American explorer, and Frederick Catherwood, an English architect, in 1841 revisited the lost cities of Yucatan where they had been two years earlier. The daguerreotypes which they took of ruined Mayan architecture, supplemented by *camera lucida* drawings, were published as engravings in *Incidents of Travel in Yucatan* (1843).

According to *La Lumière* some unusual daguerreotypes were taken by a Frenchman named Tiffereau in Mexico in 1842–47. They included documentary pictures such as a Colima family preparing a meal outside their hut, and the extraction of silver ore.

Some beautiful panoramic views of Paris measuring 15 × 4¾ inches were taken by Friedrich Martens, a German residing in Paris, with a panoramic camera of his own invention (1845). Other prominent amateurs who did excellent landscape work were the diplomat Baron Gros and Hippolyte Bayard, who had apparently lost confidence in photography on paper, of which he was one of the independent inventors.

Portraiture became practicable in France only after Claudet's communication to the Académie des Sciences on 7th June 1841 of his accelerating process (details of Goddard's having been kept secret by Beard). Lerebours was probably the first person in France to open a public portrait

54 J.-P. Girault de Prangey. Daguerreotype of statue at portal of Genoa Cathedral, 1842.

studio; at any rate, during the second half of that year he is stated to have taken about 1,500 portraits. He was also one of the earliest to take 'Académies'—nude studies for which there was always a demand in Paris from artists and tourists.

Louis Bisson also opened a studio in Paris some time in 1841. Soon after, he was joined in business by his younger brother Auguste, and with the support of a financial backer they were established in the fashionable quarter of the

55 Antoine Claudet. 'The Geography Lesson'. Stereoscopic daguerreotype, 1851.

The keen interest of the Germans in the daguerreotype is evinced by the surprisingly large number of ten publications on the process which appeared there during 1839. In Berlin, daguerreotypes were taken within a month of publication of the manipulation, by Louis Sachse, Theodor Dörffel, and Eduard Petitpierre, a Swiss. The first professional studio in Berlin was opened by J. C. Schall, a portrait painter whose earliest traceable daguerreotype advertisement appeared on 16th August 1842. Within three weeks competition arose from another portrait painter, Julius Stiba. These Berlin daguerreotypists had, however, been preceded by another artist, Hermann Biow, whose Heliographic Studio at Altona near Hamburg opened on 15th September 1841. Between 1846 and his early death in 1850 Biow daguerreotyped royalties and celebrities in Dresden, Frankfurt, and Berlin, where a studio was set up for him in the Royal Palace. Here he photographed King Frederick William IV of Prussia and many princes, politicians, and men famous in art and science. Like Brady in America, Biow planned a National Gallery of Photographic Portraits, of which 126 were copied as lithographs and published in 1849.

For seven months from September 1842 onward Biow had as partner in Hamburg Carl Ferdinand Stelzner, originally a miniature painter who had studied under Isabey in Paris. Stelzner's art training comes out unmistakably in his daguerreotype portraits [*Ill. 56*], sometimes with painted backgrounds, and frequently tinted by his wife, herself a professional miniaturist. Stelzner and Biow both took the most artistic daguerreotype portraits in Germany, and indeed some of the finest anywhere.

They also recorded the ruins of Hamburg following a devastating fire on 5th–8th May 1842. Only three daguerreotypes in this series survive, the earliest photographs of an historic event [*Ill. 57*]. Unaware of these authentic pictures, *The Illustrated London News* published in its first issue on 14th May 1842 an imaginary view of the fire based on an old print of Hamburg in the British Museum, suitably embellished with flames and smoke!

The important advance in the optics of the daguerreotype made by Petzval and Voigtländer has already been referred to. Chemical acceleration by the combined vapours of chlorine and bromine is due to Franz Kratochwila, a Viennese civil servant, who published the process in the *Wiener Zeitung* on 19th January 1841. Early in March the brothers Joseph and Johann Natterer of Vienna were reported to have taken portraits experimentally with the Voigtländer camera on plates prepared according to Kratochwila's method, which they found increased the sensitivity five times. The exposure was 5 to 6 seconds in clear weather or 10 seconds on dull days, reinforced by the light of an oil lamp. Chemical

Madeleine. Henceforth until their retirement from photography in the mid-1860s their work was usually signed 'Bisson Frères'.

Other well-known French professional portraitists in the 1840s include Richebourg, Derussy, and Victor Plumier in Paris, and I. Thierry and Vaillat in Lyons, all of whom took up to 3000 portraits a year at prices varying from 10 to 20 francs according to size, whether tinted, and style of frame. On the Continent white passepartout frames were usual; in England and America daguerreotypes were framed like miniatures in attractive velvet-lined red morocco or moulded plastic Union cases, or occasionally in hanging-frames of the kind used for silhouettes.

People could hardly believe that the photographer could depict a large group [*Ill. 55*] just as quickly as a single portrait, and some early advertisements drew special attention to the fact that there was no extra charge for additional sitters in the picture. Many photographers, however, charged more for children on account of the likelihood of their spoiling several plates by fidgetting. Incidentally, it was a Parisian daguerreotypist, Marc-Antoine Gaudin, who in 1843 first used the famous stock phrase to children: 'Now look in the box and watch the dicky-bird!'

acceleration in conjunction with the Voigtländer camera reduced the exposure to a fraction of a second out of doors in bright weather, enabling the Natterer brothers to take instantaneous street views with people and traffic. The first professional portrait studio in Austria was opened by Karl Schuh, who came from Berlin, in the Fürstenhof, Vienna, some time in the second half of 1841.

Johann Baptist Isenring, a copperplate engraver in St. Gallen, Switzerland, deserves to be remembered as the first person to hold a public exhibition of photographic portraits, to retouch photographs, and to attempt to give daguerreotypes a painterly appearance by colouring them. Isenring's eight-page catalogue listing 39 portraits, in addition to still-lifes, architecture, and so on, published in St Gallen in August 1840, is the first of its kind. The quality of his coarse over-painted daguerreotype portraits, in which the pupils of the eyes were scratched in, can only be imagined, for none seems to have survived. It is rather doubtful that they were worth preserving. Isenring himself cannot have been very satisfied, for it was only after learning of Kratochwila's chemical acceleration that he accepted orders for portraits from the public. Until then, he had only photographed relations and friends. The novelty of having one's portrait taken proved a great success in Munich, where Isenring operated a portrait booth at a fair in the summer of 1841. The following year this itinerant photographer began travelling around the countryside in his *Sonnenwagen*, the earliest photographic carriage with darkroom and living and sleeping quarters. Altogether, Isenring has the dubious distinction of being the first low-class photographer.

Enough has been said to show that by 1842–43 probably all European capitals and large towns

[*Ill. 58*] had one or more portrait studios, and smaller places were visited by itinerant photographers.

The daguerreotype was a *cul-de-sac* in photography. Each picture was a unique image, and although various etching processes were devised to convert the picture into a printing plate, they proved too complicated and expensive for widespread use. Moreover, the daguerreotype had other insuperable disadvantages: the mirror-like sheen of the silvered plate made it difficult to see the picture, and unless the photograph was taken through a prism—which lengthened the exposure—the image, being a direct positive, was laterally reversed.

57 C. F. Stelzner. Daguerreotype of ruins around the Alster after the great fire of Hamburg, May 1842. The earliest news photograph.

56 C. F. Stelzner. Daguerreotype group, *c.* 1842.

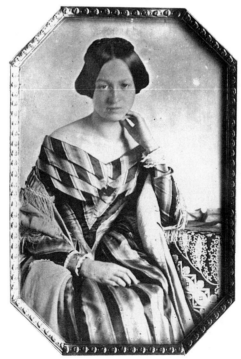

58 Daguerreotype of a Milanese lady, *c.* 1845.

Photographs on Paper

Great Britain

Talbot's first licensee was the miniature painter Henry Collen, who opened a Calotype studio in London in August 1841. He took small portraits in about a minute, using them merely as a base for drawing or painting over.

The Calotype never became really popular, partly on account of the stringent conditions imposed by Talbot under his patent, partly because the soft grainy effect of the paper was generally considered a disadvantage compared with the brilliantly sharp daguerreotype, and partly because of its liability to fade. In the early and mid-'forties there were only about a dozen practitioners of the Calotype, despite its inventor's efforts to popularize it by selling 'Sun Pictures' through printsellers and stationers. Talbot hoped to recoup his family fortunes with his invention, and this accounts for his strict enforcement of patent rights and his interests in various commercial ventures, considered hardly suitable in those days for a gentleman and a man of learning.

To demonstrate the chief advantage of his process over the daguerreotype, which did not lend itself to publication, Talbot brought out two books illustrated with original Calotypes. The prints were made at his photographic establishment at Reading [*Ill. 59*], started in 1843 under the management of his former valet and photographic collaborator, Dutch-born Nicolaas Henneman [*Ill. 60*].

The Pencil of Nature [*Ill. 61*], the first photographically illustrated book in the world, came out in six parts during 1844–46, and less than 20 complete copies containing all the 24 photographs are known. *Sun Pictures in Scotland*, with 23 photographs, was published in 1845. An explanatory 'Notice to the Reader' in both books stressed the novelty of photographic illustrations: 'The plates in the present work are impressed by the agency of light alone, without any aid whatever from the artist's pencil. They are the sun pictures themselves, and not, as some persons have imagined, engravings in imitation.'

The majority of Talbot's photographs are rather matter-of-fact records, though his work does include a number of highly artistic compositions, in some of which he may have had the collaboration of Henry Collen. At any rate, it is known that Collen's opinion prevailed when photographing 'The Ladder', and he may well have advised Talbot on other occasions. Moreover, it has been stated that some of the pictures in *The Pencil of Nature* were taken by Benjamin Bracknell Turner, an artist who became a well-known Calotypist. However, even if Talbot lacked artistic talent, he showed aesthetic perception in remarking with regard to his photograph of 'The Open Door': 'A painter's eye will often be arrested where ordinary people see nothing remarkable. A casual gleam of sunshine, or a shadow thrown across his path, a time-withered oak, or a moss-covered stone, may awaken a train of thoughts and feelings, and picturesque imaginings.'

In a further effort at publicity Talbot presented to each of the 7,000 subscribers to *The Art Union* (journal) a specimen Calotype to illustrate an article on his process in the June 1846 issue. This was the last important work undertaken at the Reading establishment, which was closed the following spring when Talbot opened a portrait studio in Regent Street, London, in Henneman's name. But like an earlier attempt of Claudet to introduce Calotype portraits in his daguerreotype studio in 1844, this commercial venture was not a success, and Henneman later changed over to the collodion process.

Although Talbot's patent did not cover Scotland, there was surprisingly only one professional Calotype studio north of the Border—that of Hill and Adamson.

David Octavius Hill, a native of Perth, was a landscape painter well known in his day. His reputation was established by *The Land of Burns* (1840) illustrated with 61 steel engravings copied from his paintings of scenes associated with the life and works of the Scottish poet Robert Burns.

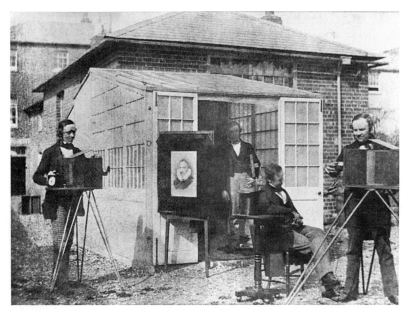

59 W. H. Fox Talbot's establishment at Reading. Calotype, 1844.

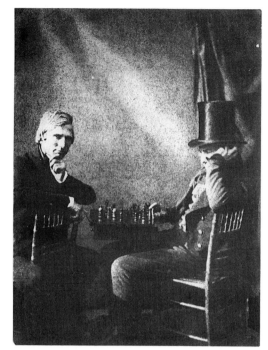

60 N. Henneman. 'The Chess Players' (A. Claudet and W. H. Fox Talbot). Calotype, 1844.

61 W. H. Fox Talbot. Cover of *The Pencil of Nature*, 1844. The first photographically illustrated book.

During his lifetime Hill exhibited nearly 300 pictures at the Royal Scottish Academy (of which he was a founder-member, and secretary for forty years) and elsewhere. His romantic landscapes were much admired at the time, and indeed judging from the half-dozen or so which survive, are superior to most Victorian paintings. There is more than a touch of both Turner and Samuel Palmer in the mountainous landscape bathed in the golden light of the setting sun, in a painting possessed by the author.

What caused this successful landscape painter to take up photographic portraiture? Wishing to commemorate the disruption of the Church of Scotland in May 1843 by a monumental painting including portraits of 474 ministers and prominent lay members, Hill soon realized the difficulty of his self-imposed task. Sir David Brewster, a member of the Free Church Committee and a friend of Talbot, suggested taking Calotype portraits of the resigning ministers to serve as studies for the painting, and put Hill in touch with Robert Adamson, who earlier that year had opened a Calotype studio at Rock House, Calton Hill, Edinburgh. The collaboration turned out to be an ideal association. Adamson's technical skill was indispensable to Hill, who brought to photography an artistic conception of an unusually high order. They started by taking portraits of some of the participants in the first General Assembly of the newly-formed Free Church of Scotland. Their fame soon spread and many other distinguished people came to be photographed [*Ill. 62*]. Since sunlight was essential, they were posed in the porch at Rock House [*Ill. 63*], and in many pictures an arrangement of

curtains and furniture conveys a convincing impression of an interior. Most of these photographs are 6 × 8 inches, and the exposure must have been about a minute.

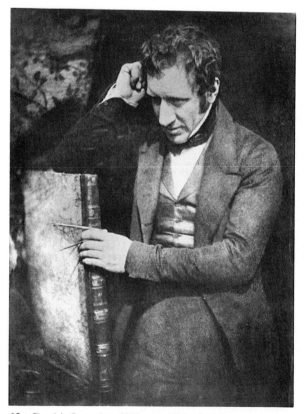

62 David Octavius Hill and Robert Adamson. James Nasmyth, inventor of the steam hammer. Calotype, *c*. 1845.

63 David Octavius Hill and Robert Adamson. 'The Birdcage'. Calotype, *c*. 1843.

64 David Octavius Hill and Robert Adamson. Cottage at Newhaven near Edinburgh. Calotype, *c*. 1845.

Hill and Adamson often took their camera to nearby seaside villages to photograph old stone cottages, fishing boats, groups of sailors and fisherfolk in scenes of everyday life. Their joint *opus* of some 1,600 photographs also includes architectural views of St Andrews and Edinburgh, where Greyfriars churchyard with its ivy-clad walls and ancient monuments formed a favourite background for picturesque groups. Curiously enough, though Hill was a landscape painter, there are comparatively few photographic landscapes by him and Adamson.

Contemporary critics were full of admiration for these Calotypes, which look not unlike purple-brown mezzotints. On account of the grain and thickness of the paper negative, the Calotype gave broad effects [*Ill. 64*], which suited Hill's style much better than the brilliantly detailed daguerreotype would have done. The Hill/Adamson portraits are powerful in characterization and display a masterly sense of form and a sure instinct for bold and simple composition. The massing of light and shade and apparent ease of pose give them great charm.

After the death of Adamson at the age of twenty-seven Hill devoted the remainder of his life to painting. The enormous canvas *Signing of the Deed of Demission* on which he worked on and off for twenty-three years is no better than a gigantic 'mosaic' group, of interest only because of the comparison it affords with some of the Hill/Adamson Calotype portraits. In this crowded composition Hill portrayed himself with sketchbook and pencil, whereas Adamson is depicted as the camera-man. However, the artistic failure of Hill's later short comeback to photography with another collaborator proves that Adamson's role can hardly have been merely that of technician, in spite of the fact that Hill used to show their joint productions in photographic exhibitions and at the Royal Scottish Academy alongside his paintings as 'Calotype portraits executed by R. Adamson under the artistic direction of D. O. Hill'.

In the autumn of 1847 a dozen or so keen amateurs started the Calotype Club in London. They included Roger Fenton and P. H. Delamotte, who both later did outstanding work with the waxed-paper process, the former during a visit to Russia [*Ill. 65*] in 1852, the latter in views of the Crystal Palace in Hyde Park.

In Edinburgh a similar association is said to have existed in the 'forties, but it probably ceased before the gynaecologist Dr Thomas Keith took up photography. He took architectural and landscape photographs [*Ill. 66*] on waxed paper in and around the Scottish capital between 1854 and 1856, achieving in these fields the same high artistic level as Hill/Adamson had in portraiture and *genre*. Another Scottish landscape photographer of distinction was John Forbes-White, his brother-in-law.

Calotype views and architectural close-ups of unusual artistic merit were taken by John Shaw

Smith, an Irish landowner, during a tour through southern Europe and the Near and Middle East in 1850–52 [*Ill. 67*]. Smith and his wife ventured as far as Petra, though he was not the first to photograph the rose-red city. That distinction belongs to Dr. George S. Keith, brother of Thomas Keith, who in 1844 accompanied his father on a tour of the Near East and took about 30 daguerreotypes.

France and Other Counties

The Calotype had been patented in France on 20th August 1841, but the only person known to use it (as well as the daguerreotype) was Hippolyte Bayard, whose 'Windmills of Montmartre' [*Ill. 68*] is one of his most attractive pictures. In spite of Bayard's example and Talbot's public demonstrations in Paris in May 1843 [*Ill. 69*] there was no demand for photographs on paper until the publication of Blanquart-Evrard's modification in 1847, which reduced the exposure to about a quarter of that previously needed. His process had, however, the disadvantage of requiring the final preparation to be carried out immediately before exposure, so that for outdoor work a dark-tent and chemicals had to be transported to the scene, as with the daguerreotype and later the collodion process.

In July 1851 Blanquart-Evrard opened a photographic printing firm near Lille for the production of positives for book illustration, and the printing of amateurs' negatives on a much larger scale than Talbot's Reading establishment. The earliest and best-known book for which Blanquart-Evrard's firm printed the photographs (125 in number) was Maxime Du Camp's *Egypte, Nubie, Palestine et Syrie* [*Ill. 70*], the first instalment of which appeared in September 1851. By his method of developing positive copies (as is done today) Blanquart-Evrard was able to print 200–300 copies from each negative per day, whereas with the slow printing-out paper generally used until the turn of the century the average daily output per negative was restricted to two or three copies. These developed prints had a rather cold grey tone far less attractive than the warm purple-brown colour of Calotypes. At the Lille printing works the photographs were particularly thoroughly rinsed and gold-toned for permanence.

The waxed-paper process published in December 1851 by Gustave Le Gray, a painter and photographer, was another variant of the Calotype. Ordinary Calotype negatives were usually waxed before printing in order to speed up the copying and to give a clearer positive, but this did not altogether eliminate the grain of the paper. In Le Gray's process a thinner type of paper was preliminarily waxed, rendering it quite transparent and giving as fine detail as a glass negative. Exposures were on the whole about the

65 Roger Fenton. Domes of the Cathedral of the Resurrection in the Kremlin. Waxed-paper process, 1852.

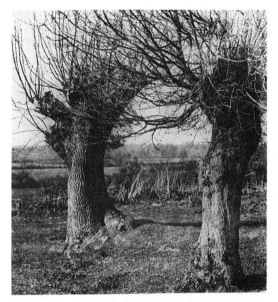

66 Dr Thomas Keith. Willow trees. Waxed-paper process, *c.* 1854.

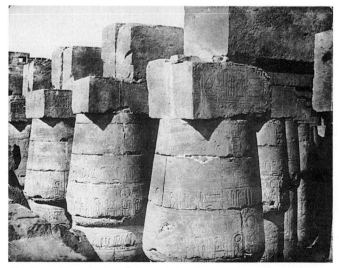

67 John Shaw Smith. Pillars of the Great Hall of the Temple of Karnak, Luxor. Waxed-paper process, 1851.

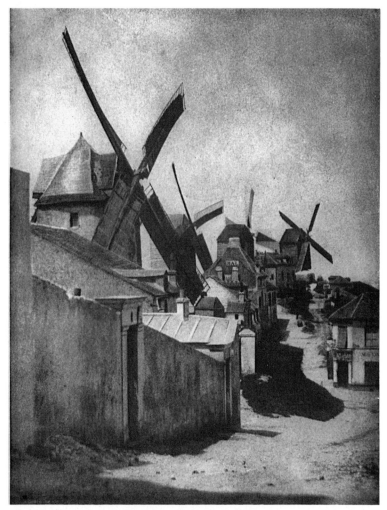

68 Hippolyte Bayard. The windmills of Montmartre. Calotype, 1842.

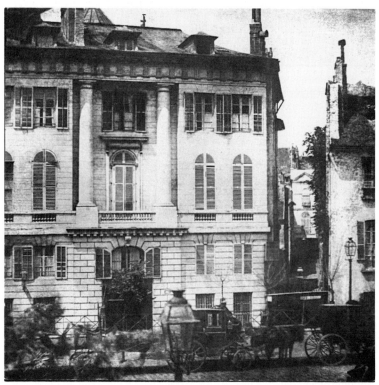

69 W. H. Fox Talbot. House in Paris opposite Talbot's hotel. Calotype, 1843.

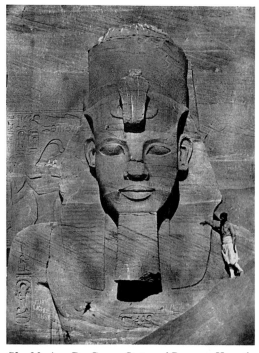

70 Maxime Du Camp. Statue of Rameses II on the façade of the temple at Abu Simbel, Nubia. Calotype, 1849.

same as with the Calotype, but development took one to three hours. Though occasionally used for portraits by amateurs, the waxed-paper process was mainly employed for landscapes and architecture, being very convenient for the travelling photographer because the paper could be sensitized ten to fourteen days beforehand (instead of the day before as with the Calotype) and did not need to be developed until several days after the picture had been taken (whereas the Calotype had to be developed the same day).

The convenience of paper negatives, as improved by the French, encouraged many people to take up photography, and the Société Héliographique was formed in Paris in January 1851 under the presidency of Baron Gros. Among its founder-members were several artists and authors, above all Delacroix and Champfleury. During that year Gustave Le Gray, O. Mestral, Henri Le Secq, Edouard Baldus and others used the paper process for photographing buildings of historic importance in various districts of France for the Government Commission on Historic Monuments. Charles Nègre, a pupil of Delaroche and Ingres, took up photography early in 1851 primarily in order to make studies for his Salon paintings [*Ill. 71*], but he became chiefly known for his genre and architectural photographs of Chartres Cathedral and in the South of France. Other well-known photographers using the paper processes include Hippolyte Bayard, Baron Humbert de Molard, John Whistler [*Ill. 72*], Vicomte Vigier, Charles Marville, and Baron Gros. Within a few years all these photographers changed over to the collodion process.

In Rome the French artist Frédéric Flacheron

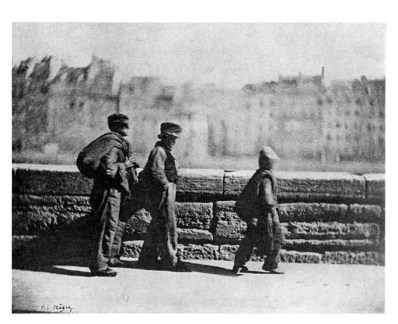

71 Charles Nègre. 'Les Ramoneurs'. Waxed-paper process, 1852.

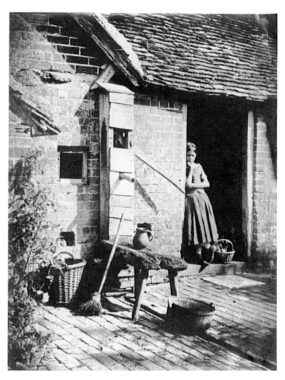

72 John Whistler. Old farmhouse. Waxed-paper process, 1852.

was the centre of a small photographic circle, to which belonged Prince Giron des Anglonnes, Eugène Constant, and Giacomo Caneva.

The first French photographically illustrated book, L. A. Martin's *Promenades poétiques et daguerriennes*, was published in 1850. *Italie Monumentale*, by Eugène Piot, commenced publication in Paris in May 1851, and later the same year Henri Le Secq's *Amiens: Recueil de Photographies* appeared. Despite the title of the Martin work, these two small guidebooks on Bellevue and Chantilly were illustrated with paper photographs. Almost simultaneous with Maxime Du Camp's *Égypte* was Blanquart-Evrard's *Album Photographique*. His Lille establishment also printed Auguste Salzmann's two-volume work *Jérusalem, étude et reproduction photographique des monuments de la Ville Sainte* (1856).

In Spain, Charles Clifford, an Englishman domiciled in Madrid since 1852, became Court photographer to Queen Isabella II. He had learned the waxed-paper process and published four years later *Vistas del Capricho*, an album of fifty views of the charming eighteenth-century summer palace near Madrid [*Ill. 73*]. He is, however, best known for his large collodion photographs of scenery and ancient architecture in Spain issued in 1858 under the title *Voyages en Espagne*.

Except in France, photography on paper was comparatively little used on the continent. Despite the fact that in Germany two manuals were published on Calotype portraiture, in Aachen 1841 and Quedlinburg 1842, the Calotype was still referred to as 'a hitherto unknown process'

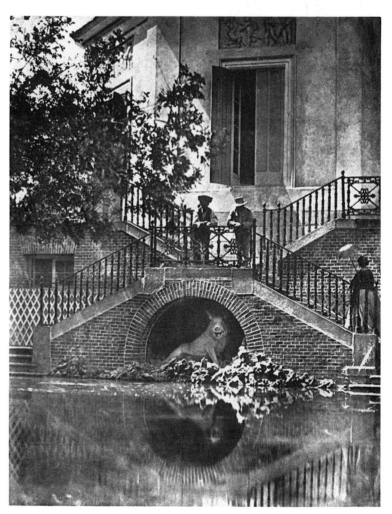

73 Charles Clifford. Fountain and staircase at Capricho Palace near Guadalajara, Spain, *c*. 1855.

when taken up by Wilhelm Breuning, a Hamburg daguerreotypist, in July 1846.

Two Calotypists in Munich became prominent. Alois Löcherer, a professional portrait photographer from 1847 onward, is especially noted for his six pictures of the transport of the

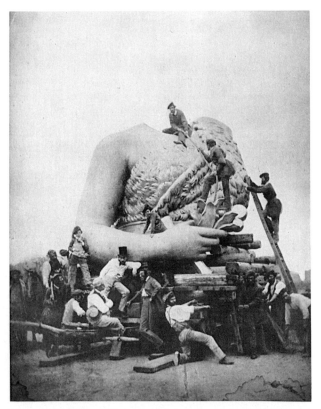

74 Alois Löcherer. Transport of the colossal statue of 'Bavaria' from the foundry to its present site in Munich. Calotype, 1850.

gigantic statue *Bavaria* from the foundry to its position in front of the Hall of Fame in Munich in 1850 [*Ill. 74*]. Franz Hanfstaengl, founder of the still-existing art publishing firm, changed over from lithographic to photographic reproduction in 1853, opening at the same time a studio where he photographed many celebrities.

A Dresden amateur, A. F. Oppenheim, used the waxed-paper process on a tour through Spain in 1852 and the following year in Athens, where a local photographer, Margarite, sold large Talbotype views to tourists.

The large waxed-paper photographs of Venice taken in 1852 by Dr August Jacob Lorent, a German traveller, were admired at photographic exhibitions in the late 1850s. In 1861 he published in Mannheim a volume of his photographs of Egypt, the Alhambra, Algiers, and so on. This was followed by similar works on Sicily and Jerusalem, where as late as 1864 he was still using waxed paper.

In Switzerland the lithographer Carl Durheim of Berne, a daguerreotypist since 1845, in 1849 changed over to the paper process, as apparently also did J. B. Isenring, previously referred to.

A Calotype studio was opened in Vienna in October 1847 by the portrait painters R. Gaupmann and G. Fischer.

The only professional Calotypist in Scandinavia was a former lawyer, Hans Thøger Winther, who had a portrait studio in Stockholm for a few months in 1842 before settling in Oslo, where he published a manual in 1845.

The brothers William and Frederick Langenheim, leading daguerreotypists in Philadelphia, bought Talbot's U.S. patent in 1848 but were unable to create a demand for paper photographs in spite of their own excellent examples.

Photographs by the Collodion and Gelatine Processes

It is impossible to judge whether a photograph has been taken on albumen, collodion, gelatine dry plate, or film negative, by looking at the print, which is in most cases a contact copy on sepia-toned albumen paper lacking the visible distinctions that characterize the daguerreotype, the Calotype, and the Ambrotype. In any case, such information would be of interest only from the purely technical point of view and has no bearing on the quality of the picture. A rough division occurs around 1880 with the changeover to gelatine dry plates, though many photographers continued using collodion for another decade or so.

On its introduction in 1851 the collodion process was received with delight, for Archer—who died in poverty six years later aged forty-four—did not try to make money out of his invention

like Daguerre and Talbot. The latter even put forward the extraordinary claim that collodion was covered by his Calotype patent, and issued injunctions against a number of English photographers. Eventually, a test case against Silvester Laroche settled the matter, and on 20th December 1854 after an exciting three-day trial the collodion process was thrown open to the world 'amidst loud and continued cheering' in court. Talbot dropped his application for renewal of the Calotype patent, knowing that it would not bring him any financial advantage now that the faster collodion process had been judged free. The daguerreotype patent had already run its term in 1853, so from the beginning of 1855 photography in England was at last on an equal footing with the rest of the world.

Strange as it may seem—in view of the manip-

ulation being more difficult than previous methods—Archer's process started the first great wave of popularization of photography. Not only were there thousands of newcomers to the art, but there soon arose an insatiable demand from the public for photographs of all kinds of subjects, now that one could collect prints that promised greater permanence than Talbotypes. In any case, as we have seen, the majority of people were hitherto only acquainted with daguerreotypes.

Exploration and Topographical

Photography brought the four corners of the world to the family circle. It showed them scenes so far known only through the inaccurate descriptions of travellers or exaggerated engravings, which were now regarded with suspicion since photography revealed the truth. How wildly far from reality some of the older topographical representations were is shown in *Ill. 75*, which was published in Banks's *New and Complete System of Geography* (1790?). The period of photographic realism now replaced philosophising and romanticism. The whole world was seen afresh through the eyes of the photographer, who recorded factually, and frequently also artistically, the relics of ancient civilizations, familiarizing people with the scenic and architectural beauty of their own and other countries and the domestic life, customs, and costumes of other nations. 'By our fireside we have the advantage of examining them,' wrote Claudet in 1860, 'without being exposed to the fatigue, privation, and risks of the daring and enterprising artists who, for our gratification and instruction, have traversed lands and seas, crossed rivers and valleys, ascended rocks and mountains with their heavy and cumbrous photographic baggage.'

John Lloyd Stephens's illustrated volumes on the Yucatan (1843) inspired Désiré Charnay, a French school teacher in New Orleans, to photograph in the same area of Mexico in 1857–58 the almost inaccessible ruined sites of the ancient Mayan civilization destroyed by the Spanish conquerors c. 1500. Dense tropical jungle and a civil war are trying enough conditions for photography, but probably less terrifying than the nocturnal visit of a jaguar in the dark-tent just as Charnay started developing! His *Album fotográfico mexicano*, which appeared in Mexico in 1860, contained 25 photographs 13 × 17 inches in size.

Concurrently with Charnay, Paul de Rosti, a Hungarian political exile after 1848, took excellent photographs in the same district, in Havana and Venezuela, which he published on his return to Budapest in 1861.

Francis Frith's finest pictures were taken during three journeys to Egypt, Palestine, and Syria between 1856 and 1860. On his third expedition this English traveller went further up the Nile

than any photographer had been before, proceeding by horse and dromedary beyond the Fifth Cataract about 1,500 miles from the Nile Delta. Producing these photographs [*Ill. 76*], some as large as 16 × 20 inches, was a feat of endurance with temperatures in the dark-tent sometimes reaching 130°F., flies and sand adding to the difficulty. Frith's photographs are both artistically and technically superior to Maxime Du Camp's, and were exploited by him in a large number of publications. He later travelled extensively through Britain and the Continent and became Europe's largest publisher of topographical views.

Francis Bedford is best known for the photographs he took in 1862 during a tour of the Near East on which he was commanded by Queen

75 The Egyptian pyramids. Engraving from Joseph Banks's *New and Complete System of Geography* (1790?). It was copied, with slight alterations, from O. Dapper's *Beschreibung Afrikas* (*Description of Africa*), 1670.

76 Francis Frith. Pyramids of Dahshoor, Egypt, 1858.

Victoria to accompany the young Prince of Wales.

As chief photographer of the London Stereoscopic Company, William England in the 1850s took thousands of pictures in many lands [*Ill. 77*] for the stereoscope—the television of

77 William England. Blondin crossing the Niagara River, 1859.

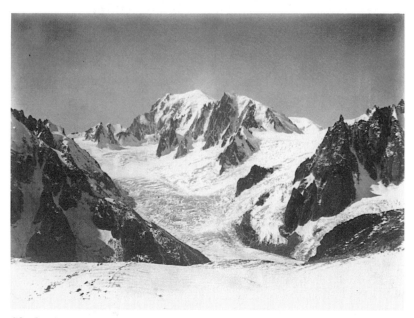

78 Louis and Auguste Bisson. Mont Blanc and the Mer de Glace, 1860.

the Victorian family. After making himself independent in 1863, England specialized in Alpine views for the rest of his life.

The Alps naturally attracted many photographers, including Ruskin, who daguerreotyped the Matterhorn in 1849. Many of them produced mainly views for the stereoscope, which were bought by tourists as postcards are today. Whilst the French photographers J.-A. and C.-M. Ferrier and Adolphe Braun did excellent work in this format, Louis and Auguste Bisson became justly famous for their superb large views of the high Alps, as well as architecture in France and Italy. In 1860 the Bisson brothers were commanded to accompany Napoleon III and the Empress Eugénie on a climbing expedition at Chamonix in the Savoy Alps [*Ill. 78*]. In July the following year Auguste Bisson became the first to photograph from the top of Mont Blanc, the highest mountain in Europe (15,780 feet). Twenty-five porters were needed to carry his equipment, and owing to adverse weather conditions the climb lasted three days. For rinsing the plates, snow had to be melted over the feeble heat of oil lamps, which would hardly burn at that altitude. Bisson succeeded in taking three negatives on the summit, and the return of the party was celebrated in Chamonix with fireworks and a salute of guns.

Aimé Civiale had different aims. From 1859 onward for ten years he made with great exactness a record of the entire range of the Alps from the geological point of view, which he published in forty-one panoramas in 1882.

Whereas Alpine photographers were seldom more than two days from their headquarters, and could usually find shelter in a mountain hut at night, those who photographed in remoter regions had naturally still greater difficulties to contend with.

Philip H. Egerton, Deputy Commissioner of Kangra, in his *Journal of a Tour through Spiti to the Frontier of Chinese Thibet* (1864) describes an arduous three-months' journey in the summer of the previous year to investigate an alternative route for the shawl-wool trade, during which he took the first photographs of the Shigri Glacier, and the life of the natives of Spiti. The same year Samuel Bourne, an English professional photographer in Simla, made a ten-weeks' tour in the Himalayas. It was followed by several other expeditions, one lasting as long as nine months and requiring sixty coolies to carry the equipment and other baggage. In 1868 Bourne made three exposures on the Manirung Pass 18,600 feet up, the greatest altitude at which photographs were ever taken by the wet collodion process. In thousands of fine photographs, Bourne made known the beauties of India to the European public for the first time [*Ill. 79*].

Important topographical and ethnographical works on China, Siam, and Cambodia were published in the 1860s and early '70s by John Thomson, a Scottish explorer and photographer who spent ten years in the Far East.

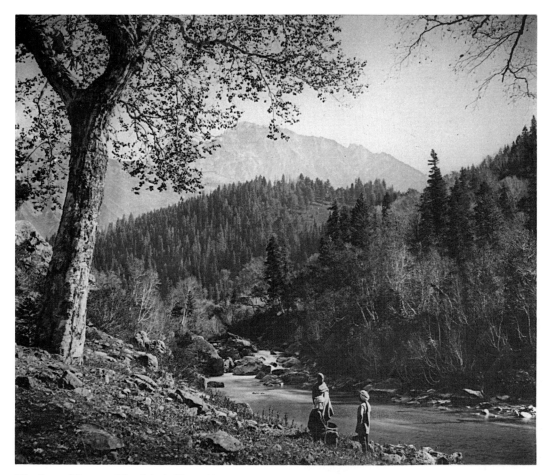

79 Samuel Bourne. The Scinde River, 1864.

In America outstanding work was produced by the San Francisco photographer Carleton E. Watkins, whose beautiful 21 × 16 inch views of the Yosemite Valley [*Ill. 80*] made a considerable stir at the Paris International Exhibition of 1867. In the same year Eadweard Muybridge's photographic activity was first mentioned in connection with his large views in the same region. They may well have been undertaken for Watkins, from whom Muybridge learned photography and with whom he was for a time in partnership. In 1868 he worked in Alaska on an official survey which led to his appointment as chief photographer to the U.S. Government. During the 1870s Muybridge took hundreds of views for the Central & South Pacific Railway and for the Pacific Mail Steamship Co., but gave up landscape photography when he embarked on the thorough investigation of animal locomotion for which he is chiefly remembered today.

One of the most famous photographers of the American West was William Henry Jackson. Between 1870 and 1877 Jackson accompanied eight Government geological surveys and had a canyon and a lake named after him. Some of his photographs of the Yellowstone region, which were handed to every member of the House of Representatives and the Senate, were instrumental in the passing of the Act of Congress (1872) declaring this area the first National Park.

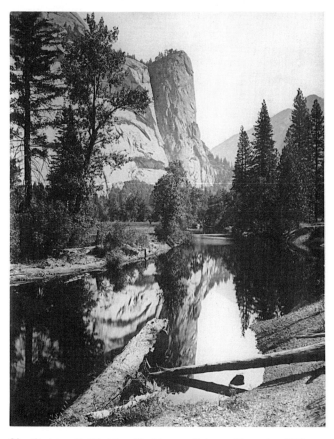

80 Carleton E. Watkins. Washington Column, Yosemite, 1867.

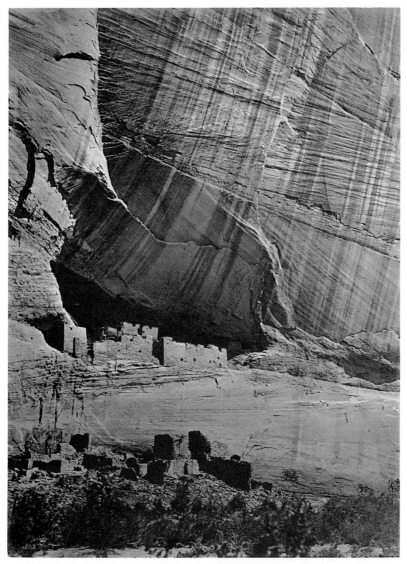

81 Timothy H. O'Sullivan. The Canyon de Chelle, 1873.

82 Herbert Ponting. The 'Terra Nova' in the Antarctic, 1912.

Timothy H. O'Sullivan, a prominent photographer during the American Civil War (nearly half the photographs in *Gardner's Photographic Sketchbook of the War* are by him) took part in a Government survey of the 40th Parallel 1867–69, and in 1870 in an expedition to survey a possible ship canal across the Isthmus of Panama. In further expeditions O'Sullivan photographed the canyons of the Colorado River, and in Arizona, where he produced one of his finest pictures, the Canyon de Chelle [*Ill. 81*].

Vittorio Sella combined photography with Alpinism, like his father Giuseppe Sella, who wrote the first general handbook on photography published in Italy. From 1880 onward his exploits in the Alps, the Caucasus, Alaska (1897), Equatorial Africa (the 'Mountains of the Moon') (1906), and the Himalayas (1909), mostly as official photographer on the Duke of Abruzzi's expeditions, made Sella's photographs world-famous. Many of these climbs established altitude records. Sella did not, of course, at that late date have to contend with the great difficulties of wet collodion.

Herbert Ponting as official photographer to Captain Scott's second and last South Pole exploration (1910–12) brought back a superb record of the expedition and the Antarctic landscape [*Ill. 82*]. Similar splendid documentations made by Captain Frank Hurley, an Australian, on no fewer than five Antarctic expeditions, demanded great resourcefulness. The crushing of the *Endurance* by ice and the rescue of the party six months later was recorded by Hurley in highly dramatic pictures on Sir Ernest Shackleton's second Antarctic expedition of 1914–16. They express better than words the hardships endured.

Landscape

Landscape photography was a field in which the British particularly excelled (as they had in watercolour views) and Roger Fenton, P. H. Delamotte, Charles Clifford, and Robert MacPherson [*Ill. 83*], whose work in different fields is discussed elsewhere in this book, most be referred to in this connection.

Henry White, partner in a London firm of solicitors, was one of the earliest artistic landscape photographers and considered the best by many of his English and French contemporaries. Like that of many gifted amateurs of the early period, White's work was chiefly confined to the 1850s. His close-up of bramble and ivy [*Ill. 84*], and some of the nature studies taken by the photographic school of the Royal Engineers, in their objective and realistic representation bear the characteristics that were to be associated with the *Neue Sachlichkeit* movement seventy years later.

In advance of their time, too, though purely for a technical reason, were the seascapes of Gustave Le Gray, who instead of the usual blank sky of the time, succeeded in 1856 in depicting

83 Robert MacPherson. Garden of the Villa d'Este, Tivoli, *c.* 1857.

84 Henry White. Bramble and ivy, 1857.

clouds and the moving waves of the sea in large exhibition photographs [*Ill. 85*]. The extreme difficulty of depicting the bright sky in the same length exposure as the darker landscape was a great vexation to early photographers and led to the use of separate cloud negatives which were printed in—a technique devised by Hippolyte Bayard in summer 1852, and widely practised from the 1860s on.

James Mudd, a Manchester portrait photographer, in a beautiful set of pictures caught the fantastic scene after a disastrous dam-burst near Sheffield in 1864 [*Ill. 86*].

Francis Bedford's views, highly praised by his contemporaries, seem today topographical rather than artistic. The same criticism applies to a certain extent to the work of Francis Frith, George Washington Wilson of Aberdeen, and James Valentine of Dundee, all of whom were publishers of views on such a mass-production scale that only a small proportion of the photographs bearing their names were actually taken by them.

The importance of Hermann Krone of Dresden lies in the technical and educational fields. His portraits, and in particular his views of 'Saxon Switzerland' (1853) and towns in Saxony, have been made much of in Germany, but are of no more than average merit when compared with French and English photographs. Even in these countries, the artistic interpretative landscape work of the 1850s and '60s gradually degenerated into topographical depiction. In fact, there was a dearth of artistic work after many of the first generation photographers gave up in the 'sixties in disgust at the steadily growing commercialization of photography.

85 Gustave Le Gray. 'Brig upon the Water', 1856.

86 James Mudd. Dam-burst at Sheffield, 1864.

87 P. H. Delamotte. Opening ceremony by Queen Victoria of the rebuilt Crystal Palace, Sydenham, 10th June 1854.

Architecture

Philip Henry Delamotte, a designer and artist, during 1853–54 made the first extensive documentation of the progress of a building: the rebuilding of the enlarged Crystal Palace at Sydenham, from the levelling of the site to the opening ceremony by Queen Victoria on 10th June 1854 [*Ill. 87*]. The latter is one of the earliest instantaneous photographs of an historic occasion. Delamotte's two volumes published in 1855 contain a total of 160 photographs forming a documentation of great architectural interest as well as unusual aesthetic merit [*Ill.88*]. In the following years he continued publishing brilliant pictures of the exterior and interior of this great Victorian glass palace and its exhibitions.

One of the leading architectural photographers of the nineteenth century was a former Edinburgh surgeon, resident in Rome. Robert MacPherson took up photography in 1851 and quickly won a high reputation with his fine photographs of antiquities. He emphasized in a striking way the mouldering grandeur of these Roman subjects, and many of his pictures are poetic descriptions, not mere transcriptions of the Classical scene [*Ill. 89*]. Macpherson first used the albumen on glass process, and after 1856 the collodio-albumen, a modification of the wet collodion process published by Dr Taupenot in September 1855. This slow 'dry' preservative process was most suitable for interiors requiring long exposures, for ordinary wet collodion would have dried up in ten to fifteen minutes. MacPherson explained that in some of the Vatican sculpture galleries where the light was poor two hours were often required, and in one or two cases even an exposure of two days was necessary to produce a good negative.

MacPherson's only rival was an English watercolour artist, James Anderson, who in 1853 began taking photographs of antique sculpture in the Roman museums, to which he later added reproductions of paintings, and views of the Eternal City [*Ill. 90*], in great demand by tourists. Anderson's firm remained in the hands of his descendents until quite recently when the large stock of negatives was acquired by Count Vittorio Cini and united with those of the Alinari brothers, Brogi, etc., in an art archive in Florence.

Leopoldo Alinari and his brother Giuseppe, originally craftsmen in *intarsia*, were encouraged to take up photography by the Florentine printseller Luigi Bardi, who for some years acted as their agent. All their earliest fine photographs of 1854–55, such as the Cathedrals of Florence and Pisa and the famous bronze doors of the Baptistry in Florence, bear Bardi's stamp, which naturally led to their attribution to him. Later, the Alinari brothers carried out surveys of the paintings and sculpture in the Uffizi and other Italian art galleries.

Carlo Ponti, optician to King Victor Em-

88 P. H. Delamotte. Upper gallery of the Crystal Palace, Sydenham, 1854.

manuel II, specialized in views of Venice, Padua, and Verona, and published in the 1860s a number of albums under the title *Ricordo di Venezia*, each containing twenty large views [*Ill. 91*], some by other local photographers such as Antonio Perini and Carlo Naya.

In England, Roger Fenton's fine series of cathedrals, and classical sculpture in the British Museum, taken shortly after his Crimean War reportage, were as much admired as his landscapes. Indeed Fenton's art training under Paul Delaroche proved a great asset in the eleven years of his photographic career, after which he returned to his legal profession in 1862.

In the 'fifties the painter-photographer Edouard Baldus [*Ill. 92*] and the Bisson brothers

89 Robert MacPherson. Relief on Arch of Titus, Rome, *c*. 1857.

90 James Anderson. Base of Trajan's Column, Rome, *c*. 1860.

were particularly noted for their excellent architectural work. Baldus made for the French Government in 1854/55 a complete survey of the new wing of the Louvre in 1,500 detail photographs—a very modern approach compared with the general views usually taken in those days. Some of these photographs were of exceptional size, 39½ × 30 inches. At the same period Charles Marville made a unique documentation of those Parisian districts that were shortly to be swept away by Haussmann.

Valuable work was undertaken for the Society

91 Carlo Ponti. Piazza San Marco, Venice, *c*. 1862.

93 Henry Dixon. The office of the *Daily News*, founded by Charles Dickens, in Fleet Street, shortly before demolition, 1884.

92 Edouard Baldus. The Pont du Gard near Nîmes, *c*. 1855.

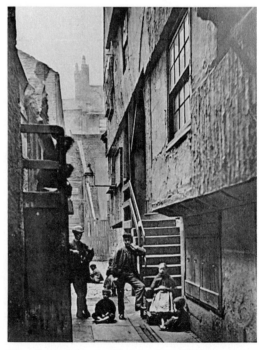

94 Thomas Annan. Glasgow slum, 1868.

54

for Photographing the Relics of Old London by Henry Dixon [*Ill. 93*] and A. & J. Boole between 1874 and 1885, for what had not been destroyed by the Great Fire of 1666 was rapidly disappearing under modernisation schemes. In Glasgow Thomas Annan documented the notorious slums for the Glasgow City Improvement Trust during the period 1868–1877. Some of his work goes deeper than the recording of a picturesque close or alley that was due for demolition, by the inclusion of the poverty-stricken people standing outside their ramshackle houses [*Ill. 94*].

Unaware of Baldus's great unpublished survey of the Louvre, Ferdinand Ongania believed his monumental work on the Basilica di San Marco (1878–86) to be the first photographic survey ever to be made of a building. In over 500 photographs printed by the heliotype process every noteworthy feature of the brilliant exterior and gloomy interior of St. Mark's can be studied without neck-twisting or the need for binoculars.

Portraiture and Genre

With few exceptions, the majority of the professional portrait photographers of the 1850s took either daguerreotypes or, after about 1854, Ambrotypes. The latter gave the poorer *clientèle* the possibility of having cheap portraits at last. Under the title 'Art-Progress' *Punch* (London) published in May 1857 a delightful cartoon [*Ill. 95*] showing two rival photographic portrait shops side by side and four photographers touting for sitters, seizing a passing woman: 'Now, Mum! Take orf yer 'ead for Sixpence, or yer 'ole body for a Shillin'!' This was no exaggeration.

People wanting larger portraits and more than one copy could have 8½ × 6½ inch or 10 × 8 inch prints made from collodion negatives, but the demand for these arose only in the best studios, for the price varied between £2 and £4, depending on size and whether the picture were handcoloured or not.

Realizing the latent demand for a large number of prints cheap enough to give away to friends and relations, André-Adolphe Disdéri, a well-known Parisian photographer, devised a practical way of reducing production costs by taking eight portraits on one plate, and introduced the *carte-de-visite* [*Ill. 36*]. As early as August 1851 Louis Dodero, a Marseilles photographer, had put his portrait on his visiting cards, and at the same time suggested small portraits for passports, permits, and so on. Though the idea of photographic visiting cards was again put forward by two Parisian amateurs, Edouard Delessert and Comte Aguado, a month before Disdéri's patent was taken out in November 1854, the *carte-de-visite* photograph did not win much favour at first. The craze for these portraits dates only from May 1859, when Napoleon III had himself photographed by Disdéri in the new for-

mat which made him and the *carte-de-visite* famous overnight. All of fashionable Paris followed the Emperor's example, and by 1861 Disdéri was reputed to be the richest photographer in the world, taking £48,000 a year in his Paris establishment alone—and he also opened branches in Toulon, Madrid, and London. Disdéri had the most sumptuous studio in France, yet only charged 20 fr for 12 *cartes* in one pose or 30 fr for 25 *cartes* in two poses. The daily production was 2400 *cartes*, and a staff of ninety employees took care that every order could be delivered within 48 hours. But no craze lasts forever and when the end came Disdéri had no resources to fall back on. Being a born gambler, he had dissipated them and died in the poorhouse.

In England, too, popularization of the *carte* portraits introduced in 1857 began after royal approval. In May 1860 J. E. Mayall took *carte* portraits of Queen Victoria, the Prince Consort, and their children. These were published three months later in his *Royal Album*, which set the fashion for collecting *cartes* of celebrities, as well as of one's friends, and putting them in albums. Mayall frequently photographed the royal family [*Ill. 96*]. He had a turnover of half a million *cartes* a year, and an estimated gross annual income of £12,000. Even provincial studios did excellent business, and altogether 300 to 400 million *cartes* were sold annually in England. No wonder more than one Chancellor of the Exchequer seriously considered following the example of the United States by imposing a small tax on these pictures.

'Cartomania' was truly international. Ludwig Angerer, who introduced the *carte-de-visite* in Vienna in 1857, sold enormous quantities of *cartes* of the Imperial family; so did Rabending & Monckhoven. L. Haase & Co. in Berlin could not print their *carte* portraits of the Royal family and other Prussian celebrities quickly enough. The same can be said of Sergej L. Lewitzky in St

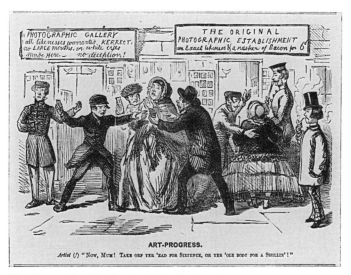

ART-PROGRESS.
Artist (?) "Now, Mum! Take orf yer 'ead for Sixpence, or yer 'ole body for a Shillin'!"

95 Cartoon by John Leech in *Punch*, May 1857.

96 J. E. Mayall. Queen Victoria and the Prince Consort, 1861.

97 Camille Silvy. *Carte-de-visite* of an unknown lady, *c.* 1860.

Petersburg and Georg Hansen in Copenhagen. In the United States, during the Civil War, the popularity of *cartes* was just as great as in Europe. In Paris an army of photographers sprang up to exploit the boom; no fewer than 33,000 people were stated to be making their living from the production of photographs and photographic materials in 1861. In this year the number of portrait studios in London had risen from sixty-six in 1855 to over two hundred; in 1866 when the *carte-de-visite* craze had already passed its peak there were 284.

Photographs of celebrities were sold at stationers' shops as picture postcards are today. The price of a *carte* was 1/– to 1/6d according to the fame and popularity of the sitter.

Some of the finest *carte* portraits were taken by Disdéri and by another Frenchman, Camille Silvy, who exchanged a diplomatic career for the lucrative business of portrait photography. In the autumn of 1859 Silvy opened a sumptuous studio in London giving employment to forty assistants. Gifted with exquisite taste, Silvy posed his sitters gracefully in elegant interiors or against charming painted landscape backgrounds, which earned him the appellation of 'the Winterhalter of photography' [*Ill. 97*]. They are rather in the nature of fashion-plates. With the Frenchman's intuitive understanding of the fair sex, he published a series entitled 'The Beauties of England'—a brilliant idea, for not to be included implied that a woman was either not pretty enough, or was not in society.

Swamped with orders, some inferior photographers were tempted to serve mammon rather than art. One boasted of taking 97 negatives in eight hours!—and it is not to be wondered at if all attempt at characterization is lacking and the poses stereotyped. In the degree to which the portrait was reduced in size, its setting increased in importance, and the photographer's studio became a stage with elaborate 'properties' and pictorial backgrounds. A glamorous effect was what people demanded, and the humbler their home the greater their desire for splendour; and the grander his studio the more business a photographer could expect.

No longer was photography an art for the privileged: it had become the art for the million. Approving this democratic tendency as the first 'people's art' *The Photographic News* (London) wrote in 1861:

> Photographic portraiture is the best feature of the fine arts for the million that the ingenuity of man has yet devised. It has in this sense swept away many of the illiberal distinctions of rank and wealth, so that the poor man who possesses but a few shillings can command as perfect a lifelike portrait of his wife or child as Sir Thomas Lawrence painted for the most distinguished sovereigns of Europe.

When the *carte-de-visite* lost its novelty, the larger Cabinet portrait, 5½ × 4 inches, introduced in England in 1866, proved a popular new

format, remaining in favour until the Great War.

Each decade in the *carte* and later Cabinet period had its specially characteristic accessories. In the 'sixties they were the balustrade, column, and curtain; in the 'seventies the rustic bridge and stile; in the 'eighties the hammock, swing, and railway-carriage; in the 'nineties palm-trees, cockatoos, and bicycles; and in the early twentieth century it was the motor-car, for snobs.

Concurrently with the *carte-de-visite* there were a number of photographers, both professional and amateur, whose work stands out from the mass of stereotyped portraiture.

Nadar, Carjat, Adam-Salomon, Bertall, Mulnier, and Pierre Petit, all Parisian photographers, are remembered for their splendid portraits of famous people published in *Galerie Contemporaine*. Owing to this circumstance an opinion can be formed of the high artistic qualities of a number of photographers who would otherwise be remembered only by their 'bread-and-butter' *carte* and Cabinet pictures.

The caricaturist's ability to grasp quickly the essential characteristics of his sitter was an asset to Nadar, Carjat, and Bertall in immortalizing the famous. Etienne Carjat's portraits of celebrities are often livelier than Nadar's, as comparison of his photographs of Rossini and Baudelaire [*Ill. 98*] with Nadar's proves. Following the tradition of the daguerreotypists, their portraits are straightforward and realistic, striking in their simplicity. They allow the intellectual power of the sitter to speak for itself, without the intrusion of elaborate 'properties' which mar some of the photographs of Antoine Adam-Salomon, a successful sculptor and part-time photographer whose portraits in the style of Old Masters occasionally strike a false note. Adam-Salomon's tendency to mannerism and 'Rembrandt' lighting appealed to people who failed to appreciate the camera's necessarily different approach, which indeed is evident in many of his portraits [*Ill. 99*].

Gaspard-Félix Tournachon, called Nadar, overshadowed all other French portrait photographers, partly because he had a flair for showmanship, and was much in the public eye as a balloonist. His studio in the Boulevard des Capucines, painted red and with his name spreading in colossal letters across fifty feet of wall, was the meeting place of intellectual, not aristocratic, society, for Nadar was an ardent Republican. He was the photographer *par excellence* of the intelligentsia of the Second Empire and the Third Republic, but only the most distinguished men were taken by Nadar himself, the general run being left to his employees. His finest portraits include those of Delacroix, Daumier, Baron Taylor, Victor Hugo, and George Sand—one of his rare portraits of a woman [*Ill. 100*].

Nadar was a pioneer in many fields: he took the first aerial photograph (1858) and made a more successful series over Paris four years later, a feat that afforded Daumier—strangely an op-

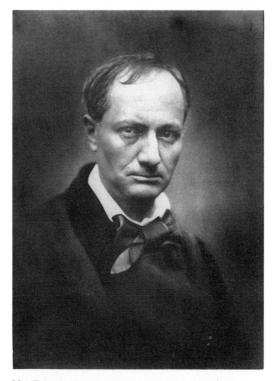

98 Etienne Carjat. Charles Baudelaire, *c*. 1862.

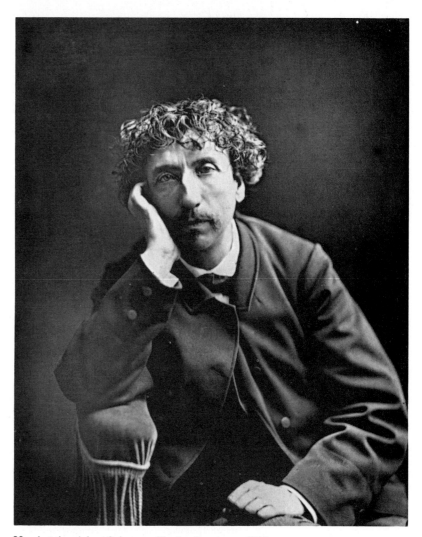

99 Antoine Adam-Salomon. Charles Garnier, *c*. 1865.

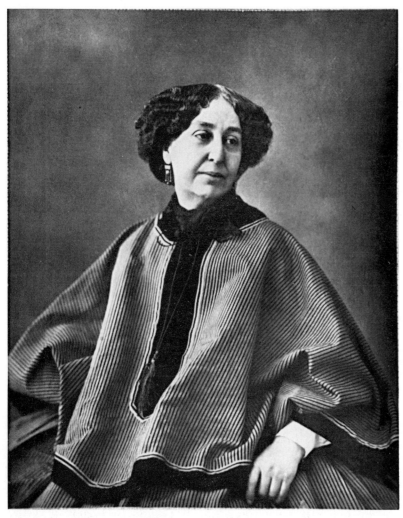

100 Nadar. George Sand, 1866.

101 Honoré Daumier. 'Nadar raising photography to the height of Art'. Lithograph, 1862.

ponent of photography—an opportunity to mock at Nadar's claim of raising photography to the height of art [*Ill. 101*]. About this time Nadar made the first underground photographs by electric arc light from a Bunsen battery, in the catacombs and sewers of Paris. His balloon 'Le Géant', three times the size of any other balloon in Europe, was a sensation in 1863. During the Siege of Paris Nadar commanded an observation balloon corps, and provided at his own expense a balloon postal service to the seat of the Delegate Government at Tours, later Bordeaux.

When Nadar heard that the artists later known as the Impressionists were looking for a place to show their first exhibition (1874), with characteristic generosity he lent them his old studio from which he had just moved, and welcomed the sensation which the exhibition caused in the art world as good personal publicity.

Julia Margaret Cameron deplored the shallowness and lack of individuality in the *carte-de-visite* portraits of her famous friends, in which there was no endeavour to record what she called 'the greatness of the inner as well as the features of the outer man'. This aim was her resolve when at the age of forty-eight she took up photography, which to her was a 'divine art'. Working for her own satisfaction and not for a living, Mrs. Cameron could afford to go her own way, and became a pioneer in a new kind of portraiture—the close-up. She had the real artist's gift of piercing through the outward appearance to the soul of the individual. Nowhere is this more striking than in her photograph of Sir John Herschel, one of the greatest portraits ever taken [*Ill. 102*]. Although the impressiveness of J. M. Cameron's portraits in some cases undoubtedly owes much to the strong personality of the sitter—and this remark applies frequently to portraits of the famous—her large head studies have a boldness which is startling in its originality of conception. A comparison of her forceful portraits of great Victorians such as Tennyson, Carlyle, Browning, and Darwin [*Ill. 103*] with the paintings of the same sitters by the leading portrait painters G. F. Watts and Sir John Millais is rewarding: the photographer scores in every case against the painter. Roger Fry's claim that 'Mrs. Cameron's photographs bid fair to outlive most of the works of the artists who were her contemporaries' holds good for a great many other classic photographic portraits, which give a truer and more intimate impression of the men and women who left their mark on this epoch, than do painted portraits.

Reportage portraits and photo-interviews with celebrities are a common feature of newspapers and magazines today. Few people are aware that the first reportage portrait was taken by Robert Howlett as early as 1857. Howlett, who, the previous year, had taken some lively pictures at the Derby to serve as studies for William Powell Frith's well-known painting *Derby Day*, photographed the launching of the 'Great Eastern' steamship, and its designer I. K. Brunel [*Ill.*

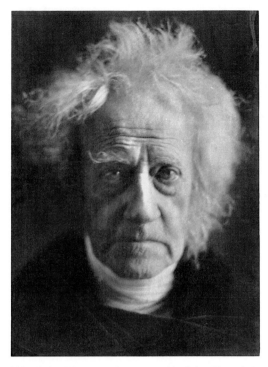

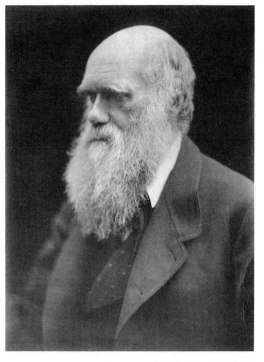

102 Julia Margaret Cameron. Sir John Herschel, 1867.

103 Julia Margaret Cameron. Charles Darwin, 1869.

104], in a way that is completely modern in conception.

The photo-interview was pioneered in 1886 by Félix Tournachon and his son Paul Nadar for *Le Journal Illustré*. The occasion was the hundredth birthday of the great chemist M.-E. Chevreul, who greeted them: 'I was an enemy of photography until my ninety-seventh year, but three years ago I capitulated.' While Nadar senior asked prepared questions, Paul Nadar recorded the centenarian's animated expressions and gestures [*Ill. 105*] as he explained his philosophy on 'the Art of Living a Hundred Years'. Thirteen of the photographs were published as half-tone blocks in this newspaper on 5th September 1886, with Chevreul's lively answers, noted down by a stenographer, serving as captions. The experiment was repeated a few years later with General Boulanger.

Whereas Paul Nadar took a large series of portraits, At Home photography, the precursor of reportage portraiture, was usually limited to three or four. Mélandri in Paris and J. P. Mayall in London were the first in the field with At Home portraiture of theatrical celebrities and artists in the 'seventies and 'eighties respectively. Sarah Bernhardt with her bust by Rodin [*Ill. 106*] is one of the liveliest and most natural photographs of the great actress, and was as advanced in style for 1876 as her costume. There is no doubt that people feel more at ease in their own surroundings, and it is surprising that until comparatively recent times, when the miniature camera greatly simplified the task, so few photographers took the trouble to transport their

104 Robert Howlett. Isambard Kingdom Brunel, 1857.

105 Paul Nadar. F. T. Nadar interviews the centenarian M.-E. Chevreul, August 1886.

106 Mélandri. Sarah Bernhardt in her studio, 1876.

107 Elliot & Fry. Sir Joseph Wilson Swan, 1904.

equipment to the sitter's home. The photographer who interviewed Sir Joseph Wilson Swan [*Ill. 107*] in his laboratory in 1904 at the time knighthood was conferred on him, would probably not have achieved such an intimate and penetrating likeness with the traditional studio portrait. This is equally true of the series of remarkable At Home interviews with distinguished men which W. B. Northrop published the same year in his book *With Pen and Camera*.

Very original is Adrian Nadar's portrait of Dr G. B. Duchenne, founder of electro-therapy, which Duchenne used as frontispiece to *Album de Photographies Pathologiques* (1862), introducing himself, his electrization apparatus, and his

108 Adrian Nadar. Portrait of Dr G.-B. Duchenne using his electrization apparatus, 1857.

109 Maull & Polyblank. Robert Stephenson, 1856.

patient [*Ill. 108*]. Adrian was a brother of Félix Tournachon.

Space only permits the mention of a few other memorable portraits by leading photographers: Napoleon III (1854) by Mayer & Pierson; W. E. Gladstone and Robert Stephenson (1856) [*Ill. 109*] by Maull & Polyblank; David Livingstone (1864) [*Ill. 110*] by Thomas Annan; Ludwig II of Bavaria (1867) by Josef Albert; Camille Corot (1871) [*Ill. 111*] by Constant Dutilleux; Robert Louis Stevenson (1885) by A. G. Dew Smith; Cardinal Newman (1887) by Herbert Barraud; William Morris (1889) by Sir Emery Walker; Oscar Wilde (1890) by W. & D. Downey; Henri de Toulouse-Lautrec (c. 1892) [*Ill. 112*] by Paul Sescau, Lautrec's night-life companion, for whom he designed a poster [*Ill. 113*]; Sir Henry Irving as Thomas à Becket (1893) by H. H. H. Cameron (son of J. M. Cameron); Aubrey Beardsley (c. 1895) by Frederick Hollyer; Mark Twain (1902) and Auguste Rodin (1903) by E. Walter Barnett; J. P. Morgan (1903) by Edward Steichen; the Archduchess Stephanie (1905) by Alice Hughes; Alice Meynell (1908) and John Galsworthy (1912) by E. O. Hoppé.

The Rev. Charles Lutwidge Dodgson, better known as Lewis Carroll, author of *Alice in Wonderland*, pursued many a celebrity with his camera, but his favourite subjects were little girls [*Ill. 114*]. He summed up his preference with the cryptic remark 'I am fond of children, except boys'. Photography was Lewis Carroll's chief

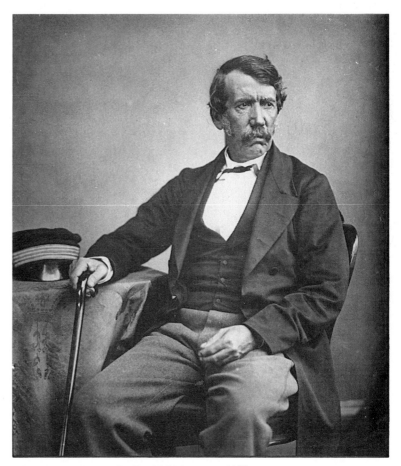

110 Thomas Annan. Dr David Livingstone, 1864.

111 Constant Dutilleux. Camille Corot at Arras, 1871.

112 Paul Sescau. Double portrait of Henri de Toulouse-Lautrec, *c*. 1892.

113 Lithographic poster for Paul Sescau by Toulouse-Lautrec, *c*. 1894.

114 Lewis Carroll. Ella Monier-Williams, 1866.

hobby from 1856 to 1880, and though in later years he had a glass-house constructed on top of his rooms at Christ Church, Oxford, where he was professor of mathematics, his best work dates from the 'fifties and 'sixties when he used to take his cumbersome apparatus to the homes of friends and acquaintances, where he found full scope for his inventive genius. Sometimes he composed amusing anecdotal or *genre* scenes. The original and casual-looking poses he arranged constitute the chief charm of his pictures. Only an amateur could have taken such an independent course from the usual stilted studio portraits of children, and that is why Lewis Carroll's pictures strike us today as so greatly superior to professional work.

Viscountess Hawarden's photographs of children, admired and collected by Lewis Carroll, show a remarkably fresh outlook. She did not restrict herself to children any more than Lewis Carroll did, and the picture of her daughter reflected in the looking-glass is one of the most delightful *genre* photographs [*Ill. 115*] of the Victorian period.

The same appealing naturalness and individuality which raise Lewis Carroll's, Lady Hawarden's, and many other English amateurs' pictures above the mass of conventional professional portraits is also evident sometimes in France, above all in the work of Charles Nègre, the first French photographer of *genre* subjects. Nègre's chimney-sweep boys [*Ill. 71*], though of necessity posed, look as though they had been caught by a modern miniature camera.

The photograph albums of Charles-Victor Hugo, who found an outlet for his creative energy in photography while living in exile with his father and the poet Auguste Vacquerie 1853–55, contain a remarkable documentation of their life in Jersey: Victor Hugo glowering with frustration, perched on the Rock of the Exiles and resting in the conservatory under the flowering vines, as well as studies of his hands and many other unusual pictures.

Oscar Gustave Rejlander, an English portrait photographer of Swedish origin, is noteworthy for the *genre* pictures which he made for his own pleasure and as studies for artists. Like a reportage photographer, Rejlander aimed at genuine slices of life, but owing to the technical difficulties at this period had to pose his subjects to give the impression of natural scenes [*Ill. 116*]. This he did with great artistry, as one would expect of a trained painter.

William Morris Grundy's stereoscopic *genre* pictures, published posthumously under the title *Rural England*, are little gems of photography. Some of them (as single pictures) illustrate an anthology of poetry called *Sunshine in the Country* (1861), and show scenes such as 'Resting after the Shoot', 'Angling', 'At the Brook', and so on.

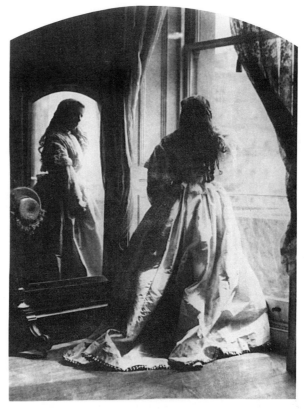

115 Lady Hawarden. At the window, *c.* 1863.

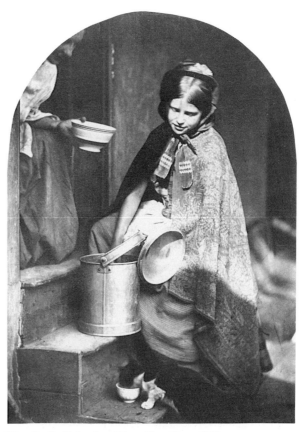

116 O. G. Rejlander. The milkmaid, *c.* 1857.

War Reportage

Though scenes in the war between the United States and Mexico, 1846–48, and the Siege of Rome in 1849 and other historic events at the beginning of the Risorgimento were recorded by photography in individual pictures, the first extensive war reportage was Roger Fenton's and James Robertson's coverage of the Siege of Sebastopol during the Crimean War. The initial phases of hostilities in the Balkans had been recorded by Karl Baptist de Szathmari, an amateur in Bucharest, whose photographs have unfortunately not survived.

Roger Fenton's 360 photographs of the Crimean War, taken in 1855, are not very warlike by present-day standards [*Ill. 117*], but this is explained by the dual purpose of the undertaking: to sell prints to the public, who would have abhorred gruesome pictures, and to give convincing proof of the well-being of the troops after the disasters of the preceding winter which had caused the downfall of the Government. Despite their lack of action, the photographs provide a far more convincing picture of life at the front than the wide views of William Simpson, published as lithographs by Colnaghi.

The photographic van [*Ill. 30*] formed a conspicuous target and on several occasions drew the fire of the Russian batteries. The heat in the Crimea made working in it extremely trying. Exposures were 10–15 seconds, but Fenton was very skilful in arranging groups naturally to con-

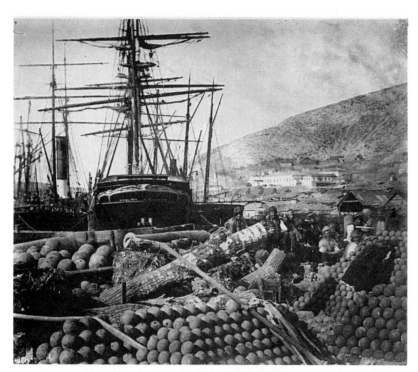

117 Roger Fenton. Crimean War, Balaclava harbour, 1855.

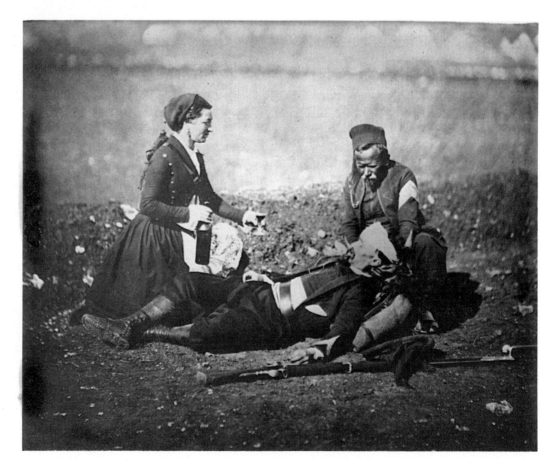

118 Roger Fenton. Crimean War, cantinière and wounded man, 1855.

vey the impression of having been taken instantaneously [*Ill. 118*].

Fenton was obliged to leave the seemingly endless Siege of Sebastopol at the end of June, but James Robertson, chief engraver of the Imperial Mint at Constantinople, completed the reportage of this senseless campaign with photographs of the English and French trenches, the wrecked Russian forts [*Ill. 119*], and the ruins of the bombarded city immediately after the retreat of the Russians on 8th–9th September 1855.

Two years later Robertson made a valuable documentation of scenes of the Indian Mutiny in collaboration with his partner A. Beato, who afterwards took gruesome photographs of the second Opium War in China in 1860.

The Austro-Sardinian conflict of 1859, in which Napoleon III took the field as ally of Victor Emmanuel II, was followed by a number of photographers including Luigi Sacchi, Bérardy, and the Ferriers, father and son, whose stereoscopic pictures showed not only camp life but for the first time the horrors of war which Fenton had intentionally avoided.

It is as organizer of the photographic documentation of the American Civil War that Mathew B. Brady is today remembered and honoured. Believing that 'the camera is the eye of history', Brady left his prosperous portrait studios in New York and Washington in the care of employees, and with his staff of nineteen photographers covered almost every theatre of the Northern war. Many of the finest pictures were taken by Alexander Gardner, Brady's former studio manager in Washington, Timothy H. O'Sullivan [*Ill. 120*], and other members of the team, and only a comparatively small number can be ascribed to Brady himself. Nevertheless, without his farseeing plan the war might well have remained unrecorded on the Northern side, for the Federal Government took no interest in the venture either before or after the event. Today the Civil War photographs belong to America's most treasured and most publicized historical documents.

Excellent photographs of the attack of Prussia and Austria on Denmark in 1864 were taken by Friedrich Brandt, a Flensburg photographer, and by Heinrich Graf and Adolph Halwas of Berlin.

The names of the French and German photographers of the Franco-Prussian War are not known [*Ill. 121*], with the exception of Disdéri, who photographed the ruins of St. Cloud. The same applies to the devastation wrought in Paris during the Siege and the insurrection which began with the pulling down of the Vendôme column and statue of Napoleon I on 16th May 1871 [*Ill. 122*]. As illustrations of man's inhumanity to man, 'The Harvest of Death' after the Battle of Gettysburg [*Ill. 120*], and the unidentified Communards in their coffins, are as unforgettable as the recent pictures of Sharpeville [*Ill. 278*].

During the Siege of Paris mini-photographs

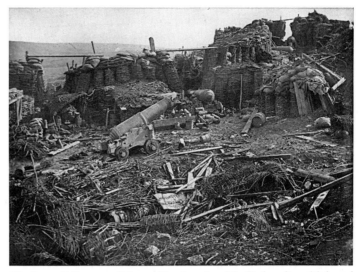

119 James Robertson. Crimean War, interior of the Redan after withdrawal of the Russians, September 1855.

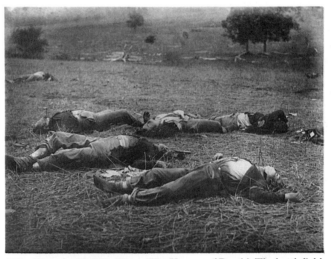

120 Timothy H. O'Sullivan. 'The Harvest of Death'. The battlefield of Gettysburg, July 1863.

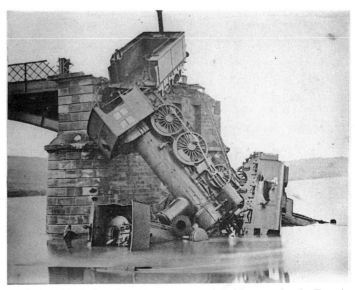

121 Franco-Prussian War, German troop train blown up by the French near Mézières, August 1870.

were first applied to a practical purpose. Messages greatly reduced in size were printed photographically on collodion pellicles, rolled into quills and attached to the tails of carrier pigeons, which had been brought to the seat of the Delegate Government by balloon from the capital.

After arrival in Paris the messages were projected by magic lantern [*Ill. 123*], copied by clerks, and distributed. This was a kind of forerunner of the airgraph letter service during World War II.

Lively stereophotographs were taken during the Boer War (1899–1902) for Underwood & Underwood, New York publishers of stereoscopic pictures. There were no official photographers attached to the army, but thanks to private enterprise such as *The Daily Graphic*, which sent out its staff photographer Reinhold Thiele, and others working on the Boer side, the documentation of the South African War was very extensive [*Ill. 124*]. This was the first war covered by cinematographers, whose news-reels were projected in London music-halls as part of the evening's entertainment.

More peaceful historic events at home and abroad were naturally also recorded by photography, even though no picture agencies existed before 1899 and photographers' main recompense for their trouble lay in the sale of prints to the public. Photographs were sometimes copied as woodcuts in newspapers, but photomechanical reproduction in the press only gradually came into use in the early years of the twentieth century, despite the fact that practical methods of half-tone printing had been devised by Stephen H. Horgan of New York and Georg Meisenbach of Munich in 1880 and 1882 respectively.

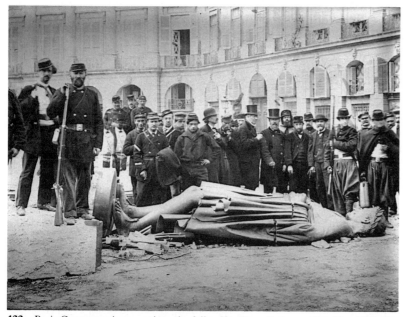

122 Paris Commune insurrection, the fallen Vendôme Column, 16th May 1871. The bearded man in the second row is Gustave Courbet.

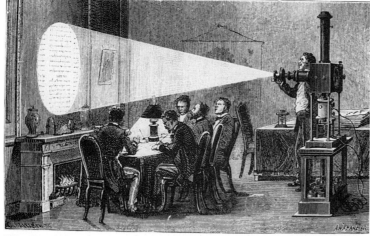

123 Copying pigeon post dispatches during the Siege of Paris, 1870–71.

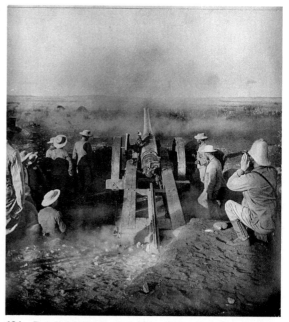

124 Reinhold Thiele. Boer War, firing 'Joe Chamberlain' at Magersfontein, 1899.

Social Documentation

The first social documentation, which unfortunately no longer exists, was daguerreotypes by Richard Beard of street types to illustrate Henry Mayhew's monumental social survey *London Labour and the London Poor* (1851) in which they were copied as woodcuts. Lacking any environmental indication, the street traders were probably photographed in the studio. In the early 1860s Carlo Ponti issued a series of photographs of Venetian street traders and beggars, which were, however, merely intended as souvenirs for tourists.

John Thomson produced a kind of small sequel to Mayhew with his *Street Life in London* (1877) documenting the life and work of the poorer classes. In contrast to Beard—as far as one can judge from the woodcuts—Thomson depicted people in their usual surroundings [*Ill. 125, 126*], producing superlative pictures worthy of any modern reportage photographer. Each is accompanied by an article on the living and working conditions of the subject, written by Thomson or in some cases by Adolphe Smith, a journalist.

Jacob A. Riis, a police-court reporter on *The New York Tribune*, believing that the camera is a mightier weapon than the pen for attacking the bad conditions that lead to crime, took a poignant series of photographs between 1887 and 1892 to point out to society its obligations to the poor [*Ill. 127*]. With his books *How the Other Half Lives* (1890) and *Children of the Poor* (1892) Riis awakened the conscience of New Yorkers and influenced the Governor of New York State,

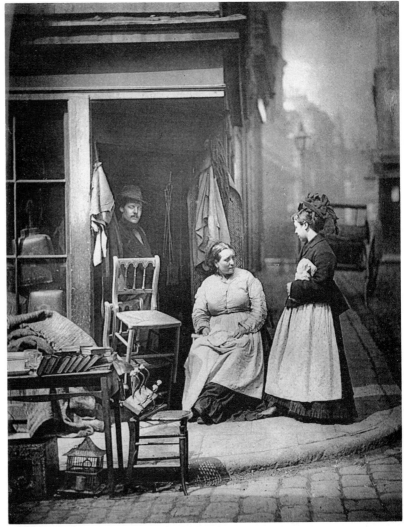

126 John Thomson. Junkshop in London, 1876.

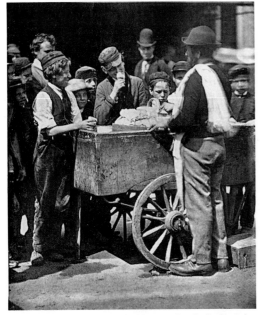

125 John Thomson. 'Ha'penny Ices', Italian ice cream seller in London, 1876.

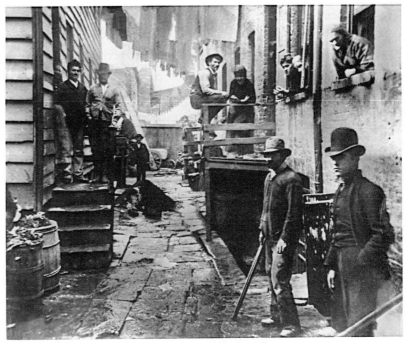

127 Jacob Riis. 'Bandits' Roost', New York slum, 1888.

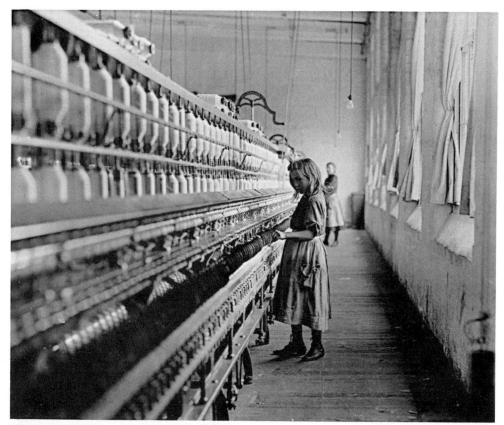

128 Lewis W. Hine. Carolina cotton mill, 1908.

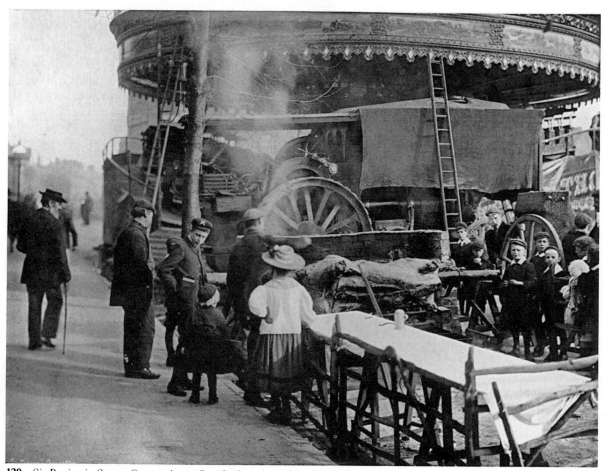

129 Sir Benjamin Stone. Ox-roasting at Stratford-on-Avon 'Mop', *c*. 1898.

Theodore Roosevelt, to undertake a number of social reforms, including the wiping out of notorious tenements at Mulberry Bend. Today the Jacob A. Riis Neighborhood Settlement commemorates the photographer's great work.

Lewis Wickes Hine, an American sociologist, took up photography in 1905 in order to highlight the plight of poor European immigrants. Three years later he continued his sociological studies with photographs of Pittsburgh iron and steel workers. As staff photographer to the National Child Labor Committee, Hine exposed shocking conditions, which resulted in the passing of the Child Labor Law [*Ill. 128*].

Dr Arnold Genthe's excellent pictures of life in San Francisco's Chinatown (1897) and the devastation caused by the earthquake and fire of 1906 are infinitely more interesting than his rather uninspired portraits of stage and screen stars that made him one of America's most prominent photographers after settling in New York in 1911.

In 1897 Sir Benjamin Stone, Member of Parliament for Birmingham, founded the National Photographic Record Association with the aim of documenting old English manners and customs, picturesque festivals and pageants, and traditional ceremonies which he feared were in danger of dying out [*Ill. 129*]. Stone himself was the most active member of the Association, and left a collection of 22,000 photographs—some dull records, others of artistic merit, and all of historic value.

Nahum Luboshez, Kodak's representative in St Petersburg before World War I, was an enthusiastic amateur photographer, chiefly in portraiture. But his most striking photographs are of life in Russia, including pictures taken during one of the recurrent famines, in 1910 [*Ill. 130*].

Paul Martin's snapshots of London street scenes [*Ill. 131*] and of people enjoying themselves at the seaside, taken in the 1890s, make him the first 'candid cameraman' nearly forty years before the phrase was coined. Using a hand camera concealed in a briefcase, Martin was able to capture revealing moments. His 'London by Night' pictures taken in the winter of 1895–96 were the first of their kind [*Ill. 132*].

Eugène Atget had a passion for documentation similar to Sir Benjamin Stone's, though it took a different form. Atget wanted to record Paris in all its facets, and between 1899 and 1927 took thousands of photographs of buildings, staircases, door-knockers, ornate stucco decorations, shop fronts [*Ill. 133*], and vehicles. During his lifetime few people were interested in Atget's self-imposed task, yet he was able to sell great quantities of his prints to museums, leaving nearly 10,000 to posterity. The most publicized side of Atget's work is his street life series, very similar to Thomson's and Martin's, but his roving eye was fascinated by many things which other people pass by as nothing remarkable [*Ill. 189*].

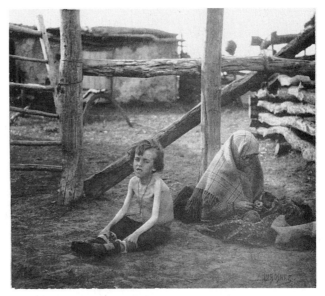

130 Nahum Luboshez. Famine in Russia, 1910.

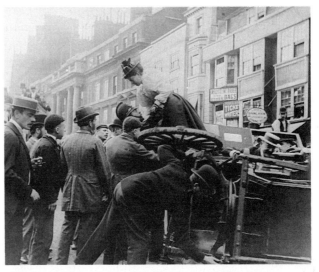

131 Paul Martin. Cab accident in London, 1895.

132 Paul Martin. Piccadilly Circus at night, 1895.

133 Eugène Atget. Basket and broom shop in Paris, c. 1910.

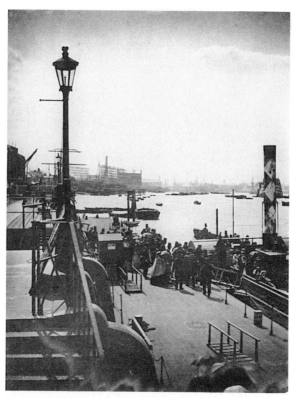

134 G. W. Wilson. Greenwich Pier, 1857.

Photography of Movement

The desire to record action existed right from the earliest days of photography, but remained in general unfulfilled until the introduction of the stereoscopic camera in 1856 [*Ill. 33*]. Noteworthy exceptions were a few small daguerreotypes taken in 1841: street views including people and slow-moving traffic by the Natterer brothers of Vienna; a view of the Pont Neuf, Paris, by Marc-Antoine Gaudin; and the changing of the guard at the Tuileries, with a crowd of spectators, by Girault de Prangey.

Ten years later Hippolyte Macaire of Le Havre showed daguerreotypes of a trotting horse, a moving carriage, and a walking man, and seascapes with waves and steamships with smoke coming out of the funnel. For these novel subjects, taken in a fraction of a second, Macaire could command as much as 100 francs each. Some of his sea views were bought by the marine painter Eugène Isabey.

Such subjects had to be photographed from a considerable distance to minimize the effect of movement. In the instantaneous stereoscopic views taken in the late 1850s by G. W. Wilson [*Ill. 134*], William England, Adolphe Braun [*Ill. 34*], and Edward Anthony, the vantage point was usually an upper window. Valentine Blanchard photographing from the roof of a cab in 1862 was able to snatch very lively impressions of the hustle and bustle of busy London thoroughfares. Twenty-five years later Charles A. Wilson (son of G. W. Wilson), using gelatine dry plates, took still better pictures of larger size from inside a furniture van [*Ill. 135*].

Action photographs made it possible to record and study the movements of animals scientifically. Best known in this field are the serial photographs of Eadweard Muybridge, the first man to think of a photo-finish in horse-racing. His investigation of the locomotion of animals originated in 1872 with a controversy about the leg movements of a trotting horse. His serial photographs of horses, taken for ex-Governor Leland Stanford of California in 1878–79 with a row of twelve to twenty-four small cameras, demonstrated for the first time movements too fast for the eye to perceive, and exposed the absurdity of the conventional 'rocking-horse' attitude of galloping horses' legs in paintings. At first the consecutive positions of the legs were criticized as being ludicrous and impossible, but when Muybridge synthesized the movement by projection on a screen even sceptics had to admit the truth. Between 1883 and 1885 Muybridge carried out an investigation of animal and human locomotion in all forms under the auspices of the University of Pennsylvania, using up to thirty-six cameras with clockwork shutters and gelatine dry plates, with which he was naturally able to secure much better results. His monumental work *Animal Locomotion* (1887) contains 781 plates and remains to this day the most com-

prehensive publication of its kind [*Ill. 136*].

Muybridge's photographic analysis led Prof. Etienne-Jules Marey of Paris, who had also been investigating animal movement, to abandon his method of chronography in favour of chronophotography. In contrast to Muybridge's battery of cameras Marey used only one, with a disk shutter, and recorded the consecutive phases of movement on a single plate, to give the impression that one observer following the movement would obtain. For the flight of birds [*Ill. 137*] Marey devised in 1882 a photographic gun. Men and horses in rapid movement were photographed with a camera set up on a moveable wagon running on rails parallel to the subject [*Ill. 138*]. In 1890 Marey used the new celluloid roll-film in a cine-camera of his own invention, and two years later a projector, but his pioneer work in cinematography was overshadowed by the better apparatus of the Lumière brothers.

It was natural that Thomas Eakins, America's super-realist painter, who based his art on scientific principles, should take an interest in photography and its use to record anatomy and movement. He studied Muybridge's experiments, but was critical of his use of a battery of cameras instead of Marey's single-camera method. Eakins himself constructed a camera with two disk shutters, one revolving eight times as fast as the other, and making nine or ten exposures on one plate. With it—simultaneously with Muybridge—Eakins made an independent series of

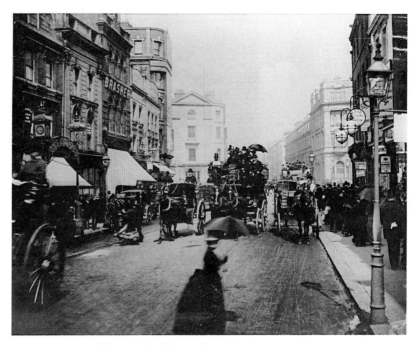

135 Charles A. Wilson. Oxford Street, London, 1887.

experiments for the University of Pennsylvania, producing pictures of horses and nude athletes which are practically indistinguishable from Marey's.

The German photographer Ottomar Anschütz also became prominent through his in-

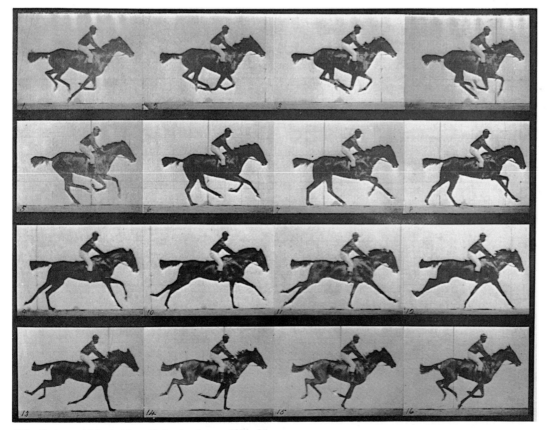

136 Eadweard Muybridge. Galloping horse, 1883–85.

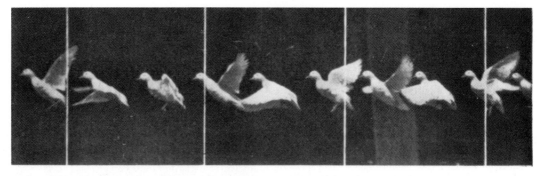

stantaneous photographs of animals and birds taken from 1882 onward. At first he took single photographs, but four years later changed to Muybridge's system of twenty-four cameras for chronophotography, making chiefly photographs for military training purposes. For stroboscopic synthesis of these pictures Anschütz constructed the Electrotachyscope in 1887, in which the pictures were arranged round the edge of a rotating wheel and each in turn briefly illuminated by an electric spark.

The 'freezing' of rapidly moving objects for a fraction of a second by the sudden flash of an electric spark in a darkened room was demonstrated by Sir Charles Wheatstone five years before the introduction of photography. Talbot applied photography to record this phenomenon in 1851, when he photographed a rapidly revolving wheel with a page of *The Times* attached to it, and obtained a clear picture, the duration of the spark being $\frac{1}{100,000}$ second. With this demonstration before the Royal Institution Talbot laid the foundation of high-speed photography.

Ernst Mach, a professor at Prague University, and Dr P. Salcher, a professor at the Naval College at Pola, in 1887 succeeded by the electric spark method in photographing bullets with a velocity of 765 m.p.h. In 1892 Charles Vernon Boys of the Royal College of Science, London, obtained photographs of bullets piercing a sheet of plate-glass at about twice this speed. Whilst

these pioneers of ballistic photography only recorded the *shadows* of bullets and the sound waves they produced, Prof. Hubert Schardin's photograph [*Ill. 139*] taken at the Scientific Research Institute at Weil c. 1950 shows the great technical advance made in this field since then.

A similar improvement in technical quality is naturally evident in the multiple-flash photographs of splashes by Harold E. Edgerton and Kenneth J. Germeshausen of the Massachusetts Institute of Technology in 1933, compared with the pioneer work of A. M. Worthington in England and Theodor Lullin in Switzerland in the mid-'nineties, or Lord Rayleigh's photograph taken in 1891 of a soap bubble at the moment of bursting. These and other experiments made the public familiar with high-speed photographs and exposures of one-millionth second in the mid-'nineties.

In the early years of the twentieth century Dr Lucien Bull, assistant of E. J. Marey, was able by the spark method to film the wing oscillations of insects, which were far too rapid to be successfully recorded in single pictures.

From 1933 onward Edgerton and Germeshausen extended multiple-flash photography to the motion study of games: a tennis player, a diver, a baton-thrower, and a golfer [*Ill. 140*] whose amusing parrot-like pattern of movement was obtained with 100 flashes per second.

138 Prof. E.-J. Marey. Jumping man, *c.* 1884 (reproduction).

139 Prof. Hubert Schardin. Bullet passing through candle flames, and the sound waves caused by it, *c.* 1950.

140 Harold E. Edgerton. Multiple-flash photograph of the golfer Dennis Shute, *c.* 1935. 100 flashes per second.

Pictorial Photography

The earliest exponent of fine art photography was J. E. Mayall, who in 1845 produced a series of ten daguerreotypes illustrating 'The Lord's Prayer'. Six years later at the Great Exhibition in London Mayall showed several compositions described in the catalogue as 'Daguerreotype pictures to illustrate poetry and sentiment'—'The Soldier's Dream', 'The Venerable Bede blessing a child', and 'Bacchus and Ariadne' measuring no less than 24 × 15 inches. Despite Prince Albert's encouragement, Mayall abandoned art photography, realizing probably the validity of the criticism put forward by *The Athenaeum:* 'To us these pictures seem a mistake. At best, we can only hope to get a mere naturalistic rendering. Ideality is unattainable—and imagination supplanted by the presence of fact.'

Apart from Mayall's misguided excursions into a realm best avoided by photography, no attempt seems to have been made in the first fifteen years or so of the new art to deviate from the realistic representation of the everyday world. Whilst it was recognized that this set a limitation to photography, perceptive people were fully aware that there remained ample scope for artistic expression through selection, viewpoint, lighting, and composition.

The annual exhibitions of the Photographic Society of London, founded by Roger Fenton in 1853, stimulated photographers to compete with one another in the production of pictures to be admired by the public and discussed in the press. The critics, who had hitherto only reviewed art exhibitions, were really not quite sure whether photography were an art, a science, a bit of each, or neither. Finding the constant repetition of portraits, views, and still-lifes somewhat monotonous—for exposures were still too long to record action—they drew invidious comparisons between painting and photography, pompously urging photographers to strive for loftier themes than the 'mere reproduction of reality', subjects that would 'fire the imagination, instruct, purify, and ennoble'. Photographs of historical, allegorical, literary, and anecdotal subjects, similar to the pictures of contemporary Academy painters, would be the best way—so they argued—to counter the reproach that photography was a mechanical art. 'For photography there are new secrets to conquer, new Madonnas to invent, and new ideals to imagine. There will be perhaps photograph Raphaels, photograph Titians.' This confusion about the aims of photography and painting led to shocking errors of taste in both fields.

The idea of raising photography to the exalted regions of High Art attracted particularly the many former painters who found it easier to earn a living with the camera than with the brush. In 1855 William Lake Price, a watercolour artist,

73

141 O. G. Rejlander. 'The Two Ways of Life', 1857.

astonished the world of art and photography—and the President of the Royal Academy, Sir Charles Eastlake, who was also President of the Photographic Society of London—with his 'Don Quixote' and other compositions in the chivalric style of the Academician George Cattermole. They heralded an unfortunate trend—photographic picture *making* instead of picture *taking*. Whilst the art critics welcomed High Art photography, as it was then called, those with a deeper knowledge of the photographic medium were convinced that 'photographic renderings of historical or poetic subjects . . . give at best only the impression of a scene on the stage'.

The most ambitious allegorical composition in the entire history of photography is O. G. Rejlander's 'Two Ways of Life' [*Ill. 141*]: Industry on the right and Dissipation on the left, with Penitence in between. This photograph, as big as an easel painting (16 × 31 inches), was first shown at the Manchester Art Treasures Exhibition in 1857. Here for the first time photographs were displayed in equality with paintings, drawings, and sculpture, and Rejlander, a painter devoted to the new medium, saw in the honour accorded to it a splendid opportunity to prove publicly that it was possible to create photographs on a par with paintings. Queen Victoria admired 'The Two Ways of Life' for its moral content and bought it for Prince Albert, who greatly appreciated the present and hung it in his study. Photographers were on the whole less partial to it. Many were shocked at the semi-nudity of some of the figures: in Scotland, only the respectable half of the picture was exhibited! Others rightly disapproved of the technique of concocting a photograph out of over thirty negatives, and some objections were raised against the principle of representing an allegory by the realistic medium of photography. The prevailing opinion in art circles seemed to be that this was the highest level which photography could attain, and the seal of royal approval naturally encouraged the production of some other pretentious compositions. A few titles may suffice: 'The Baron's Feast', 'The Adventures of Robinson Crusoe', 'A Scene in the Tower' (after Paul Delaroche) by Lake Price; 'The Head of St John the Baptist', 'Iphigenia', 'Judith and Holofernes' by Rejlander.

Henry Peach Robinson's well known photograph 'Fading Away' (1858) showing a dying girl surrounded by her grieving family was a less pretentious subject and enjoyed immediate success at exhibitions. It was a combination print from five negatives. For the next thirty years or so Robinson produced at least one composition

142 H. P. Robinson. Study for a composition picture, *c*. 1860.

picture for each annual exhibition of the Photographic Society of London, which afterwards made the round of the important exhibitions in Britain and the Continent. These and other compositions created the style known as 'pictorial photography'. Robinson's method, entirely contrary to the true technique of photography, was to build up the picture in stages. After making a preliminary sketch of the design, he photographed individual figures, or groups of figures, cut them out, and pasted them on the separately-photographed foreground and background [*Ill. 142*]. When all the photographs had been printed in, the joins were carefully retouched and the whole picture re-photographed for the final version. 'Dawn and Sunset' [*Ill. 143*], Robinson's exhibition picture in 1885, shows his great though misapplied skill; one cannot possibly detect the joins of the five negatives from which it was made up. But why should anyone go such a roundabout way of building up his pictures from a number of negatives, instead of simply posing and photographing the group? This complication was partly necessitated by the long exposure, for it was impossible to rely on several sitters' keeping still. In this particular picture, moreover, the contrast between the shadows in the room and the light streaming in from the window would have been too great for the negative-material of the period to record satisfactorily. But whereas Rejlander's method of printing in the separate pictures direct on to one large sheet of paper was purely photographic, Robinson's technique can only be described as 'scissors and paste-pot' or photomontage.

Like an infectious disease, *Picture Making by Photography* (the title of Robinson's most influential book, still reprinted during World War I) affected even some of the greatest photographers such as Julia Margaret Cameron and David Octavius Hill—striking examples of how those who reached the greatest heights of truly artistic photography could plumb the depths of artificiality and sentimentality when they strove 'to further the development of fine art in photography'. This was Hill's declared intention when about 1860 he made a short comeback to photography in collaboration with A. McGlashan, an Edinburgh portrait photographer, but their achievement hardly went beyond mediocre anecdotal pictures.

Under the influence of her friend and mentor G. F. Watts, Julia Margaret Cameron spent much time in the misguided effort to explore the realm of fancy, and like the Academic painters of the period, whom she emulated, produced the worst kind of Victorian trash in pictures like 'Pray God, bring Father safely home'. Her illustrations to the Bible, Shakespeare, and Tennyson, though compared by her contemporaries with the paintings of Old Masters, appear ludicrous to modern eyes. In this rational age it is obvious to us that one cannot photograph 'The Wise and Foolish Virgins', a Sibyl, St Cecilia, or

143 H. P. Robinson. 'Dawn and Sunset', 1885 (detail).

the Annunciation, because the realism of the medium inevitably reduces the sublime to the ridiculous. Mrs. Cameron and her friends did not see this. The Poet Laureate himself asked her to illustrate his 'Idylls of the King', with results that are often comically suggestive of amateur theatricals.

The New Amateurs

With the general introduction of factory-produced rapid dry plates and small hand cameras in the 1880s snapshooting became a popular pastime for hundreds of thousands of amateurs of a different calibre from the English and French amateurs of the early period. They were on the whole people of position, who in those days learned to draw as part of their education and therefore had a trained eye for composition. Moreover, the very difficulty of photography tended to result in carefully composed pictures. The new amateurs using simple apparatus, and mostly lacking art training, had never heard of any rules of composition and took rather free-and-easy snapshots, often very charming like J. Bridson's picnic (1882) [*Ill. 144*]. They were

144 J. Bridson. Picnic, *c.* 1882.

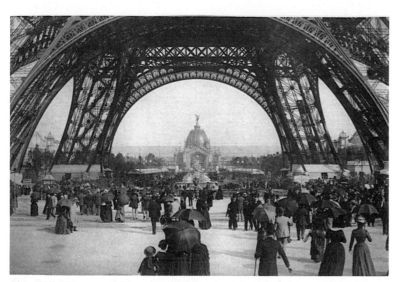

145 Eiffel Tower and Trocadéro. International Exhibition, Paris, 1889.

146 Oscar van Zel. Skating in Vienna, *c.* 1887.

fascinated that a click of the shutter could capture a slice of life bustling with activity [*Ill. 145*]. Oscar van Zel's snapshot [*Ill. 146*] of figure skaters in Vienna 'froze' their movement and shows what short exposures could be attained. Degas, who disliked painting out of doors, relied a good deal on photographs as studies for his canvases, many of which convey a casual snapshot-like impression, for example the 'Place de la Concorde' with people half cut off.

Most of the new amateurs were content to remain unknown, photographing solely for their own pleasure. For this reason the work of some of them has only recently come to light. For example, Count Giuseppe Primoli chronicled Roman life both high and low between 1885 and 1905 with directness and admirable originality of vision. Similar qualities distinguish the pictures of Jacques-Henri Lartigue, who as a boy took fascinating snapshots of early motoring and flying, and photographed race meetings in the years preceding the Great War.

Many amateurs joined photographic clubs. Up to World War I Great Britain retained its position as the country most active in photography, and by 1900 had no fewer than 256 clubs as against 99 in the United States and only 23 throughout the whole of the Continent. Those taking their cue from the Royal Photographic Society of Great Britain—the oldest society still in existence—remained uninterested in the new range of subject matter that had been opened up, using the recent technical advances merely to indulge in trite pictorialism with greater facility.

Naturalism and Impressionism

By the mid-'eighties H. P. Robinson had gained such international prestige that artificiality was synonymous with pictorial photography. Realizing that exhibition photography was completely divorced from reality, Dr Peter Henry Emerson urged a return to Nature for inspiration, as Courbet had done thirty years earlier in a similar reaction against academic painting. An admirer of the Barbizon School, and particularly of Millet, Emerson for the next ten years photographed the life and landscape of the Norfolk Broads, and convincingly demonstrated that quite ordinary subjects could be imbued with artistic quality bearing a personal stamp [*Ill. 147*]. His manifesto *Naturalistic Photography* (1889) was a strong attack on artificial picture-making. Emerson's example brought about a revival of landscape photography in England. Prominent among his followers were a number of gifted amateurs: George Davison, Benjamin Gay Wilkinson [*Ill. 148*], Colonel Joseph Gale, Lyddell Sawyer [*Ill. 149*], and Frank M. Sutcliffe. The two last-named had professional portrait studios, but made delightful landscape and *genre* pictures for exhibitions.

Under the influence of the first exhibition of

147 P. H. Emerson. Gathering water-lilies, 1885.

French Impressionist paintings in England in 1889, George Davison revived the old argument that a soft photograph was more beautiful than a sharp one—an idea that had led to heated discussions among English photographers in the 'fifties. The following year he exhibited the first impressionist photograph, 'The Onion Field' [*Ill. 150*], in which the image was slightly blurred by a combination of soft focus and rough-surfaced paper. Soon the desire arose to increase the softness and to break up the smooth half-tones of the photographic image to emphasize the Impressionistic effect. This met with stubborn opposition from the traditionalists who were purists in technique, at least, and since the artistic photographers were already dissatisfied with the recent scientific bias of the Photographic Society, they broke away from the establishment and founded a secession movement in 1892. The Linked Ring Brotherhood was formed by Davison and all the members of the Naturalistic school of photography (except its founder) and, incongruous as it seems, the old pictorialist H. P. Robinson. Since England had the longest tradition of pictorial photography and was indeed until the 'nineties the chief country where it was practised, it is not surprising that the Linked Ring group was looked up to as the natural leader by amateur organizations that grew up in other countries about this time. Within three years the leading French, Austrian, and American art photographers had become members of the Linked Ring and sent their pictures to its annual exhibitions, the London Salon, which remained the most important international event in photography up to 1914. The

London Salon set an example for international exhibitions of aesthetic photography on the Continent: Vienna (1892), Hamburg (1893), Paris (1894), Turin (1897), Berlin (1899); and the Linked Ring led to similar secession movements, of which the most important was the Photo-Secession founded by Alfred Stieglitz in New York in 1902.

The pursuit of art unifying photographers of many nations resulted in the formation in 1904 of the International Society of Pictorial Photogra-

148 B. Gay Wilkinson. Sand dunes. Original photogravure, *c.* 1890.

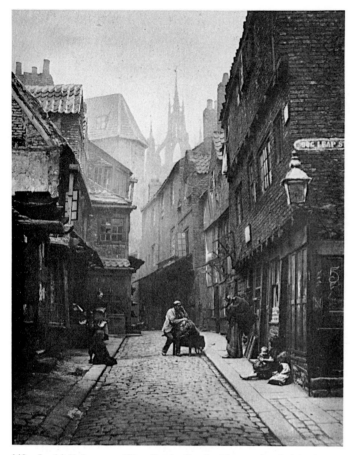

149 Lyddell Sawyer. The Castle Garth, Newcastle. Original photogravure, 1888.

151 Lacroix. Park-sweeper. Photogravure of a gum print, *c*. 1900.

150 George Davison.
'The Onion Field', 1890.

phers under the presidency of J. Craig Annan of Glasgow.

The international status of the aesthetic movement brought in its wake—at least in Europe— an extraordinary uniformity of style. Most pictorial photographs were sombre in tone, grainy in texture, with broad decorative effects, lacking in perspective. They owed as much to the *art nouveau* style as to the adoption of new printing techniques. The gum bichromate, bromoil, and other controlled pigment processes introduced between 1894 and 1907 enabled the photographer to destroy the unique photographic qualities of his medium. He could omit details, alter tone values, and by manual interference with brush, pencil, or rubber, change the image to such an extent that it no longer resembled a photograph but assumed the appearance of a painting, especially if the negative had been initially exposed to coarse canvas. Rough drawing paper and certain pigments could make the photograph look like a red chalk or charcoal drawing. Nothing flattered the *fin-de-siècle* photographer more than the admiring exclamation: 'That doesn't look a bit like a photograph!' [*Ill. 151*], for it proved their distinction from the mass of casual snapshooters for whom these techniques were far too difficult. Whilst in their ambition for recognition as artists many photographers moved further and further away from pure photography in the *presentation* of their pictures, these were—in contrast to the earlier High Art photographs— invariably of legitimate camera subjects. Not infrequently photographers imitated the style of particular artists. Is it Demachy or is it Degas whom we admire in the charming picture of a ballet dancer [*Ill. 152*]? On the other hand, Frau E. Nothmann's 'In the Garden' has the character of a Renoir without being directly indebted to him [*Ill. 153*].

The most prominent art photographers using the gum bichromate and other controlled printing processes were, in France: Robert Demachy, C. Puyo. In Austria: Heinrich Kühn [*Ill. 154*], Hugo Henneberg, and Hans Watzek [*Ill. 155*]. In Germany: the brothers Theodor and Oskar Hofmeister [*Ill. 156*], Rudolph Dührkoop, and Hugo Erfurth [*Ill. 157*].In Belgium: Léonard Misonne. In Spain: José Ortiz Echagüe. In Britain: Alfred Horsley Hinton, Alexander Keighley [*Ill. 158*], and F. J. Mortimer. The American Edward Steichen, then living in Paris, may also be considered to fall in this European group. His imaginative composition of Rodin with two of his greatest sculptures [*Ill. 159*] is an effective though rather pretentious essay in photographic impressionism. It was made from two negatives, 'The Thinker' being printed in.

However attractive, art photography was neither art nor true photography but a hybrid arising from a misconception of its functions, which befuddled even the usually clear-headed Munich art critic Karl Voll into proclaiming: 'Since the introduction of the gum print their results have

152 Robert Demachy. 'Behind the Scenes'. Photogravure of a gum print, 1904.

153 Frau E. Nothmann. 'In the Garden'. Photogravure of a gum print, *c.* 1897.

154 Heinrich Kühn. Venice. Gum print, 1897 (reproduction).

155 Hans Watzek. A peasant. Photogravure of a gum print, 1894.

156 Theodor and Oskar Hofmeister: Great-grandmother, Cuxhafen, August 1897. Photogravure of a gum print.

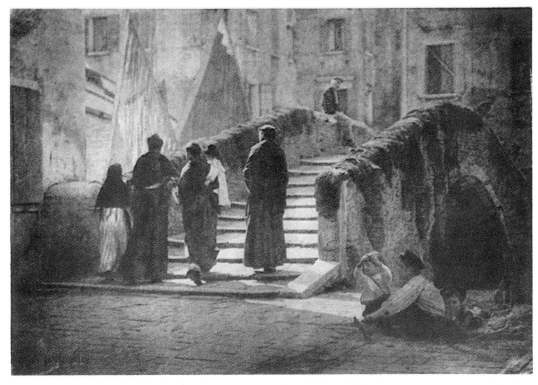

158　Alexander Keighley. The bridge. Photogravure of a bromoil print, 1906.

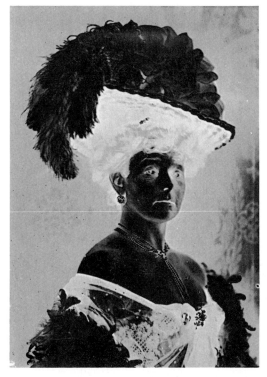

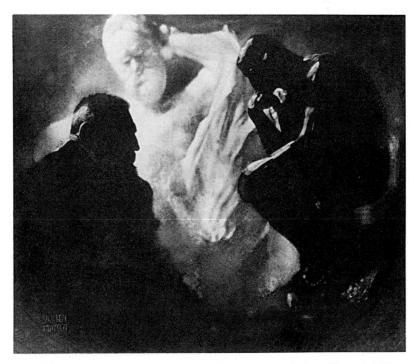

159　Edward Steichen. Auguste Rodin with his sculpture of Victor Hugo and 'The Thinker'. Gum print, 1902.

157　Hugo Erfurth. Lady with hat. Negative print, 1907.

no longer anything in common with what used to be known as photography. For that reason one can proudly say that these photographers have broken the tradition of the artificial reproduction of nature. They have freed themselves from photography.'

When one art copies the characteristics of another, decadence inevitably sets in. This had happened to art when photographic realism became the hallmark of academic painting; it happened to photography when it abandoned realism in a striving for painterly effects. Now the two opponents had come so close together that recognition was readily accorded to the new art. At no time during its entire history has photography been held in such high esteem by painters as during this aesthetic period of art for art's sake. The Director of the Hamburg Kunsthalle, Prof. Alfred Lichtwark, was the first to open his museum doors to exhibitions of photography in 1893 and the following ten years [*Ill. 160*], a step which to the public was at first as anomalous as holding a scientific congress in a church. This official acceptance of photography was by no means altruistic, for Lichtwark's declared expectation was a revitalization of painting through photography. The artists of the Munich and Vienna Secessions admitted the *art nouveau* photographers to their exhibitions in 1898 and 1902 respectively, and in 1899 the first exhibition of art photography in Berlin took place at the Royal Academy!

By no means all photographers of the *art nouveau* period were forgers of painters' work or imitators of non-photographic techniques. A number of English photographers and practically the entire American group, with the exception of Steichen, had no desire to 'free themselves from photography'. They favoured the soft silver-grey or sepia toned platinum paper, or hand-made photogravures or photo-etchings. These techniques had been chosen by P. H. Emerson as giving a slightly softer and more artistic presentation of a photograph than the usual glossy albumen or bromide prints. To this purist group, who exhibited side by side with the 'daubers and gum-splodgers' as Emerson dubbed them, belonged, in Britain: James Craig Annan [*Ill. 161*], Frederick H. Evans [*Ill. 162*], Frederick H. Hollyer, Frank M. Sutcliffe. In France: Maurice Bucquet [*Ill. 163*]. In America: Alvin Langdon Coburn [*Ill. 164*], Frank Eugene, Gertrude Käsebier, Clarence H. White [*Ill. 165*], Alfred Stieglitz [*Ill. 166*], and Harry C. Rubincam [*Ill. 167*]. Their pictures frequently show soft impressionistic effects, with occasional *contre-jour* lighting, and a preference for wet or snowy weather.

George Bernard Shaw admitted to the author that he originally aspired to be a Michelangelo, not a Shakespeare, but could not draw well enough to satisfy himself [*Ill. 168*]. Considering the camera a wonderful substitute for the paintbox, he began 'pushing the button' in 1898, with such lack of success that he made the classic comparison: 'The photographer is like the cod, which lays a million eggs in order that one may be hatched.' Nevertheless Shaw audaciously prophesied in the third year of his hobby: 'Some day the camera will do the work of Velasquez and Pieter de Hoogh, colour and all . . . Selection and representation, covering ninety-nine hundredths of our annual output of art, belongs henceforth to photography.' Whilst in his own inimitable way Shaw tried to confirm Delaroche's opinion that painting was dead, he did not, of course, expect his remark to be taken literally. But before long, a photographic Pieter de Hoogh interior made its appearance [*Ill. 169*]. This was only one of many elaborate and accomplished imitations of Old Master paintings, in which great pains were taken to achieve historical accuracy. From the photographic point of view the technique itself was straightforward. Madonnas and saints far more convincing than Mrs Cameron's appeared, and even Crucifixions, Depositions, and Entombments did not escape photographic treatment. With such aberrations of taste the Dutch amateur photographer Richard Polak; the Americans J. C. Strauss, F. Holland Day, and Lejaren à Hiller; the Italians Ruffo and Guido Rey; L. Bovier of Belgium; Fred Boissonnas of Switzerland; and Mrs Barton in England won their laurels.

The man who set out to regenerate the art of true photography towards the end of the century was Alfred Stieglitz. His photographs of New

160 Title-page of exhibition catalogue, Hamburg Kunsthalle, 1899.

161 J. Craig Annan. The painter and etcher Sir William Strang. Original photogravure, *c*. 1900.

163 Maurice Bucquet. 'Effet de Pluie'. Paris, *c*. 1899.

164 Alvin Langdon Coburn. Reflections. Original photogravure, 1908.

162 Frederick H. Evans. Aubrey Beardsley. Platinum print, *c*. 1895.

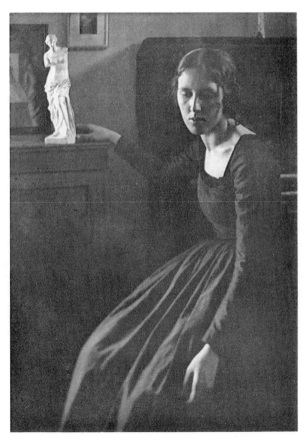

165 Clarence White. Lady in black. Original photogravure, *c*. 1907.

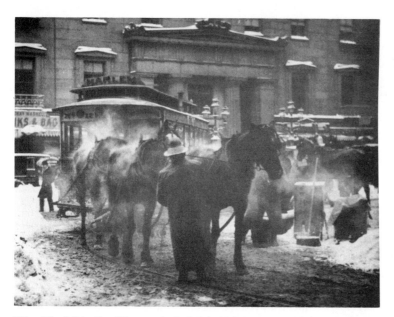

166 Alfred Stieglitz. The terminal. Original photogravure, 1893.

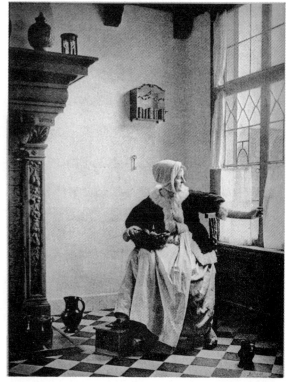

169 Richard Polak. Photograph in the style of Pieter de Hoogh, 1914 (reproduction).

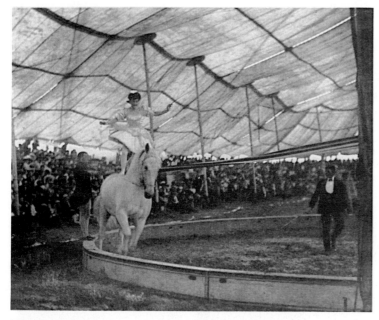

167 Harry C. Rubincam. Circus rider. Original photogravure, 1905.

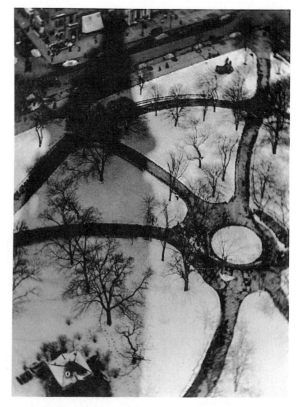

170 Alvin Langdon Coburn. 'The Octopus', New York. Original photogravure, 1912.

York streets in the 'nineties convincingly proved that everyday scenes abound in effective pictures and that it is quite unnecessary to stoop to artifice. Stieglitz's perception as art connoisseur was far in advance of his time. At the Photo-Secession gallery at 291 Fifth Avenue he introduced to America, with Steichen's assistance, the work of many now world-famous *avant-garde* artists, as well as photographers. They were also featured in *Camera Work*, a prestigious quarterly which he edited during the period 1903–17. Although a purist and an advocate of straight photography [*Ill. 1 (frontispiece)*], Stieglitz showed a surprising tolerance towards those who clung to the manipulated print, and whose work was frequently as artificial as that which he was fighting against.

In 1913 Alvin Langdon Coburn, exhibiting in London his novel bird's-eye views entitled 'New York from its Pinnacles' [*Ill. 170*], persuasively asked in the catalogue: 'Why should not the camera artist break away from the worn-out conventions that, even in its comparatively short existence, have begun to cramp and restrict his medium?' The idea of showing the world from above was original, but the impressionist softness of presentation detracts somewhat from the inherent modernity of these photographs.

Stieglitz, Steichen, Coburn, and other members of the American Photo-Secession exerted an undoubted influence on photographic exhibitions in Europe, yet it must be emphasized that

What, or who, led you to take up photography, and about what date?

I always wanted to draw and paint. I had no literary ambition: I aspired to be a Michael Angelo, not a Shakespear. But I could not draw well enough to satisfy myself; and the instruction I could get was worse than useless. So when dry plates and push buttons came into the market I bought a box camera and began pushing the button. This was in 1898.

168 George Bernard Shaw's reply to Helmut Gernsheim, giving his reason for taking up photography, 1949.

the self-conscious picture-making of these small *cliques* contributed little to the mainstream of photography. Men like John Thomson, Jacob Riis, Lewis W. Hine, Paul Martin, Eugène Atget, Benjamin Stone, and scores of amateur photographers totally indifferent to exhibitions and societies used the camera instinctively as an objective commentator on life, without requiring manifestoes on the aims of photography. They planted the seeds of modern photography well before the first World War, though the full measure of their importance only began to find recognition with the changed outlook in the 1930s. 1914 marks the end of an era in photography as well as in social structure [*Ill. 171*].

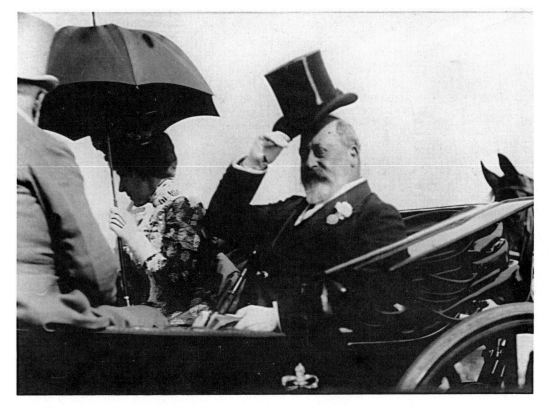

171 Edward VII and Queen Alexandra, 28th June 1904.

Pictures and their Makers:
The Modern Period

The Revolution in Photography

A deliberate break with traditional subject matter and conformity in expression is manifested in Paul Strand's photographs of 1915–16, published by Stieglitz in the last two issues of *Camera Work* in 1917. Strand observed significant forms full of aesthetic appeal in ordinary subjects such as the shadow of a fence [*Ill. 172*] and a pile of kitchen bowls. These photographs are in essence abstract designs and do not call for surface texture and fine detail. In another picture, 'The White Fence' [*Ill. 173*], Strand intentionally avoided any effect of perspective. Other photographs in the modern idiom depict ugly subjects such as a

ramshackle suburban corner, telegraph poles, and the close-up of a blind beggar woman, themes with which Strand jolted the onlooker back from the sophisticated dream-world of the aesthetic photographers to the harsh realities of everyday life, which they ignored. Strand's text to these pictures reads like an advance manifesto of the New Objectivity movement of the mid-1920s: 'Objectivity is of the very essence of photography, its contribution and at the same time its limitation . . . Honesty no less than intensity of vision is the prerequisite of a living expression. The fullest realization of this is accomplished without tricks of processes or manipulation, through the use of straight photographic methods.' Such objectivity was, in fact, only the long-forgotten natural approach of the first generation of photographers.

Whereas Paul Strand's experiments in abstraction were photographs of recognizable objects, the first purely abstract photographs were a series of 'Vortographs' made in 1917 by A. L. Coburn by photographing bits of wood, crystals, and other objects through an arrangement of three mirrors forming a triangle and resulting in multiple images [*Ill. 174*].

At the end of World War I the cynicism, disillusion, and contempt for established values led not only to political upheavals but also to a disintegration of accepted conventions in art. Traditional rules of composition were cast aside in a search for new ways of expression. Some young painters, trying to mould photography to their own visual aims, diverted it from its true functions. Christian Schad, a member of the Zürich Dada group, in 1918 made abstract designs by a

172 Paul Strand. Shadow pattern, New York. Original photogravure, 1915.

technique rather similar to Talbot's photogenic drawings by laying flat objects, strips of paper, and pieces of string on photographic paper. Tristan Tzara called them 'Schadographs'. Schad also revived photomontage, which had been used on and off since the late 'fifties. In Victorian photomontages cut-out photographs were either combined with one another to make a new composition (as in the case of H. P. Robinson) or— more usually—formed part of a painted composition to produce an incongruous or even surrealist effect. Never before, however, had photomontages been such a mad jumble as those of the Dadaists, for in their attempt to destroy all visual illusion, disjointed pieces of photographs were combined with torn-off bits of newspaper, or stuck on canvas without apparent relation to the painted parts.

In 1919 Erwin Quedenfeldt published in Düsseldorf a series of 20 'Lichtzeichnungen' (light-drawings)—graphic designs made with photographic materials, a method which he considered as 'absolute photography' because it freed the photographer from the mechanicalness of the camera.

Two years later Man Ray, the American Dadaist painter who had just settled in Paris, was shown some 'Schadographs' by Tristan Tzara, and then made somewhat similar light-drawings, which he called 'Rayographs', using three-dimensional opaque and translucent objects. In 1922 László Moholy-Nagy, a Hungarian abstract painter living in Berlin, after seeing some 'Rayographs' made his own brand of 'photograms' [*Ill. 175*] by placing three-dimensional objects on photographic plates or paper.

All these techniques aimed at the transmuta-

173 Paul Strand. The white fence. Original photogravure, 1915.

tion of the object into a non-representational light pattern in which merely the shape of the object was reproduced without detail or tone gradation.

Though not a teacher of photography, but of design, at the *Bauhaus*, Moholy-Nagy explored new techniques from 1922 on, probably with the assistance of his wife Lucia, who was a photographer. Concentrating on the idea of unifying art and technique, he strove to explore new techniques of photographic image-making on a much broader basis than had hitherto been tried, and

174 Alvin Langdon Coburn. 'Vortograph', 1917.

175 László Moholy-Nagy. Photogram, 1922.

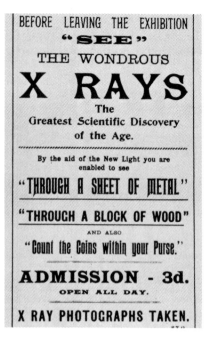

176 Early X-ray photograph, *c.* 1896–97.

177 Advertisement of X-ray exhibition, London, 1896.

178 László Moholy-Nagy. View from radio tower, Berlin, 1928.

especially to investigate the extent to which photography could serve painting, poster art, textile design, etc.—subjects which were taught at this *avant-garde* school of design founded by Walter Gropius in 1919. Techniques which had up to that time been solely employed for scientific purposes, such as X-ray photography [*Ill. 176, 177*], photomicrography, and macrophotography, were found suitable for producing novel designs of aesthetic value. The abstract artists at the *Bauhaus*—Wassily Kandinsky, Paul Klee, Lyonel Feininger, Moholy-Nagy—were intrigued by the fascinating forms revealed under the microscope. Klee wrote in 1924: 'The comparatively simple act of looking through the microscope presents the eye with pictures which we should all declare fantastic and far-fetched if we happened upon them by chance.' One of his maxims was: 'Art does not reproduce the visible, but makes visible.' Their similarity to abstract art prompted *The Illustrated London News* to publish in May 1931 a number of colour microphotographs by Mme Albin Guillot and M. H. Ragot.

Even quite simple techniques such as negative-printing [*Ill. 157*] (i.e. not reversing the image to the positive), multiple images, and distortion could result—so Moholy-Nagy pointed out—in exciting optical images, and being the *enfant terrible* who aimed at a complete break with traditional methods of picture-making, he urged his pupils to look at everything afresh, from novel viewpoints [*Ill. 178*]. Moholy-Nagy made photomontages chiefly in connection with typography, or for advertising, and called the combination of the printed word with a photograph 'typophoto'. His book *Malerei, Fotografie,*

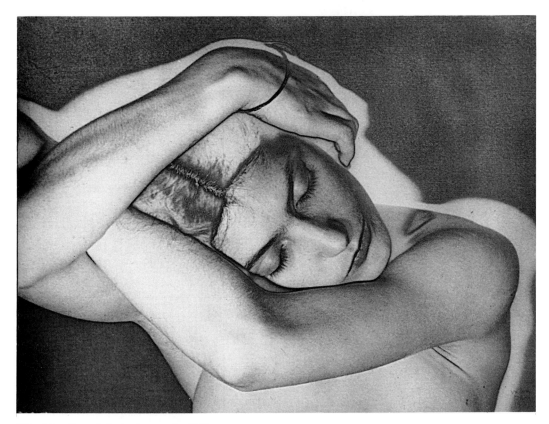

179 Man Ray. Solarized portrait, 1931.

Film (1925) is a forceful *exposé* of his revolutionary ideas on the future development and union of abstract painting, abstract photography, and abstract music—a combined art form based on optical and aural impulses conveyed by colour, photoplastic (photograms giving a three-dimensional effect), and electronic sound effects.

The phenomenon of partial reversal of the negative into a positive image by the action of light, called solarization by John William Draper in 1840, was used creatively by Man Ray in 1929 for emphasizing a certain graphic effect in photographs [*Ill. 179*].

Although much of the experimental darkroom work of the immediate postwar period was of limited value, Moholy-Nagy's, and to a lesser extent, Man Ray's contribution to photography lay in extending photographic techniques and uprooting outmoded conventions.

A search for new ways of expression occupied some photographers in England in the following decade. Cecil Beaton, for twenty-five years leading photographer of fashion and celebrities for *Vogue*, created a new style in portraiture, with the sitter forming part of an imaginative *décor* [*Ill. 180*]. The American Francis Bruguière showed in London in 1933 light patterns in which the camera had been merely used to record light effects on his abstract paper constructions. Angus McBean, Britain's leading theatrical photographer, for many years combined surrealist fantasy with photographic realism in his portraits of actresses and other compositions [*Ill. 181,*

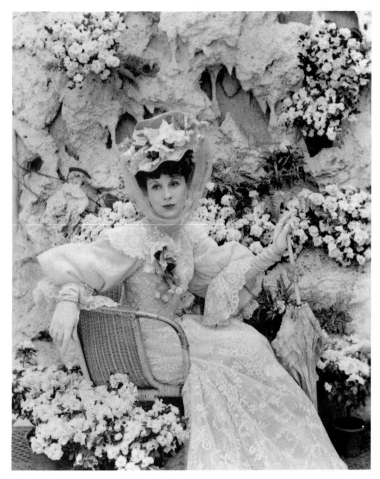

180 Cecil Beaton. The actress Diana Wynyard, 1935.

182]. Other *avant-garde* photographers active in London in the 'thirties were Peter Rose Pulham, a painter making surrealist photomontages; Edmiston, an advertising photographer; and Winifred Casson, a portrait and advertising photographer [*Ill. 183*], whose double exposure 'Accident' is a brilliant evocation of horror [*Ill. 184*].

In France, the German photographer Erwin Blumenfeld [*Ill. 185*] and the Hungarian André Kertész [*Ill. 186*], both of whom, like many other gifted Continental photographers, later emigrated to the United States, shocked the public with strange distortions in portraits and nudes.

Fascinated by the strange and fantastic, Clarence J. Laughlin was drawn to the beauty of old architecture in his home town, New Orleans, and the abandoned mansions of cotton planters along the Mississippi, which he photographed with poetical imagination sometimes in the surrealist vein, to resurrect the spirit of the past [*Ill. 187*]. It was all part and parcel of the surrealist movement, and a natural parallel to contemporary art trends.

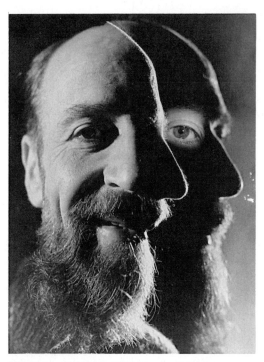

181 Angus McBean. Self-portrait (four exposures), 1946.

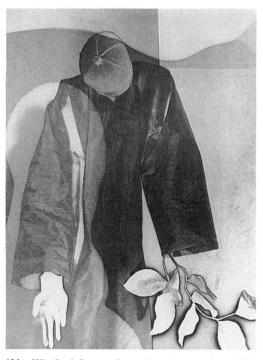

183 Winifred Casson. Surrealist photograph, *c*. 1935.

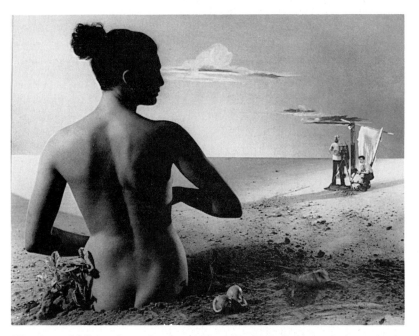

182 Angus McBean. Surrealist composition including self-portrait, 1949.

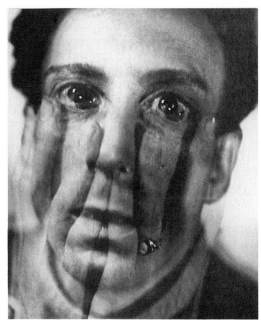

184 Winifred Casson. 'Accident', *c*. 1935.

90

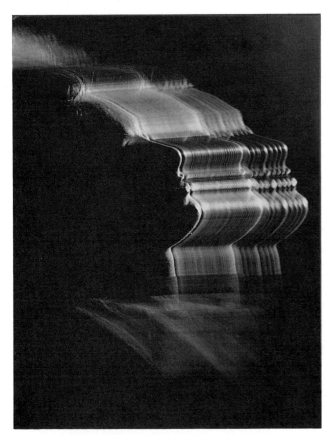

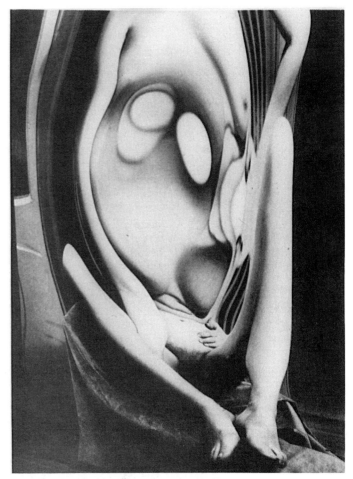

185 Erwin Blumenfeld. Profile in motion, 1942.

186 André Kertész. Distortion study, 1934 (reproduction).

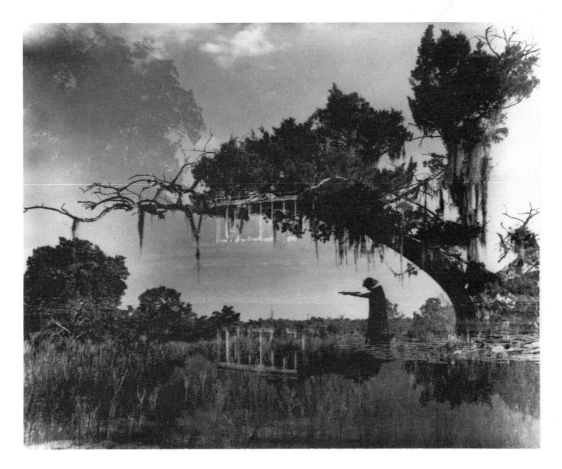

187 Clarence J. Laughlin. 'Elegy for Moss Land', 1947.

New Objectivity

Of more lasting importance in the evolution of modern photography and in direct contrast to the extremely subjective *Bauhaus* experimentation was the simultaneous New Objectivity movement pioneered by Albert Renger-Patzsch. *Neue Sachlichkeit* was a term coined in 1925 by Gustav Hartlaub, Director of the Mannheim Kunsthalle, to denote the style of several German neo-realist painters. Later it was also applied to the new realism which found expression in photography and the cinema.

Fascinated by the beauty of everyday things, Renger-Patzsch from 1922 onward made close-ups of natural and man-made objects, isolating the subject from its surroundings and recording it with the utmost realism and textural detail. Renger-Patzsch's book *Die Welt ist schön* (1928) is an eloquent proof of his contention that the aesthetic value of a photograph lies just in these specifically photographic qualities [*Ill. 188*].

Like all movements, New Objectivity was not without forerunners. The same idea had already occurred to Eugène Atget, who made extended series of close-ups of flowers and trees [*Ill. 189*] as well as many architectural details; and to Edward Steichen, whose autobiography includes a number of photographs in this style: a lotus flower, a frog in a lily-pond, and above all some stacked flower-pots, all of which antedate *Neue Sachlichkeit* by several years.

Renger-Patzsch's straightforward photographs came as a revelation. 'Let us leave art to artists,' he wrote, 'and let us try by means of photography to create photographs that can stand alone on account of their photographic quality—without borrowing from art.' Quite independently he had arrived at the same conception as Paul Strand.

Neue Sachlichkeit was a reaction against sentimentality, romanticism, picturesqueness, flattery in portraiture, and falsification of any kind. Pictorialism was left to the photographic Salons, prettiness and beauty in the conventional sense belonged to the picture postcard, and abstract designs for their own sake, to graphic art. The photographer at last began to recognize and pursue again the unique characteristic qualities of his medium with its almost unlimited possibilities of genuine expression. He was able, as William Blake wrote,

> To see a world in a grain of sand,
> And a heaven in a wild flower.

In shaping the new vision the influence of the

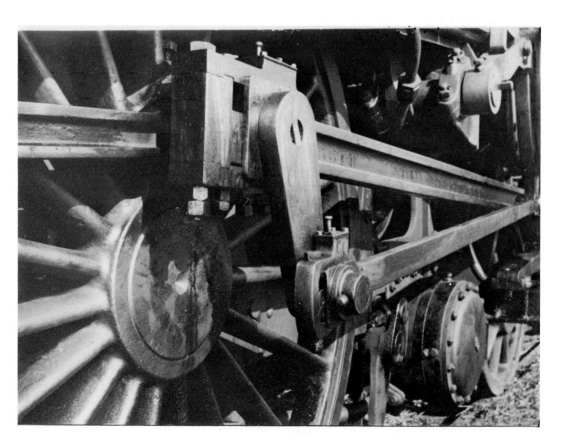

188 Albert Renger-Patzsch. Driving-shaft of a locomotive, 1923.

cinema must not be overlooked. D. W. Griffith in such films as 'Intolerance' (1916) brought for the first time to the screen the emotional close-up. The horrifying realism of Eisenstein's famous Odessa steps sequence in 'Potemkin' (1925) and the close-up in the same film of maggots crawling on the sailors' meat, along with Pabst's film 'The Joyless Street' (1925), not only firmly established realism as a major style in the cinema, but also had a tremendous impact upon still photography.

New Objectivity gathered momentum with Karl Blossfeldt's *Urformen der Kunst* (1928) (Original Forms of Art) and *Wundergarten der Natur* (1932) (Magic Garden of Nature). As professor for modelling plants at the school for handicrafts in Berlin, Blossfeldt had begun taking photographs of plants around 1900, originally to assist him in his work. Gradually, his fascination with the strange forms he discovered in quite common plants led to a conscious striving to accentuate in (25 times) enlarged details their extraordinary likeness to artefacts [*Ill. 190*]. Though of a purely documentary nature, Blossfeldt's photographs are simply breathtaking.

Before long, the close-up and reproduction of texture began to be applied to portraiture. Since the exponents of New Objectivity were interested above all in everyday things, their portraits were naturally of ordinary people, not celebrities. Erna Lendvai-Dircksen, like the German realist painter Wilhelm Leibl before her, dedicated herself for many years to portraying German peasants in their traditional costumes. August Sander's *Antlitz der Zeit* (1929) gave an unflattering portrait of a cross-section of Germany's social structure. 'I hate nothing more than sugared and posed studio photography'—it was by such work that Sander had made his living in Linz (Austria) and Cologne before and after World War I. 'From now on I only want the honest truth about our time and people', he wrote in 1927 of a large work program he had in mind. Failing to find financial backers for this project involving hundreds of pictures to document the German nation region by region, he published the less ambitious *Antlitz der Zeit* (Portrait of an Epoch), a book of only 60 images which aroused more interest after its republication in 1976 than the original had. Belonging to the lower middle class, Sander was limited in his choice of subjects and fell on rather unflattering representatives of each class and profession, so that many of the portrayed come close to caricatures [*Ill. 191*]. This tendency may not have been intentional, yet it is there nevertheless. According to Sander's nephew, in 1934 the Gestapo confiscated all unsold copies at the publisher's because the book offended their image of the Germans.

Helmar Lerski, in *Köpfe des Alltags* (1931), concentrated on everyday faces—beggars, hawkers, industrial workers, and servants—feel-

189 Eugène Atget. Tree roots at St Cloud, *c.* 1910.

190 Karl Blossfeldt. Young fronds of maiden-hair fern, 1928.

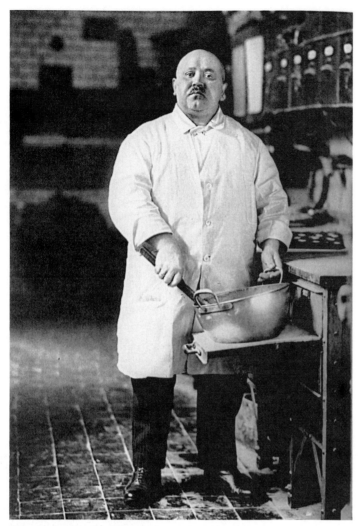

191 August Sander. The pastry-cook, 1928.

192 Helmar Lerski. Metal-worker, 1930.

ing that whereas celebrities often wear a mask and strike a pose before the camera, these unimportant people gave him a chance to make objective character studies [*Ill. 192*]. As was to be expected, isolation from social surroundings, plus film studio lights and close croppings, have robbed the portraits of their identity. The expression of a human being who has been moulded by his background and work has been lost in Lerski's far-from-objective treatment. We look into glamourized faces of classless beings. The metalworker no longer looks like a metalworker, but like a member of the intelligentsia.

The urge for originality current in all the arts in the mid-'twenties made angle-shots, distortions, and novel viewpoints common practice. When used with discretion they could add forcefulness to the expression [*Ill. 193*], increase apparent height [*Ill. 194*], or diminish apparent size. The extraordinary pictures assembled by Werner Graeff in his book *Es kommt der neue Fotograf!* (1929) (The New Photographer Arrives!) form the perfect guide to the new vision, which now began to establish itself firmly in Germany. The classic rules of composition and perspective devised in the Renaissance for painting were now deliberately discarded as photographers at last learned to *see photographically*.

Several German weekly illustrated papers and monthly magazines in the late 'twenties surprised their readers with startling photographs featured under such titles as 'The New Vision', 'The World from Above', 'Under the Magnifying Glass', 'How Our Photographer Saw It', 'The Picture can be Found in the Street', 'Beauties of Every Day', 'Journeys of Discovery with the Camera', etc.

The possibility of publishing their pictures in magazines and books freed photographers from their former dependence on exhibitions for fame. It brought about a much wider division between photographs made for exhibitions—the old art for art's sake—and those intended for publication, which were concerned with life and reality, photography's proper domain.

Some excellent photomontages were produced in Germany in the late 'twenties and early 'thirties by Hannah Höch, Herbert Bayer, Otto Umbehr [*Ill. 195*], and above all John Heartfield, a pseudonym for Helmut Herzfelde. Having produced some Dadaistic collages in collaboration with the social satirist George Grosz, Heartfield designed some very eye-catching book jackets [*Ill. 196*], mainly but not exclusively for the leftist Malik Verlag in Berlin which he and his brother had founded in 1917. Many were produced by the photomontage method, of which he considered himself the inventor—though photomontage had in fact been practised in Victorian photography. The strength and novel application of Heartfield's work lay in its use as an effective means of propaganda in the service of the working class and political anti-Nazi doctrine. From 1929 to 1938 he produced a weekly

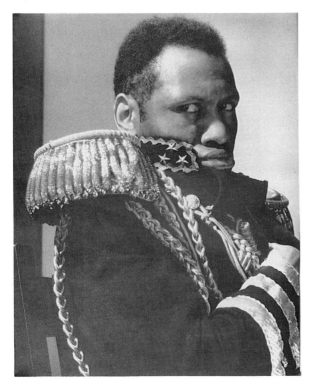

193 Edward Steichen. Paul Robeson as The Emperor Jones, 1933.

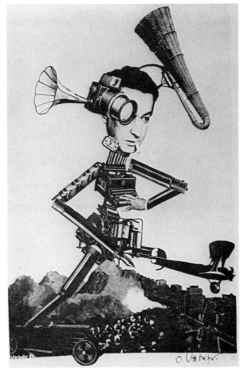

195 Otto Umbehr (Umbo). Photomontage, 1926, depicting Egon Erwin Kisch as a roving reporter (see page 114).

194 Albert Renger-Patzsch. Tower of the Hofkirche in Dresden, 1923.

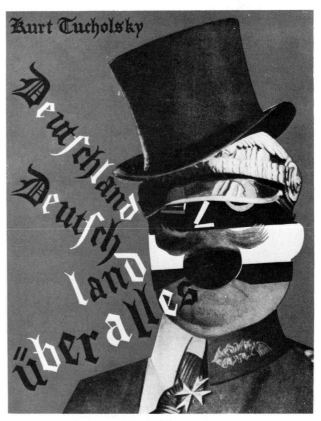

196 John Heartfield. Photomontage for a Tucholsky book cover, *Deutschland, Deutschland über Alles*, 1929.

197 John Heartfield. Photomontage, 'We worship the power of the bomb', 1934.

198 Cover of *USSR in Construction*, July 1936.

199 Walter Hege. Ionic capital from the entrance to the Propylaea, 1929.

photomontage for the *Arbeiter Illustrierte Zeitung*, printed in Berlin until the Nazi rise to power in 1933 and continuing in Prague until December 1938. These brilliantly graphic designs are usually cunning expositions of Nazi lies [*Ill. 197*].

Propaganda of a different kind was served by *USSR in Construction*, a highly sophisticated picture magazine with an *avant-garde* layout, edited from 1930 to the outbreak of World War II by Maxim Gorki, Michael Kolzow, and others [*Ill. 198*]. This monthly folio magazine was published in Moscow in English, French, German, and Spanish and recorded Soviet achievements in industry, building, and agriculture. Particularly outstanding in layout and photography are the issues designed by El Lissitzky and Alexander M. Rodchenko in 1933–36, making use of photomontages, cut-outs, and fold-out pages as well as several printing colors. Each issue was devoted to one main subject, such as 'White Sea Canal in Construction', 'Kazakhstan', 'Mayakowsky'. The work of Rodchenko, the most gifted of Russian photographers between the two World Wars, was banished for many years under Stalin as being too newfangled and has been seen in the West only in the last ten years.

Germany, which had played no role in the development of artistic photography until late in the nineteenth century, found herself suddenly leading Europe, and with no hampering tradition, progress was rapid. Walter Hege's photographs in the 1930s of German cathedrals, the Athenian Acropolis [*Ill. 199*], and Olympia, in-

spired later contributions in the fields of architecture and sculpture. Kurt Hielscher, Martin Hürlimann, and E. O. Hoppé [*Ill. 200*] produced for the *Orbis Terrarum* series photographic books on foreign countries which were a model for present-day publications. Other leading photographers who spread the new style beyond the borders of Germany were Adolf Lazi, Willi Zielke, and Herbert Bayer, who until 1928 was head of the typography department at the *Bauhaus* before settling in the U.S.A.

Inspired by some photographs of Marseilles by Siegfried Giedion in 1927, and having retired from the *Bauhaus*, Bayer took up photography as an adjunct to design the following year. He was soon dissatisfied with the mere reproduction of reality, creating instead dreamlike, irrational photomontages in which several layers of reality are in surrealist juxtaposition. 'Einsamer Großstädter' ('Lonely Big-City Dweller') of 1932 [*Ill. 201*] is probably Bayer's most famous photomontage. The photographer's hands stretching out from his jacket sleeves are superimposed on an apartment facade, and his eyes peer out from the open palms. This idea had been used many years previously by the Russian designer El Lissitzky in his self-portrait (1914), and now served as a cover design for Franz Roh's book *Foto-Auge* containing images of the Deutscher Werkbund exhibition *Film & Foto* held in Stuttgart, 1929. Reality and imagination have been united in a visionary expression of great power. Visual communication and the integration of photography with other media, particularly in advertising, received many impulses from Bayer's *avant-garde* work.

The *Film & Foto* exhibition was the largest assembly of photographs from many countries ever brought together. There were about one thousand works by German, Austrian, Swiss, Dutch, French, American, and Russian photographers and designers whose style was akin to the *Neue Sachlichkeit* or fell under the heading documentation. At the request of Gustaf Stotz, Werner Graeff had prepared a list of photographers and designers to be invited and it must have been his oversight that a prominent figure was not represented in the exhibition: August Sander. His book *Es kommt der neue Fotograf!* was likewise prepared by him for the opening of the exhibition to drive home the message: 'Break with outdated traditions and rules, see photographically.' The selection of the American section had been entrusted to the combined efforts of Edward Steichen and Edward Weston.

Hugo Erfurth, though adhering to the manipulated gum and oil pigment print, depicted the German intelligentsia in the 1920s with a depth of understanding and artistic conception [*Ill. 202*] equalled by South African-born Howard Coster, who settled in London in 1925, in his portraits of the English intelligentsia [*Ill. 203*].

The only country outside Germany where New Objectivity found immediate acceptance

200 E. O. Hoppé. Brooklyn Bridge, 1919.

201 Herbert Bayer. Einsamer Großstädter (Lonely Big-City Dweller), 1932.

was Switzerland, in the works of such photographers as Hans Finsler and Herbert Matter. Perhaps it was natural that the new factual style should appeal to a nation noted for clockwork precision and down-to-earth exactitude, and be considered unpoetic in England and France.

Finsler was one of the most influential propagators of the *Neue Sachlichkeit*, first as a teacher at the arts and crafts school in Halle, and from 1933 on at a similar school in Zurich. At the latter, his most prominent pupils were Emil

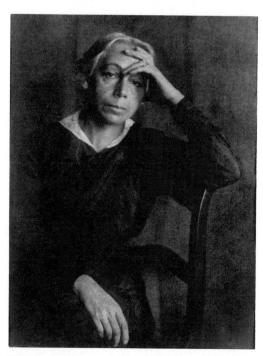

202 Hugo Erfurth. Käthe Kollwitz. Oil pigment print, *c*. 1925.

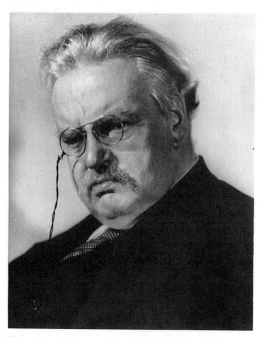

203 Howard Coster. G. K. Chesterton, 1928.

Schulthess and Werner Bischof, whose early work is an echo of Finsler's precise and factual way of rendering objects. It was only under the influence of his second mentor, Arnold Kübler, editor of the *Schweizer Illustrierte* until its demise in February 1941 and afterwards founder-editor of the new art magazine *Du*, that Bischof discovered his true expression in reportage.

In the United States new realism began independently of German influence with a small number of photographers, of whom Edward Steichen, Paul Strand, and Edward Weston are the best known. Steichen's early work in this style has already been referred to. Strand began in 1926 to take close-up photographs of machinery, plants, and rock formations. Weston was a Salon romantic until, during three years' residence in Mexico, the stimulating influence of his mistress, Tina Modotti, resulted in a complete change of style. In September 1925 Weston exhibited his first sharp objective landscape photographs and portraits, and after returning to California in 1927 embarked on close-ups of unusual natural forms for which he later became justifiably famous. Whether it were a sweet pepper [*Ill. 204*], an eroded rock forming an abstract pattern, or Californian sand dunes, he rendered every subject with its surface texture strongly emphasized. The contributions of Edward Weston and his son Brett; Edward Steichen; Imogen Cunningham; Berenice Abbott, a pupil of Man Ray; and the realist painter-photographer Charles Sheeler made a deep impression at the important International Film & Photo Exhibition in Stuttgart in 1929. About a year later Ansel Adams, stimulated by the work of his teacher and friend Edward Weston, began to devote himself to similar subject matter [*Ill. 205*], before turning to the grand landscapes of the Yosemite Valley and other American National Parks, for which he is today chiefly celebrated.

This American group did not abandon their 10 × 8 inch plate cameras in favour of the miniature cameras introduced in the 'twenties, because they considered superlative technique just as essential as imaginative vision. In 1932 Willard van Dyke, a cinematographer, formed the F64 Group with a few other like-minded photographers, including the Westons and Imogen Cunningham. They used the smallest diaphragm opening on their lens in order to obtain the greatest possible depth and sharpness from foreground to background, rarely making larger prints than contact copies. This was a return to the practice of the pioneer landscape photographers three-quarters of a century earlier, except that they had usually worked with much larger plates.

Inspired by the Westons and Adams [*Ill. 206*], there are today in America a number of dedicated nature photographers—Wynn Bullock, William Garnett, Eliot Porter, and Cedric Wright—whose brilliant work has appeared in

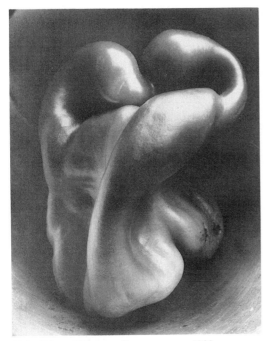

204 Edward Weston. Sweet pepper, 1930.

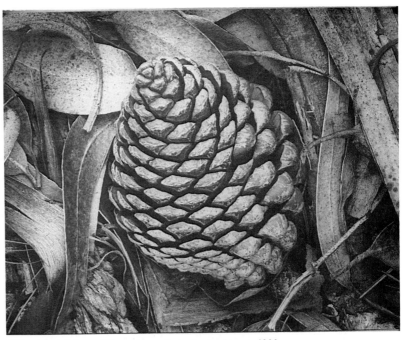

205 Ansel Adams. Pine-cone and eucalyptus leaves, 1933.

This Is the American Earth (1960) by Nancy Newhall and other fine publications sponsored by the Sierra Club in San Francisco.

Mention must also be made in this connection of the originators of New Objectivity who continued this trend in later publications and published a number of books containing superb photographs: Paul Strand on Mexico (1940), New England (1950), France (1952), and the Hebrides (1963); Renger-Patzsch on the Ruhr and Möhne landscape (1958), trees (*Im Wald*, 1965), and stones (*Gestein*, 1966).

After studying art history and photography in his hometown, Munich, the author of the present book settled in London in 1937 as a colour photographer. When he tried to propagate New Objectivity in Britain, his book *New Photo Vision* (1942) [*Ill. 207*] met with the same kind of hostile reception from the old guard as *Die Welt ist schön* had previously. For many years the new style found little favour outside advertising [*Ill. 208*], despite the excellent annuals *Modern Photography* and the books of Ansel Adams and the Viennese Wolfgang Suschitzky, all published by *The Studio*. Suschitzky applied the modern realistic style to close-ups of animals [*Ill. 209*] and children in a way that had not been attempted before. During World War II the author brought the same approach to the architecture and sculpture of historic monuments. By isolating and lighting he intensified individual motifs and brought out significant details which in some cases would otherwise have remained unnoticed by the casual observer, since they were often in obscure positions.

Andreas Feininger, who left Germany in the mid-'thirties about the same time as the author, was staff photographer of *Life* for over twenty years, specializing in subjects calling for an intellectual rather than an emotional approach. An architect by training, Feininger's analytical searching eye discovered many new vistas in American landscape and townscape [*Ill. 210*] in *The Face of New York* (1955) and fantastic forms in *The Anatomy of Nature* (1956).

Viennese Lisette Model, who emigrated with

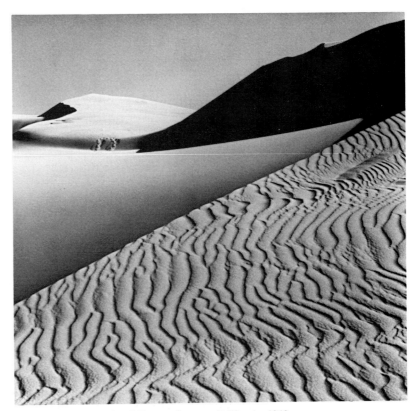

206 Ansel Adams. Sand Dunes, Oceano, California, 1962.

207 Helmut Gernsheim. Section through a cucumber, 1935.

208 Helmut Gernsheim. Design for a poster, 1935. Not a photomontage: effect was achieved by sandwiching two negatives in the enlarger.

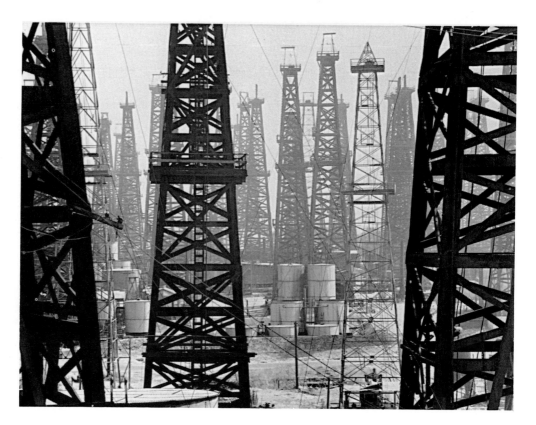

210 Andreas Feininger. Oil derricks, Signal Hill, California.

209 Wolfgang Suschitzky. Two camels, 1938.

211 Eric de Maré. Brighton Pavilion, 1969.

her Jewish painter husband to the U.S., is one of the numerous self-taught photographers whose originality of vision made an outstanding contribution to the art. Her 1937 snapshots of holiday makers bathing or sunning themselves on the Promenade des Anglais in Nice have the uninhibited naturalness of the amateur. Model passed her predilection for human oddities on to one of her pupils, Diane Arbus.

Eric de Maré is an English architect, photographer, and writer, occasionally combining all three professions. In his amazing close-up of Brighton Pavilion [*Ill. 211*] he shows the spirit of John Nash's orientalizing Regency architecture of domes, minarets, and battlements at its most exuberant.

Today good straightforward photography in the New Objectivity style is the normal standard, apart from the diehard pictorialists whose banal anachronisms still clutter the London Salon, the annual exhibitions of the Royal Photographic Society and of the Photographic Society of America, and indeed a large number of other reactionary clubs and societies. Typical is a proud note in an English exhibition catalogue as recent as 1960: 'Viewers will be able to see the continuing tradition of pictorial photography, which continues largely unruffled by modern movements. This conservatism with variations is one of the strengths of the photographic society exhibitions and one of the facets that is periodically attacked by graphic artists and fine art critics.'!

Contemporary Portraiture

The greatest contemporary representative of portraiture in the classic tradition is Armenianborn Yousuf Karsh, whose name will for ever remain associated with the image he created of Sir Winston Churchill [*Ill. 212*]—the most characteristic portrait expressing the bulldog determination of the great wartime leader. No other artist succeeded so well in catching the forcefulness of Eleanor Roosevelt, the impish, quizzical expression of G. B. Shaw, or the *Weltschmerz* of Albert Einstein. These and many other 'Faces of Destiny' photographed by

212 Yousuf Karsh. Sir Winston Churchill, 1941.

Karsh during the war for the Canadian Government make a strong case for an International Photographic Portrait Gallery. Smaller fry do not stand up to the same heroic treatment, though their portraits too are unmistakably stamped with Karsh's personality.

Like the portrait painter, the studio photographer aims at obtaining in one static picture the most characteristic expression, combining various aspects of the sitter's personality. The reportage photographer, on the other hand, will record a number of fleeting expressions in a set of pictures forming a kind of serial portrait. The reportage style of portraiture, pioneered by Nadar father and son in 1886 and re-introduced by Felix H. Man in 1929, has today become modified inasmuch as the photographer finally selects for use only one or two out of the great number taken. For a picture story on a well-known person, readers of a magazine would rather see the subject in a variety of places and activities than merely expressions and gestures recorded during one conversation with an interviewer. Progressive portrait photographers, aware that the sitter is more at ease in his usual surroundings, practise what used to be called At Home photography, except that nowadays the term also covers place of business, a film or TV studio, concert hall, club, and so on. Outstanding environmental portraits of great men of our time have been taken by the American Arnold Newman [*Ill. 213*], by Ida Kar [*Ill. 214*], and by Erich Auerbach, the latter specializing in musicians. Brian Seed's clever study of Patrick Heron [*Ill. 215*] focusses attention in a very original way

213 Arnold Newman. Igor Stravinsky, 1946.

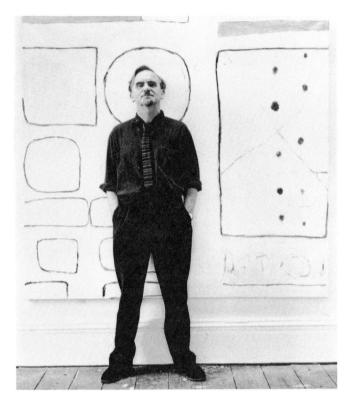

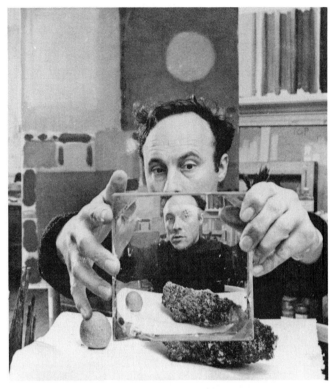

214 Ida Kar. William Scott, 1961.

215 Brian Seed. Patrick Heron, 1959.

upon the abstract painter on the occasion of an award.

Latvian-born Philippe Halsman, with over 100 *Life* cover pictures to his credit, has produced some immortal portraits displaying great originality and liveliness. To Halsman, a portrait is above all a human document, and he sees his greatest reward when one of his portraits becomes the definitive image of some famous person. History will remember Einstein as Halsman saw him [*Ill. 216*]. This and two other Halsman portraits were immortalized by U.S. postage stamps without acknowledgement to the artist. Whereas his *Jump Book* of famous people strikes one as hardly more than a gimmick, 'Dali Atomicus' [*Ill. 217*] started as a stunt and became one of the greatest photographs of the twentieth century. The carefully rehearsed action shot was based on an idea of the Spanish Surrealist, and every detail fits perfectly into place.

Living with Pablo Picasso for several months enabled David Douglas Duncan to build up a great composite portrait—the best documentation that has so far been produced on the private life of a great figure. *The Private World of Pablo Picasso* (1958) has that air of intimacy which only familiarity can give. Despite his flair for acting, Picasso refrained from playing to the gallery.

Irving Penn and Richard Avedon are America's leading fashion magazine photographers today. They have created a contemporary style for *Vogue* and *Harper's Bazaar* respectively, as distinctive as Edward Steichen's for *Vanity Fair* in the 1920s and '30s, and Cecil Beaton's for *Vogue*

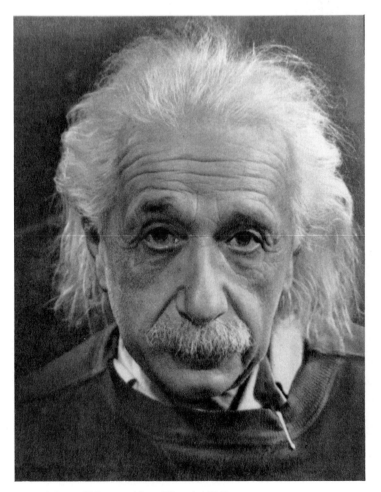

216 Philippe Halsman. Albert Einstein, 1948.

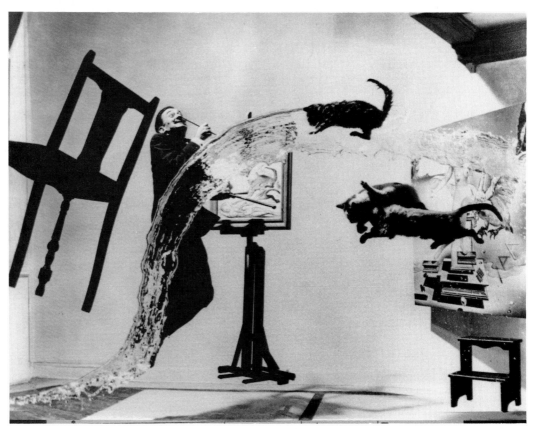

217 Philippe Halsman. 'Dali Atomicus', 1948.

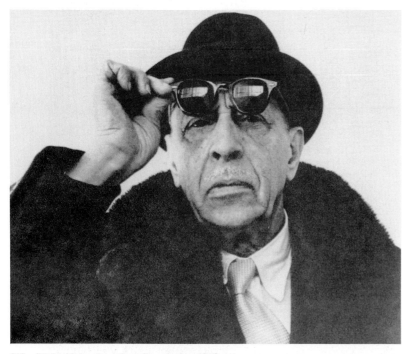

218 Richard Avedon. Igor Stravinsky, 1958.

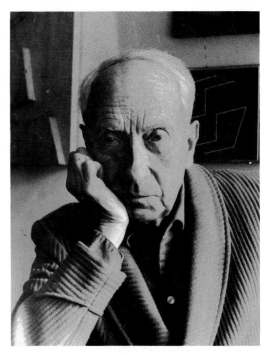

219 Gertrude Fehr. Hans Arp, 1965.

in the '30s and '40s. *Observations* (1959) and *Moments Preserved* (1960) show better than words can describe the quality which gives their fashion photographs that new look, and makes their colour advertisements so eye-catching. Economy of means, unusual viewpoints and a strong black-and-white effect create a sense of monumentality in Penn's portraits of Picasso and Marlene Dietrich. The same strength emerges from Avedon's Stravinsky [*Ill. 218*]. Occasionally, however, when the sitter has to play-act a part assigned to him, he is reduced to an insignificant figure on the photographer's stage.

This feeling is completely absent from the portraits of Wilhelm Maywald, Giselle Freund, and Gertrude Fehr [*Ill. 219*], three German-born artists who settled in France after Hitler's rise to power in 1933. Walde Huth-Schmölz, fashion photographer for the magazine of the *Frankfurter Allgemeine Zeitung* in the mid-'fifties, created some very fine—and then still fairly novel—outdoor fashion pictures of French haute couture in Paris [*Ill. 220*]. Her husband, Karl-Hugo Schmölz, a leading German advertising photographer, sometimes applies the same natural outdoor atmosphere with great effect to items normally seen in interiors [*Colour Ill. xxiv*].

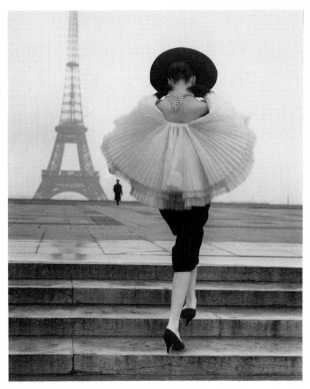

220 Walde Huth-Schmölz. Elegance, Paris, 1955.

Fotoform

Since much of the *avant-garde* art of the *Bauhaus* was stigmatized by the Nazis as degenerate, it was closed down when Hitler came to power. Walter Gropius and Moholy-Nagy had already left in 1928. To the post-war generation in Germany most of the *Bauhaus* teaching was a sealed book.

In the wave of non-representational art which swept the world after World War II Kandinsky, Klee, and Feininger, who had made the *Bauhaus* the spearhead of abstract art, were international idols. It is not surprising, therefore, that in the spirit of the times Prof. Otto Steinert, teacher at and later director of the State Art & Craft School in Saarbrücken, considered the moment opportune to revive the entire range of photographic image-making evolved by Moholy-Nagy. Under the name 'Fotoform', and with a good deal of drum-beating from art critics (one of whom, with more sense for dramatic statements than for facts, had the bad taste to compare the impact of the first Fotoform exhibition (1950) to 'an atom bomb in the dungheap of German photography'), photographs with a graphic design or abstract pattern became the rage in Germany. Some photographers discovered that nature abounded with abstract patterns if you started looking for them. Toni Schneiders' air bubble formation in ice [*Ill. 221*] and Peter Keetman's

221 Toni Schneiders. Air bubbles in ice, 1953.

222 Peter Keetman. Oil drops, 1956.

223 Peter Keetman. Pipes, 1958.

224 Peter Keetman. Oscillations, 1950.

oil drops [*Ill. 222*] and pipes [*Ill. 223*] are excellent examples. Keetman made a variety of aesthetically satisfying oscillation photographs [*Ill. 224*], unaware that the first designs made with a swinging light source had been produced as early as 1904 by C. E. Benham and published in the January 1905 issue of *The Photogram*, London. The 'Luminograph', originally introduced for time-and-motion study of factory workers, led Gjon Mili to ask Picasso to draw for him a light picture in the air. Less original, but sometimes more fantastic, were the light patterns traced by the headlights of motor cars on photographic film and the helicopter spiral [*Ill. 225*] by Andreas Feininger.

However, more often than not abstractions and graphic designs were only conceived in the darkroom, and it was in the nature of things that the desired *graphic* effect usually necessitated the suppression of the specifically *photographic* qualities in order to render the subject of the photograph meaningless. Extremists seemed to feel the same urge to 'free themselves from photography', as some of the *art nouveau* gumsplodgers had done. The quest for originality frequently led to cultivation of what had formerly been rejected as technically faulty, transforming the normal image quite surprisingly: over-enlargement of a small part of a negative, coarse grain, blurred outlines, camera-shake, double images, exaggerated contrast, and reticulation. Man Ray in his self-portrait obtained

a graphic effect by printing from a zincographic plate [*Ill. 226*]. As the metamorphosis was caused by optical or chemical methods it constituted a legitimate broadening of photographic image-making. Nevertheless, Fotoform was far too narrow a conception of photography, and fully aware of the dangers of a *cul-de-sac* Steinert, himself a distinguished photographer of great originality [*Ill. 227, 228*], in 1951 widened the scope to Subjective Photography— meaning any creatively-guided picture-making, including reportage. 'Subjective' gave pre-eminence to the personal expression or interpretation by the photographer in contradistinction to the pre-eminence of the object in *Neue Sachlichkeit*.

Steinert's revolutionary exhibitions of Subjective Photography, and two books based on them, propagated the new style, which found particularly receptive ground in Sweden and Japan, countries traditionally strong in design but before 1950 practically non-existent in the field of creative photography. Lennart Olson, Caroline and Hans Hammarskiöld [*Ills. 229, 230*], George Oddner, Rolf Winquist [*Ill. 231*], and others who have won international recognition both individually and as the Tio Group, owe their creative impulse largely to Fotoform. Most profound was its influence on modern textile design: curtain material, table cloths, and wallpaper design.

Though some *Neue Sachlichkeit* photographs

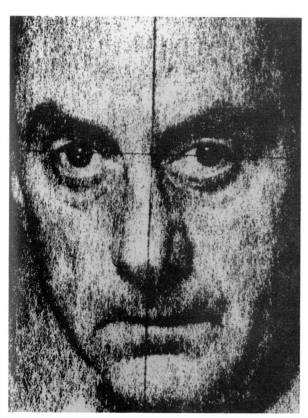

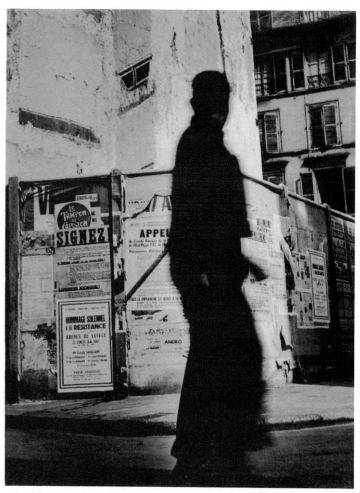

226 Man Ray. Self-portrait, 1948. Photo-zincograph.

227 Otto Steinert. Call-up notice, Paris, 1950.

228 Otto Steinert. Interchangeable forms (negative montage), 1955.

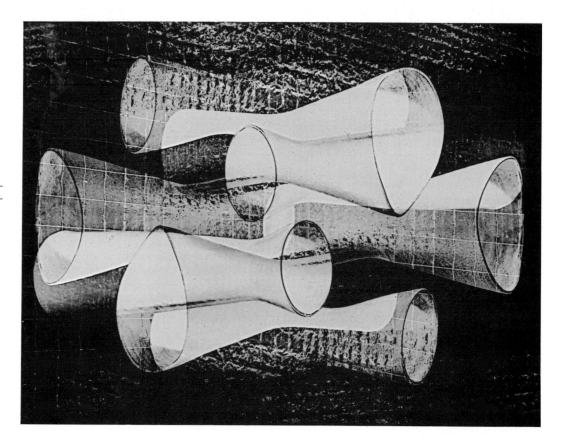

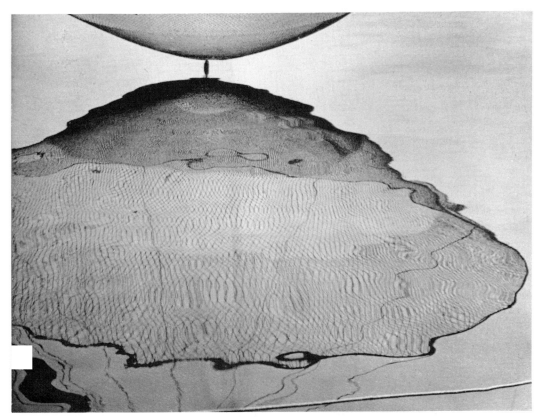

229 Caroline Hammar-skiöld. Fishing-net, 1950.

231 Rolf Winquist. Gertrude Fridh as Medea, 1951.

230 Hans Hammarskiöld. Section through tree, 1951.

232 Clarence J. Laughlin. Window, 1963.

233 Hans Hammarskiöld. Bark of a tree, 1952.

could also be classified as Fotoform, the different approach of the two styles can be demonstrated by a comparison of the author's cross-section through a cucumber [*Ill. 207*] with Hans Hammarskiöld's cross-section through a tree [*Ill. 230*]. Whilst the former wanted to intensify the reality with all possible tone gradation, the latter intentionally destroyed the half-tone in order to obtain a graphic design transcending the reality of the object. Subjects never failing to mystify the viewer are cracked windows [*Ill. 232*], fissured tree bark [*Ill. 233*], cracked paint [*Ill. 234*], and torn paper [*Colour Ill. xxiii*]. Sir George Pollock finds an infinite variety of abstract designs in the surface irregularities of lumps of waste glass and their interior flaws, according to the angle at which the lump is held, the part of it chosen for an extreme close-up, and the direction of the light. By watching the play of multiple reflections and composing them into attractive patterns, and with the use of coloured filters, Pollock creates in his 'Vitrographs' a mysterious universe aglow with colour and stimulating to the imagination. Some pictures seem to give a glimpse of a submarine world [*Colour Ill. xii*], others of outer space, a volcanic eruption, and so on. In this abstract expressionism it is left to the observer to give the pictures his own interpretation.

Raymond Moore, on the other hand, creates abstract photographs in the spirit of *Neue Sachlichkeit* by taking extreme close-ups of decayed houses and of rock formations of the Welsh coast [*Colour Ill. xiii*], to which he returns annually just as Edward Weston never exhausted his favourite subjects, rocks on Point Lobos and the sand dunes of Oceano. Both Edward and his son Brett were among the first to be captivated by the expressiveness and wonderful forms they found on their explorations of nature. However, their pictures are less closely related to the current trend in painting than those of a number of other American photographers in this field, foremost among them Aaron Siskind [*Ill. 235*] and Harry Callahan, who for many years jointly directed the photographic department of the Illinois Institute of Design (the New Bauhaus). Quite a different abstraction, depending purely on form, is given by Callahan's silhouette [*Ill. 236*] and Bill Brandt's strange study from *Perspective of Nudes* (1961) [*Ill. 237*]. Very interesting patterns are sometimes also the by-product of scientific investigations as in Prof. Schardin's photograph of the temperature distribution around a heated metal tube [*Ill. 238*].

Henry Holmes Smith has used the multiple-colour dye-transfer process for creating abstract forms in colour. Herbert W. Franke in *Kunst und Konstruktion* (1957) lists a great many techniques from X-rays to ultralight.

Influenced by Otto Steinert, Robert Häusser, one of the leading contemporary German photographers, places great stress on the graphic design of his work, as in 'Signaled Order' [*Ill.*

234 Brett Weston. Cracked paint, 1954.

235 Aaron Siskind. Wall pattern, 1960.

236 Harry Callahan. Eleanor, 1948.

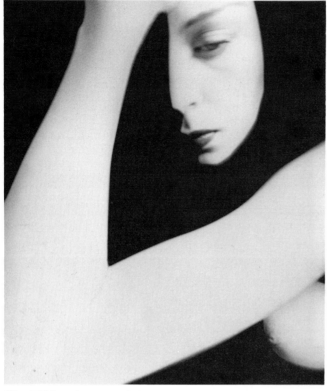

239]. In more recent photographs distortions of reality, both by optical and chemical means, to achieve abstraction has led to a form of abstract expressionism.

Several experimenters including the Welsh photographer Norman Tudgay [*Ill. 240*] and the German Heinz Hajek-Halke, have reverted, with modifications, to the *cliché-verre* process which goes back to 1839. In this, the photographic part consists solely in copying on to sensitive paper a design scratched or painted on a coated glass plate. Some of the light-drawings of the Hungarian teacher of design Gyorgy Kepes [*Ill. 241*]—co-founder with Moholy-Nagy of the New Bauhaus in Chicago in 1937—also fall into this group. Indeed, many so-called innovations in photography are ancient: light-drawing, photomontage, *cliché-verre*, oscillation photographs, solarization and other techniques have been re-invented from time to time simply because people forgot, or perhaps never knew, what had been done before. It is a common failure to ignore the past instead of learning from it.

237 Bill Brandt. Nude, 1958.

239 Robert Häusser. 'Signaled Order', 1960.

238 Prof. Hubert Schardin. Temperature distribution around a heated metal tube, *c*. 1950.

240 Norman Tudgay. 'Cliché-verre', 1955.

Reportage

No other medium can bring life and reality so close as does photography, and it is in the fields of reportage and documentation that photography's most important contribution lies in modern times. The reportage photographer makes us eye-witnesses of events as they happen, and forces us to realize, with a power never before contemplated, the strife and life, the hope and despair, the humanity and inhumanity, of the world in which we find ourselves participants whether we like it or not.

With modern techniques of transmission, photography as a communications medium has gained immeasurably in importance. Pictures of the assassination of President Kennedy were on the front page of every important daily newspaper throughout the world the next day. The modern world takes in its stride photo-telegraphy, television, Telstar, and pictures of the moon automatically taken and radioed to earth from a distance of 240,000 miles. A surprising circumstance in this revolutionary development of communications is that it is only eighty-odd years since the first newspaper in the world illustrated exclusively with photographs, *The Daily Mirror* (London), made its appearance (November 1903). Indeed it was only in June 1919 that the New York tabloid *The Illustrated Daily News* followed suit, thirty-nine years after the feasibility of printing a half-tone block alongside type had been satisfactorily demonstrated by

241 Gyorgy Kepes. Light-drawing, 1950.

Stephen H. Horgan in *The New York Daily Graphic*. Even during the early twentieth century practically the only outlet the news photographer had for pictures of events, and complete reportages of occasions such as Queen Victoria's funeral and Edward VII's coronation, was the sale of postcards.

During World War I photographers were for

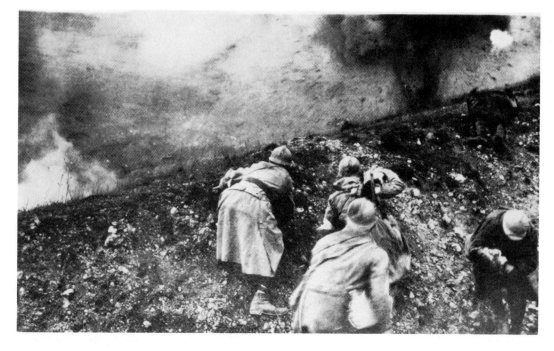

242 French machine gun detachment under fire at Helly during World War I, 1918.

the first time officially attached to the armed forces, and some action shots under fire comparable with those of World War II were taken [*Ill. 242*]. Yet comparatively few of them were published in the press, and to satisfy the growing demand, sets of official war photographs were released to the public in the 1920s in England, France, and Germany in the form of stereoscopic slides and published albums.

Newspapers were incredibly slow to adapt themselves to the photo-age. Although numerous excellent photographs of historic events had been made in the nineteenth and early twentieth century, photo-reportage in the modern sense began only in the late 'twenties [*Ill. 243*] with the introduction of the Ermanox camera and ultra-rapid plates. This new equipment made it possible to seize fleeting expressions and movements, and even to take indoor photographs in poor lighting conditions. It was, nevertheless, a rather exaggerated claim of the manufacturer of the Ermanox camera to advertise: 'What you see you can photograph'. According to Hugo von Hofmannsthal, Dr. Hans Böhm working with this camera from a box in the Josephstadt Theatre in Vienna recorded for the first time the expressions and gestures of actors during actual performances in Max Reinhardt's first season 1924–25. His success decided the former research chemist to become a professional stage photographer.

In 1925, a few years before picture stories for the illustrated press became the vogue, Egon Erwin Kisch, a well-known journalist, published a collection of short stories under the sensational title *Der rasende Reporter*, 'rasend' (usually 'furious, raving') in this case meaning 'constantly on the move'. Writing in the objective, factual spirit of the time, the author explains that 'his reports are free from any tendency. He takes no sides. He has no point of view. He is an impartial witness, his evidence free from bias, accurate and reliable.' He compares his stories to 'slow-motion pictures, taken at different times of his life and under the most diverse circumstances. Position and light were never the same, yet nothing was touched up for the presentation of this collection. Unmoved by the effect of the moment, only the wish for objective representation, for the truth, remains.' Thus the reporter's intention was analogous to that of the modern reportage photographer's a few years later. (Kisch is the subject of Otto Umbehr's photomontage, *Ill. 195*.)

The new technical facilities led in the period 1928–31 to modern photo-journalism—a preoccupation with human situations [*Ill. 244*]. The

243 The revolt of the masses. 'Red Thursday' demonstration in Paris, 1925.

fathers of modern photo-reportage are Dr Erich Salomon, Felix H. Man, Wolfgang Weber, André Kertész, and Brassaï (Gyula Halész).

Salomon started as a free-lance photo-reporter in February 1928 after the sensational success of his photographs of a Coburg murder trial taken secretly with an Ermanox concealed in an attaché case. In fact, a similar 'scoop' had already been made twenty years earlier by an English press photographer, Arthur Barrett, who caught expressive close-ups [*Ill. 245*] of suffragette leaders in the dock at Bow Street Magistrate's Court, London, with a camera hidden in his top hat, in which he had cut a hole for the lens.

Dissatisfied with the traditional static portraits and groups published in the *Berliner Illustrirte Zeitung*, Dr. Salomon astonished the world with his candid snapshots of statesmen and other celebrities in unguarded moments, especially at international political conferences. Aristide Briand called him 'le roi des indiscrets' [*Ill. 246*], for Salomon was as ingenious at getting into secret sessions from which photographers were barred, as was the Chinese who, posing as a special envoy, boldly joined the royal procession at the opening of the Great Exhibition at the Crystal Palace in 1851.

Some of the early reportage photographers took only single pictures for one or another of the many illustrated weeklies which started publication in the mid-'twenties, the editor combining the pictures from various sources into a series.

Foremost among them were the Hungarians Martin Munkacsi, André Kertész, and Brassaï. On the whole the Germans made extensive reportages from a series of related photographs of an event. This group included Heinz von Perckhammer, Wolfgang Weber, Paul Edmund Hahn, von Stwolinski, Willinger, and Felix H. Man (Hans Baumann), as well as the Swiss Walter Bosshard and on occasion the student brothers Georg and Ignaz Gidalowitsch (Tim Gidal)

245 Arthur Barrett. Suffragette leaders in dock at Bow Street, London, on 24th October 1908. Christabel Pankhurst, Mrs Drummond, Mrs Pankhurst.

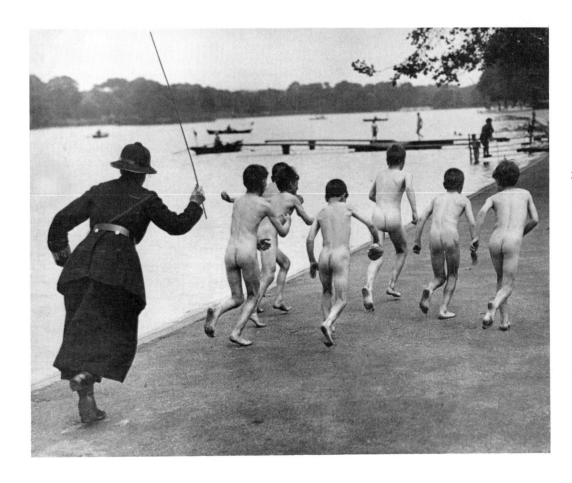

244 James Jarché. At the Serpentine, Hyde Park, London, *c.* 1925.

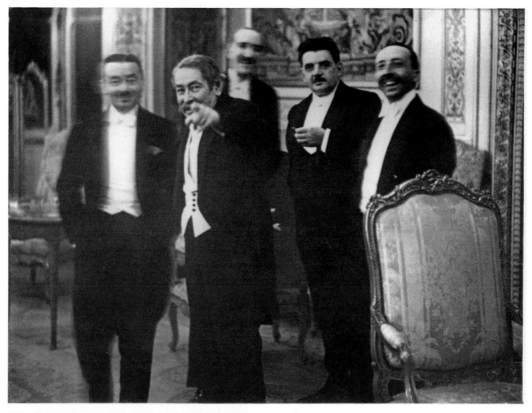

246 Erich Salomon. Aristide Briand pointing at Salomon at a banquet at the Quai d'Orsay in 1931, saying 'Voilà le roi des indiscrets'. On Briand's left is Edouard Herriot.

247 Tim Gidal. Night at Meron, 1935.

[*Ill. 247*]. Surprisingly, Lázsló Moholy-Nagy, usually associated with abstract photography (Photogram), published some very fine picture-stories in the *Münchner Illustrierte Presse* between February and May 1929, such as 'London from Morning till Midnight' (ten pictures) and 'Chamberlain and Baldwin' (four pictures). 'American Hotels' by Wolfgang Weber and Erich Salomon's eight-photo 'The Green and White Table' (Casino) were both published in the *Münchner Illustrierte Presse* in December 1928, six months prior to Man's first picture-story on the 'Women's Congress' (June 1929).

Man was obviously mistaken in considering himself the originator of the picture-story. As early as June 1924 *L'Illustrazione Italiana*, published in Milan, printed a 13-photo story on the State visit of the Italian King Umberto to his Spanish 'brother' Alfonso in Madrid. The issue of 24th July contains seven photos of the socialist uprising in Vienna which had taken place only nine days previously, while that of 4th January 1925 contains nine photos by Felici and Bruni, Rome, of Pope Pius XI opening the Holy Year ten days earlier. All the aforementioned are excellent action photos, although not every issue of the paper has such a rich harvest.

However, Man did undertake the first nocturnal photo-reportage, on the hectic night life of Berlin, 'Life on the Kurfürstendamm between Midnight and Dawn' (1929). The same year he took the first photographs of conductors [*Ill.*

248] and musicians during rehearsal and by available light, sitting in the orchestra with his Ermanox. Salomon was doing the same at a concert in Brussels when he was asked by the Queen of Belgium which instrument he was playing. His reply was, 'I'm playing the camera, Your Majesty.'

Though the *Münchner Illustrierte Presse* had been founded in December 1923, it was only under the editorship of the brilliant Hungarian Stefan Lorant, from September 1928 to March 1933, that it rose to a leading position among German illustrated weeklies, tripling its circulation to three-quarters of a million (compared to the 1.8 million of the long-established *Berliner Illustrirte Zeitung*, which was conservative and oriented toward politics, and used fewer pictures). Lorant, who became the Berlin editor of the *MIP* at age 27, bought or commissioned many picture-stories before becoming editor-in-chief. He also made contact with DEPHOT (Deutscher Photodienst), a photo agency founded in Berlin in December 1928 by Alfred Marx and Simon Guttmann, another Hungarian. DEPHOT was the leading enterprise in photo-journalism until 1933. (There were also other photo-services such as Keystone, Moss, and Ullstein.)

The two principal photographers at DEPHOT were Umbo and Felix H. Man, the former working mainly on the studio and advertising side and the latter as a photo-journalist. In 1930 they were joined by Kurt Hübschmann (later Hutton). Walter Bosshard, Lux Feininger, Harald Lechenperg (who some years later became editor of the *Berliner Illustrirte Zeitung*), and Robert Capa (then still Andrei Friedmann) were all associated with DEPHOT at one time or another. Yet the mainspring of the rapid rise of the new photo-journalism sponsored by DEPHOT was Lorant, with whom Man and Hutton worked in close collaboration in Berlin and later in London. Alfred Eisenstaedt [*Ill. 249*], formerly a salesman, became staff photographer for the Associated Press in Berlin in November 1929 and later for *Life* from the time of its founding.

Stefan Lorant laid down the axiom that the camera should be used like the notebook of a trained reporter, to record events as they occur, without trying to stop them to arrange a picture. This trend in the course of a few years transformed the German illustrated weekly magazines, of which there existed in 1930 no fewer than fifteen: the *Berliner Illustrirte Zeitung* and *Münchner Illustrierte Presse*; followed by the *Kölnische Illustrierte* (the third largest); *Hackebeil*; the *Frankfurter, Hamburger, Stuttgarter,* and *West-deutsche Illustrierte*; *Die Woche*; *Die Wochenschau*; the *Weltspiegel* (the Sunday picture supplement of the *Berliner Tageblatt*); *Zeitbilder* (the Sunday picture supplement of the *Vossische Zeitung*, Berlin); *Die Dame*; *Die Koralle*; and *Beyers für Alle*, Leipzig.

Through DEPHOT and Henry Guttmann, a

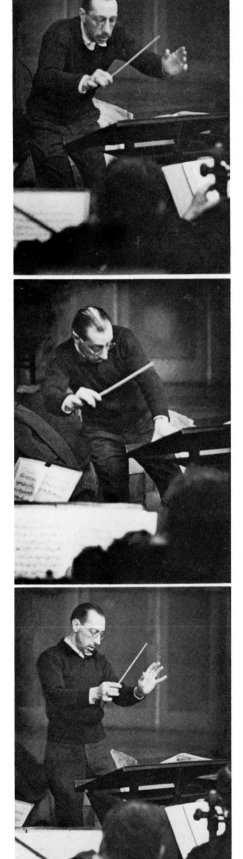

248 Felix H. Man. Igor Stravinsky conducting at a rehearsal, 1929.

249 Alfred Eisenstaedt. Ethiopian soldier, 1935.

gland by Felix H. Man (a later photo of his is seen in *Colour Ill. i*) and Kurt Hutton when Stefan Lorant founded *Weekly Illustrated* in 1934 and four years later *Picture Post*, of which Man and Hutton were leading photographers until 1945. Lorant emigrated to the United States in June 1940, and with his book *Lincoln: His Life in Photographs* (1941) pioneered a new *genre* in book-publishing, the pictorial biography.

From the foregoing it becomes abundantly clear that the oft-repeated claim that photo-reportage originated with *Life* completely lacks foundation. Eisenstaedt, staff photographer on this magazine from its foundation in November 1936, like a number of other *émigré* photographers, merely introduced into the United States a style already current in Germany for several years. Moreover, for the first two years Eisenstaedt and Margaret Bourke-White had to operate with flashlight and tripod in order to satisfy the American concept of a good photograph—pinsharpness. In fact, it was only after the appearance of *Picture Post* on October 1, 1938 that *Life* changed to the modern reportage style.

Eisenstaedt and Bourke-White were among *Life*'s first four staff photographers and remained its most important for most of the magazine's 36 years of existence (*Life* folded in December 1972). They had an inborn flair for instant seeing and shooting and produced countless famous pictures, since republished in several books of their own as well as in *The Best of Life*. During World War II Bourke-White served, at her own request, as a combat photographer on several fronts, displaying incredible courage.

Brassaï [*Ills. 250, 251*] was a struggling artist in Paris when André Kertész, his Hungarian compatriot, introduced him to photography as a means of improving his finances. This was in 1929, when Brassaï was thirty. Four years later his book *Paris de nuit* made the unknown artist famous overnight, his action pictures of nocturnal street life being the best thus far seen. More intimate nocturnal indoor scenes were included in his book *The Secret Paris of the Thirties* (1976). In the intervening years there appeared a number of other picture collections, *Seville*, *Graffiti*, and, above all, *Conversations with Picasso*. In this Brassaï records his many discussions on art and photography with the great painter, in whose studio he lived and for whom he photographed sculpture during the German occupation, thus being one of the few Jews who stayed and survived. (Bidermanas, to be discussed later, was another.) Brassaï's last oeuvre is a compilation of lively portraits and amusing verbal impressions of many leading artists and writers: *The Artists of My Life* (1982) combines the wisdom of others with his own. Using the term 'artist' in its narrowest sense, Brassaï did not include Kertész in this book, but he acknowledged his debt to his friend in an article in *Camera* in 1963.

Kertész had meanwhile produced unforgetta-

journalist in Paris, the German reportage style gradually seeped into the leading French weeklies—such as *Illustration*, *VU* (started by Lucien Vogel in 1928), and *Miroir du Monde*, as well as the *Schweizer Illustrierte* in Zurich and an illustrated paper appearing in Strasbourg—during 1929–32. The following year three DEPHOT-trained Hungarian photographers, Andrei Friedmann and N. and Ina Bandy, began working for *VU*. By this time most reportage photographers had changed over to the Leica or the Contax miniature cameras. In contrast to present-day exposures, a brief flashback to the conditions prevailing in the early 'thirties is revealing. Dr. Salomon's and F. H. Man's indoor photographs were taken both during the day and at night by available light at exposures varying from ¼ second to 7 seconds, the camera mounted on a tripod. Adolf von Blücher at this time took the first action shots of circus performances at night—naturally also with relatively long exposures, carefully waiting for the moment when the movement of acrobats swinging on a trapeze, for instance, was at its dead-point.

The new photo-journalism was brought to En-

xiii Raymond Moore. Rock pool, 1964.

xiv Marta Hoepffner. Glasses with rose. Colour-solarization, 1956.

xv Irm Schoffers. Chapel at Ronchamp. Metacollage, 1972.

xvi Pierre Cordier. Self-portrait. Chimigramme, 1958.

xvii Pierre Cordier. Chimigramme, 1977.

xviii Victor Gianella. Geometrical forms, 1972.

xix Franco Fontana. Landscape, 1968.

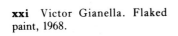

xx Georg Gerster. Wind breaks near Wichita, Kansas, 1964.

xxi Victor Gianella. Flaked paint, 1968.

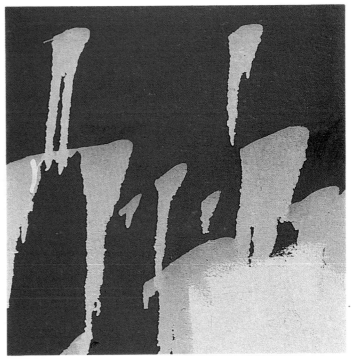

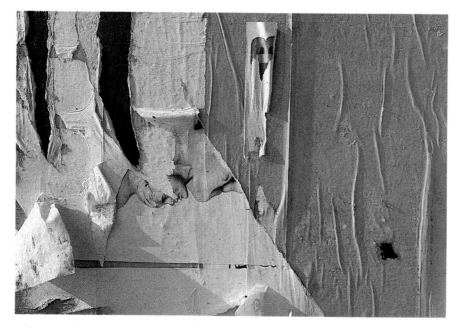

xxii Carol Cohen. Cracked paint, 1971.

xxiii Arno Hammacher. Torn paper on wood, designed by Walter Herdeg as cover of 'Graphis Annual 61/62'.

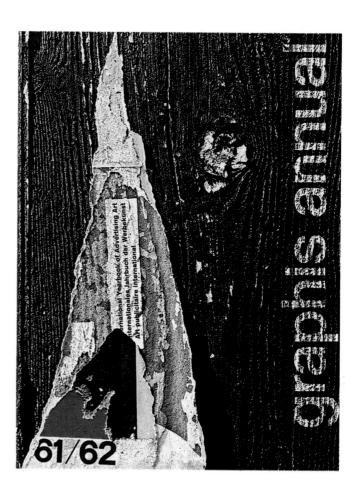

xxiv Karl-Hugo Schmölz. Chairs, 1966.

xxv Unknown photographer. Odalisque with guitar in colour, *c*. 1853.

xxvi Robert Hunt. Leaves and ferns. Photogenic drawing, chromatype, 1843.

ble images of the French capital (*Paris vu*, 1934),
and had photographed both French and foreign
artists and their studios. His images included a
strange series of surrealist nudes in grotesque
attitudes created by distortion mirrors [*Ill. 186*]
(published in book form in 1976) and a satirical
dancer lying on a sofa, bending arms and legs in
different directions to delightful effect. In 1937 a
contract from Keystone enticed him to New
York and artistic isolation. Kertész's work, not
appreciated for 27 years, has attained success
with the publication of a series of books over the
last decade or so. Today it is mainly his pre-war
body of work that museums and collectors appre-
ciate. His American output is small and lacks the
earlier magnetic quality; this probably reflected
his state of mind.

Henri Cartier-Bresson came to photography
via painting, and his countless reportages of peo-
ple in many countries have a classical beauty for
which he is justly celebrated. The two pictures
reproduced here [*Ills. 252, 273*] are superb ex-
amples. Cartier-Bresson coined the phrase 'the
decisive moment', referring to the moment at
which to take a photograph. Every good photog-
rapher over the last 150 years has probably been
aware of this moment, but the vast majority of
amateurs shoot unthinkingly without observing
or waiting for the instant when all the elements of
the picture fall into place. Most of Cartier-
Bresson's books are available in several lan-
guages, but it is his own photographic language
that counts, forming a museum without walls.

Robert Capa's and David Seymour's dramatic
reportages of the Spanish Civil War [*Ills. 253,
264*] gave the world a foretaste of what was to
come if the democratic governments let dictators
have their way. They did. Guernica became
Warsaw, and Warsaw Rotterdam, Coventry,
London. Reportage photography was firmly es-
tablished by the mid-'thirties. Every country in
the Western world had at least one illustrated
weekly, and Germany had more than a dozen
such publications which were read by millions.

Life had a circulation of 8.5 million in the
1950s, surpassing all other illustrated publica-
tions. (*Picture Post* was second, with a circula-
tion of 1.75 million in 1946.) Under these circum-
stances, *Life* could afford to be the best-paying
magazine in the world, a fact which naturally
attracted some of the best photographers from
Europe, particularly those leaving for political
reasons. New York became the mecca for pho-
tographers in the late 'thirties, for in addition to
the opportunities offered by its glut of glossy
magazines, the U.S. was the first country to
accept photography as one of the arts—as Amer-
icans had also appreciated Impressionism long
before Europeans. It does not come as a surprise,
therefore, that Alfred Barr, director of New
York's Museum of Modern Art (founded 1929),
decided in 1937 to commemorate the centenary
of photography with a major exhibition. An
event of even greater impact on the future of

250 Brassaï. Tramp sleeping in the street, Paris, 1937.

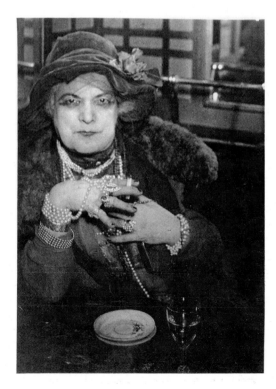

251 Brassaï. 'Bijoux' in
Place Pigalle bar, 1932.

119

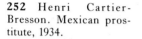

252 Henri Cartier-Bresson. Mexican prostitute, 1934.

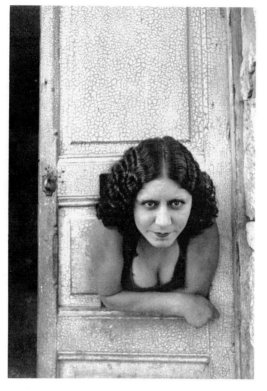

photography as a recognized medium was the foundation, in December 1940, of a Department of Photography at MoMA, supported by Ansel Adams and David McAlpin and run by Beaumont Newhall [*Ill. 254*]. It was the first photography department in the world at any art museum.

Among the many German photographers working for the early issues of *Life* and other magazines was Fritz Henle, alias Mr. Rollei (see page 26). His feature story on Paris, taken in 1938 [*Ill. 255*], was surprisingly rejected by *Life*, but it was published after the liberation of the city by the allies in *The New York Times Magazine* and in book form (1947). Always a free-lancer, Henle became well known in the 'fifties for his beautiful figure studies on beaches and on rocks [*Ill. 256*]; for his work on the Virgin Islands, where he has lived since 1956; and, above all, for his sensitive picture story on Pablo Casals's self-imposed exile in Puerto Rico.

Influenced by the work of Atget and Brassaï, Bill Brandt, a pupil of Man Ray, took up reportage photography and made an unforgettable documentation of *The English at Home* (1936), illustrating the great chasm dividing rich and poor in housing, education, and leisure. His famous picture of an unemployed miner searching for coal [*Ill. 257*] epitomizes the grimness of the economic depression.

Also in the mid-'thirties, but in the United States, a number of photographers recording for the Farm Security Administration the appalling conditions in depressed areas during the economic crisis produced outstanding pictures which shocked America by their starkness, for they were the commentary of socially conscious observers on the misdeeds of their time. Walker Evans's photographs [*Ill. 258*], as one writer said, 'put the physiognomy of the nation on your table.' The ramshackle dreariness revealed in his photographs and those of his colleagues Dorothea Lange [*Ill. 259*], Margaret Bourke-White, Arthur Rothstein [*Ill. 260*], and others, is a terrible indictment of civilization in certain parts of

253 Robert Capa. Death of a Republican soldier, Spanish Civil War, 1936.

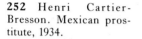

120

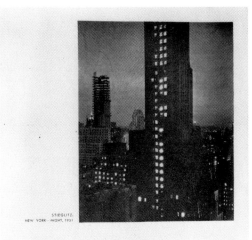

THE NEW DEPARTMENT OF
PHOTOGRAPHY

The Bulletin of
THE MUSEUM OF MODERN ART
2 · VOLUME VIII · DEC.-JAN. 1940-41

254 Cover of the Bulletin of The Museum of Modern Art, 1940.

America. John Vachon's photograph of a railway truck [*Ill. 261*], taken for the FSA in 1937, surprises the viewer with its fascinating abstract design in the background—ill-fitting in the otherwise strictly social context of Roy Stryker's organization. Founded under F. D. Roosevelt's New Deal in 1935, the FSA's work came to a stop when America entered World War II.

Bourke-White's book *You Have Seen Their Faces* (1937) contains haunting pictures that go far beyond the mere documentation of conditions in the Southern states, and especially of black chain gangs. The book she had produced with Erskine Caldwell, who later became her husband, was the first of a number of important social documentations published in the U.S. in the late 1930s and early 1940s. It was followed by Archibald MacLeish's *Land of the Free* (1938) and *American Exodus* by Dorothea Lange in collaboration with her husband, P. S. Taylor (1939). *Let Us Now Praise Famous Men* by Walker Evans and James Agee (1941), rejected by the original publisher, has meanwhile become a bestseller. Photography had become a powerful weapon in awakening the social conscience, as

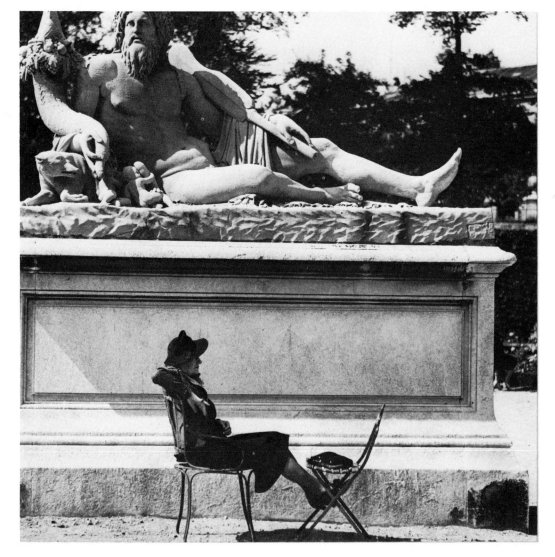

255 Fritz Henle. The woman and the river god at the Louvre garden, Paris, 1938.

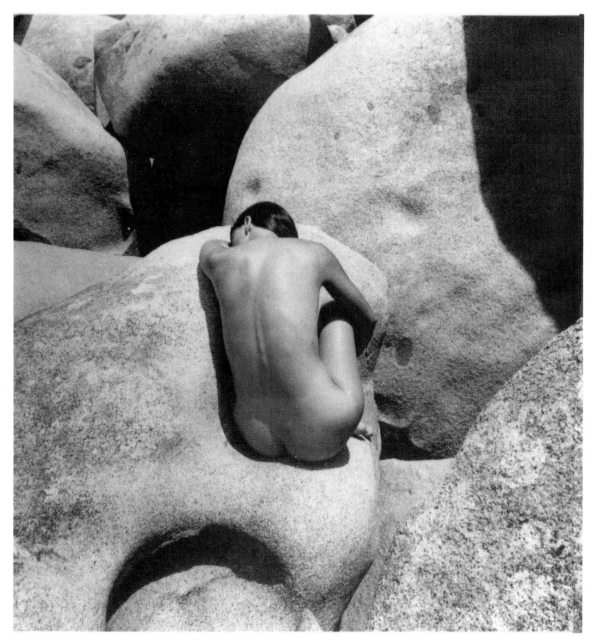

256 Fritz Henle. Nude, 1954.

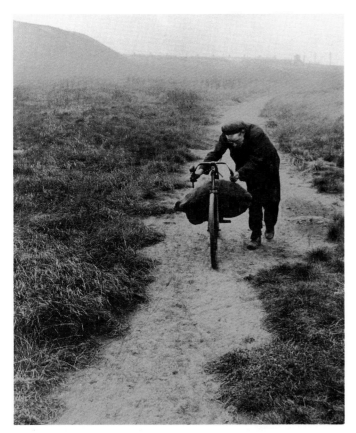

257 Bill Brandt. Coal-searcher at East Durham, 1936.

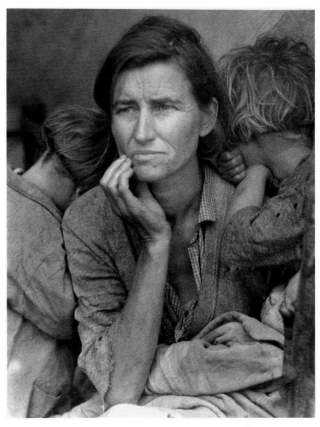

259 Dorothea Lange. Seasonal farm labourer's family, 1935–36.

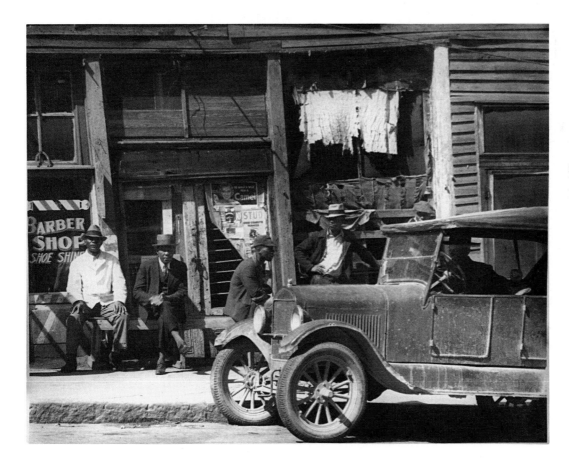

258 Walker Evans. At Vicksburg, Pennsylvania, 1936.

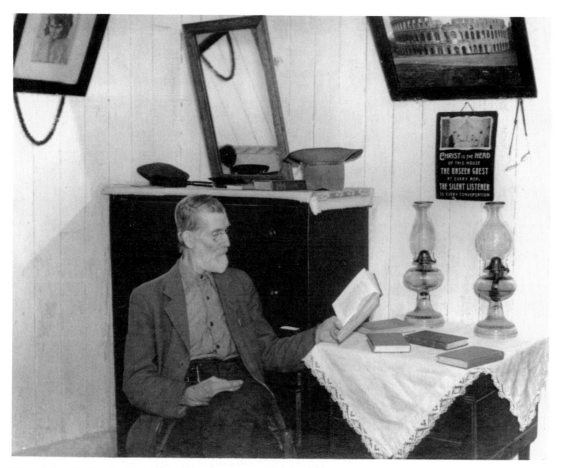

260 Arthur Rothstein. Home of Postmaster Brown, Old Rag, Virginia, 1935.

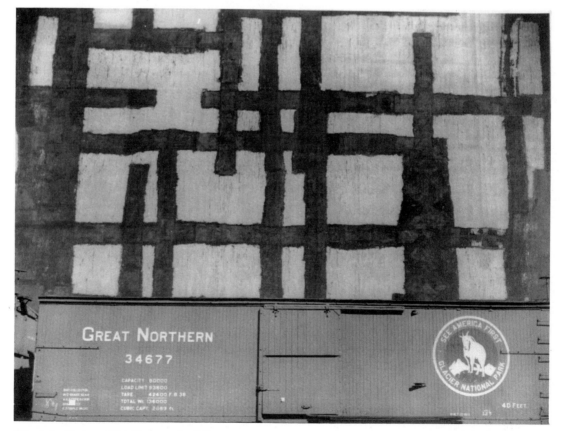

261 John Vachon. FSA Photograph, 1937.

Jacob Riis first came to realize. What Gustave Doré accomplished in his dramatic pen drawings of London slums in the 1870s can today be achieved with even greater forcefulness by a photographer equaling Doré's powers of expression.

A photographer of sensitivity cannot record poor social conditions objectively; the deeper his compassion goes, the greater will be the impact of his pictures. It is probably true that most great reportage photographers cannot help getting emotionally involved in what they see, and their creative ability may subtly influence our way of thinking.

For Robert Capa it was impossible to stand aloof from political events which were affecting the lives of millions. The inhumanity of man to man and the futility of war became an obsession with him. He hated war, and it is ironical that he should have won recognition as the best combat photographer in the world [*Ill. 262*]. Capa photographed five wars in eighteen years, and finally paid with his life for his courage.

Cornell Capa has, like his elder brother, made human interest his main theme, but in more peaceful surroundings [*Ill. 263*].

Warsaw-born David Seymour, a founder-member with Cartier-Bresson and Robert Capa of the Magnum Group in 1947, was killed in action while covering the invasion of Egypt during the Suez crisis. He made picture-stories in many countries [*Ill. 264*], and is particularly remembered for his compassionate photographs of children.

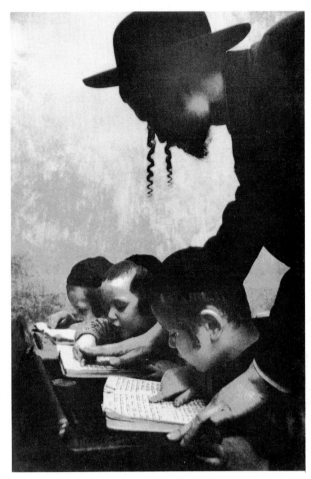

263 Cornell Capa. Talmudic teacher, Israel, 1955.

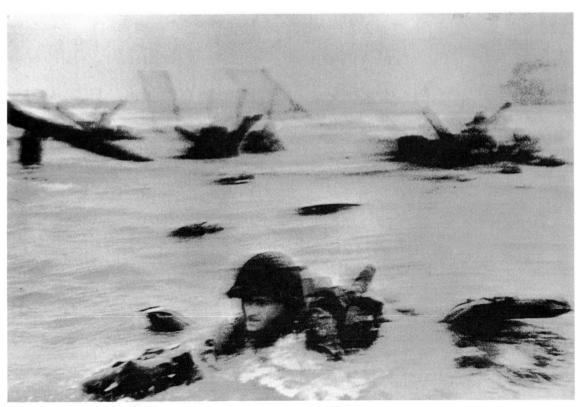

262 Robert Capa. Allied landing on Normandy beaches, 6th June 1944.

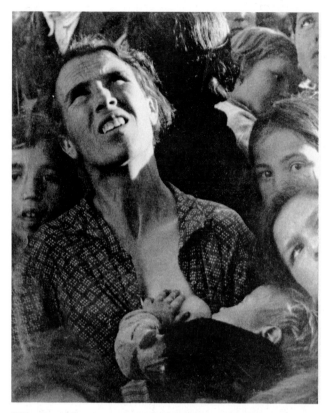

264 David Seymour. Spanish Civil War. Air raid on Barcelona, 1936.

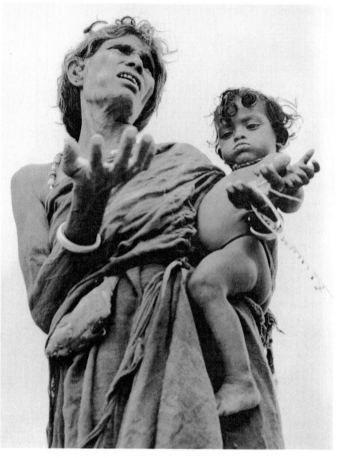

266 Werner Bischof. Famine in Madras, 1951.

265 Martyrs of Belsen, April 1945.

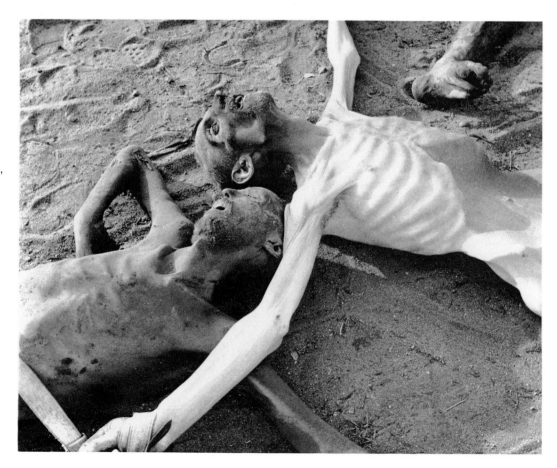

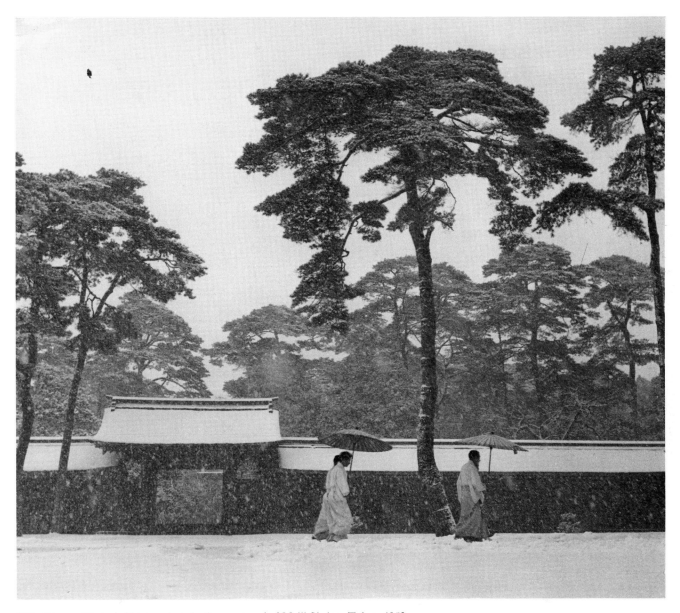

267 Werner Bischof. Shinto priests in the courtyard of Meiji Shrine, Tokyo, 1952.

Mario de Biasi caught the violence of the avenging crowds surging through Budapest as no other photographer of the Hungarian revolution did.

Thousands of pictures taken at the end of the war by the allied armies liberating Nazi extermination camps [*Ill. 265*] will remain for ever a reminder of the unspeakable brutality and flagrant violation of human rights committed by the criminals of the Thousand Year Reich.

Werner Bischof's reportages on refugees, war-scarred districts of France, Holland, and Germany, and famine in India [*Ill. 266*] leave no doubt that he was sick at heart at what he had to report. Some of his finest work is contained in his books *Japan* (1954) [*Ill. 267*] and *Unterwegs* (1957).

Suppression of Bert Hardy's reportage on an incident in the Korean War led to Tom Hopkinson's resignation as editor of *Picture Post:* the indictment of the South Korean Government, an ally of the Western Powers, that allowed totalitarian behaviour within its own ranks was inconveniently outspoken. A dramatic series of action pictures showing the misery of American troops in retreat was taken by *Life* photographer David Douglas Duncan in North Korea in 1950.

Eugene Smith's wonderful picture-story 'The Spanish Village' (1951) explores the eternal themes of life and death in a poor community whose life he shared for a few weeks in order to understand their customs and be regarded as a friend, not as an outsider. Smith's photograph of a dead man mourned by his family [*Ill. 268*] has the economy of means and strong tone contrast of a Goya etching. The same power of expression distinguishes the Peruvian and Spanish reportages of the Swede George Oddner, which are full of images of intense human interest [*Ills. 269, 270*]. Unforgettable, too, is Ernst Haas's

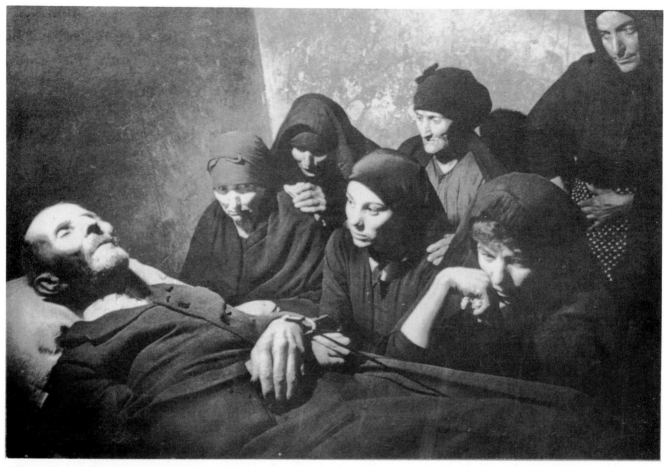

268 W. Eugene Smith. The Spanish village, 1951.

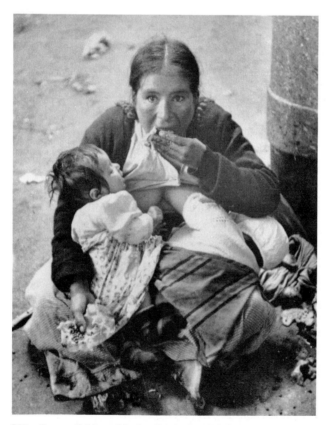

269 George Oddner. Mother Earth, Peru, 1955.

moving picture-story of the arrival in his home-town Vienna of returning prisoners-of-war from Russia in 1947.

Compassion with a strong admixture of the sensational stamps the work of Arthur Fellig, known as 'Weegee'. He built up a big reputation with his candid news coverage of poverty, crime, and calamities in New York during fifteen years' close collaboration with the New York police as a free-lance photographer. With iron nerves and cool detachment Weegee captured situations and emotions in which the photographer must have seemed an intruder.

It is, however, not only wars and bad social conditions but the whole of life which photography depicts more convincingly than any other medium. Bert Hardy's many reportages while chief photographer to *Picture Post* include some memorable shots. The *raconteur* in a French wine cellar has a Falstaffian quality [*Ill. 271*]. To obtain unfamiliar aspects of familiar subjects is one of the tasks of the reportage photographer; success lies in catching mood, atmosphere, and expression of the personalities of the people involved. Such pictures are Elliott Erwitt's intimate family scene [*Ill 272*] and Henri Cartier-Bresson's classic 'Sunday on the Banks of the Marne' [*Ill. 273*], which perfectly conveys the atmosphere of a typical French working-class

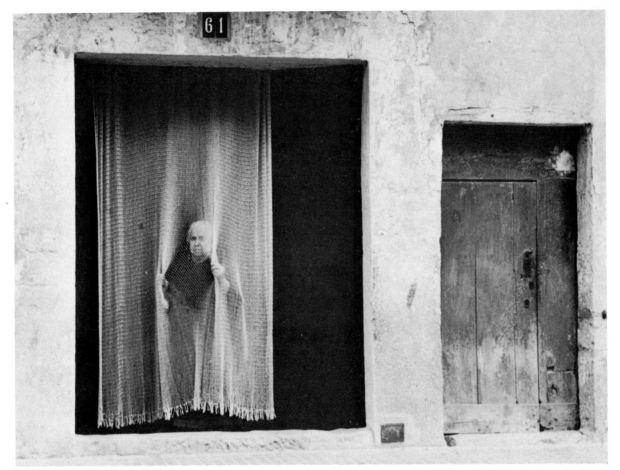

270 George Oddner. Spain, 1952.

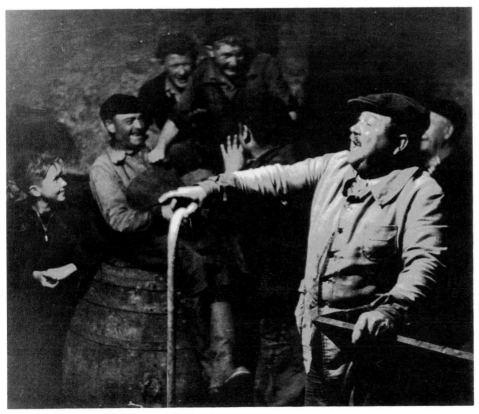

271 Bert Hardy. 'Le Raconteur', 1948.

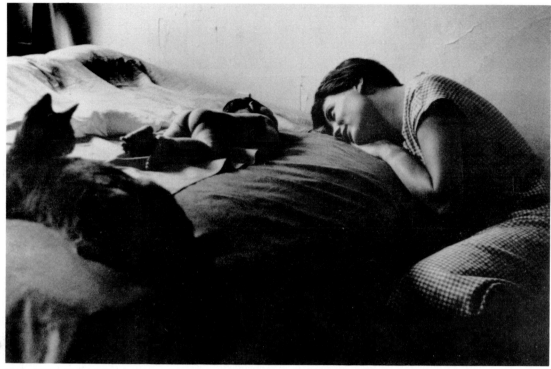

272 Elliott Erwitt. Family scene, 1953.

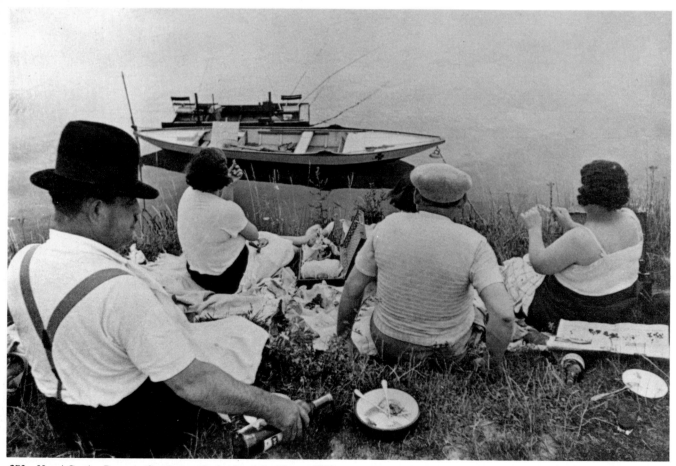

273 Henri Cartier-Bresson. Sunday on the banks of the Marne, 1938.

family's ideal Sunday outing. This is only one of the many fine pictures in his first book *Images à la sauvette* (1952). Kurt Hutton's 'Scenic Railway' [*Ill. 274*] evokes all the fun of the fair, although the scene was carefully rehearsed, which rather invalidates it as reportage.

The Dutch photographer Ed van der Elsken became internationally known with his book *Love on the Left Bank* (1956)—the rather sordid story of a young girl, who eventually returned home to Canada pregnant. More cheerful and equally good are Leonard McCombe's *You Are My Love* and de Carava's *The Sweet Flypaper of Life* that appeared about the same time.

The American William Klein—the angry young man of photography—produced provocative 'portraits' of *New York* (1956), *Rome* (1958), *Moscow* (1960), and *Tokyo* (1961) in a dynamic motion-picture style before he went into movie-making in 1965. A greater contrast to Karel Plicka's *City of Baroque and Gothic* (1946) can hardly be imagined. However, *de gustibus non est disputandum*. Plicka concentrated on the splendid architecture and town views of Prague, perhaps the most beautiful city in the world, and many readers may prefer to see the unique beauty of a city rather than dreary snatches of life common to all large towns.

In a somewhat similar cinematographic style to that of William Klein, the Swiss Robert Frank presented his impressions of America in trivial snippets which have been aptly dubbed 'the graphic iconography of the Beat Generation'. The first non-American to receive a Guggenheim grant, Frank used it to travel across the States, taking 28,000 snapshots which he reduced to 80 for his album *Les Américains*, published in Paris since no American publisher wanted to burn his fingers with this one-sided, untidy, irreverent, yet frank and alive collection. It took Americans ten years to overcome the shock of these irritating photos before reprinting the album themselves.

Simpson Kalisher took railroad men as the subject for a highly stimulating book (1961) on the forgotten men working America's declining railway system. The Swiss René Groebli highlighted the plight of Arab refugees; Bert Hardy, the colour problem in Liverpool [*Ill. 275*]; Roger Mayne, the children in Paddington slums; and Michael Petö, starving children in the East.

The fact that a great photographer will produce fine pictures even if he has to work in an unfamiliar field was shown during World War II by the fashion magazine photographers Edward Steichen and Cecil Beaton. The former, in command of U.S. Navy combat photography, made an outstanding contribution. His picture of a bomber taking off from the aircraft carrier 'Lexington' springs immediately to mind. For Beaton the switchover from peace to war meant exchanging the luxurious world of *Vogue* for the stark reality of photographing for the Ministry of Information in London during the Blitz and in the

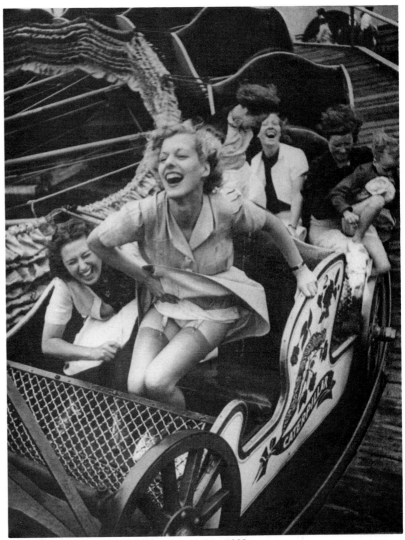

274 Kurt Hutton. Scenic railway at the fair, 1938.

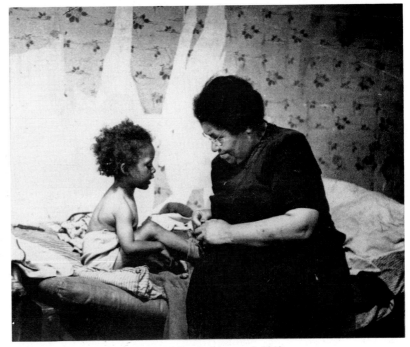

275 Bert Hardy. The colour problem in Liverpool, 1949.

276 Cecil Beaton. Remains of a tank in the Libyan desert, 1942.

Near and Far East. The striking pattern of a burnt-out tank in the Libyan Desert [*Ill. 276*] is as brilliant a war picture as any painted by Paul Nash.

Unlike free-lancing reportage photographers, press photographers are as a rule only identified by the name of the newspaper or press-agency for which they work. These usually anonymous photographers frequently take outstanding pictures, but it is only occasionally that a particularly dramatic subject becomes widely known instead of being buried in the picture-archive the day after publication. *Historic Events: 1839–1939* illustrates many great press photographs which the author retrieved from neglected picture files. A classic news picture, indeed one of the most striking ever taken, shows the explosion of the giant airship 'Hindenburg' on landing at Lakehurst, New Jersey, in 1937 [*Ill. 277*]. A more recent example that caused world-wide protest and made Sharpeville, like Lidice, a byword for mass murder, shows the ground strewn with Africans after the police fired on and killed 65 of them [*Ill. 278*]. Photographers covering such events require great presence of mind and courage.

George Rodger, a founder-member of Magnum, made expressive pictures of tribal ceremonies in Africa [*Ill. 279*]. In fact, all the photographers belonging to the Magnum group [*Ill. 280*], and all the members of the American Society of Magazine Photographers, deserve men-

277 Sam Shere. The 'Hindenburg' disaster at Lakehurst, New Jersey, 6th May 1937.

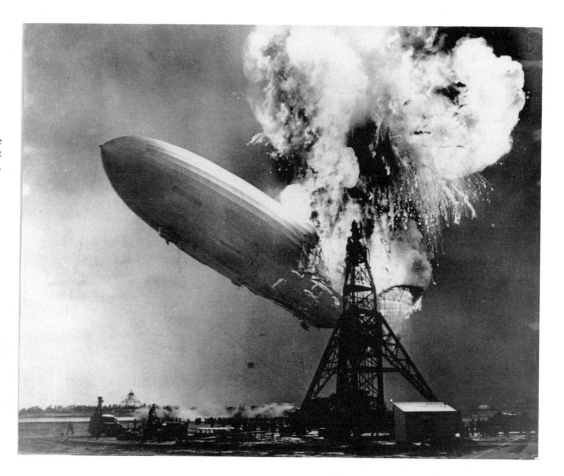

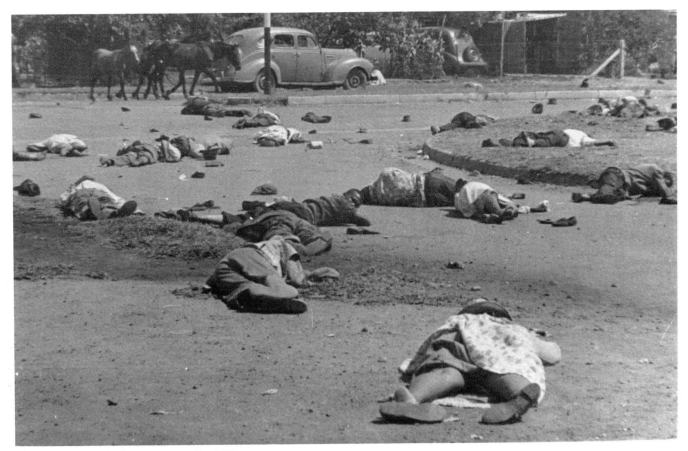

278 Massacre of Africans at Sharpeville, 1960.

tion; so do the French photographers Robert Doisneau, Daniel Masclet, Jean Roubier, Edouard Boubat, and André Thévenet; the Germans Willi Beutler, Hanns Hubmann, Thomas Höpker, Fritz Kempe, Robert Lebeck [*Ill. 281*], Stefan Moses, and Hilmar Pabel; the Italians Mario Giacomelli, Paolo Monti, Fulvio Roiter, and Toni del Tin; the Swiss Gotthard Schuh and Paul Senn; the Dutch Cas Oorthuys and Emmy Andriesse. Each of these talented photographers made valuable contributions to my theme, but out of the wealth of excellent material all over the world, only the most salient can be discussed within the page limits of a 'concise history'. This also applies to the brilliant photographers of a younger generation, such as Diane Arbus, Barbara Klemm, Don McCullin, and a host of more recent photographers whose contributions will certainly be recorded in 'concise histories' in the not very distant future.

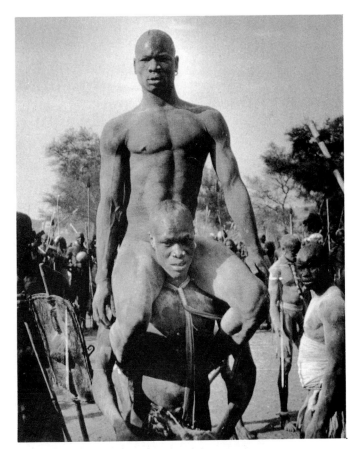

279 George Rodger. Initiation ceremony, Africa, 1956.

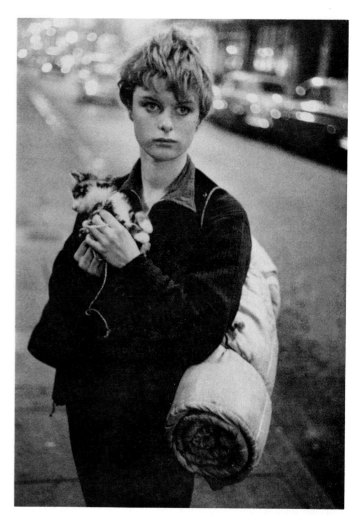

280 Bruce Davidson.
London life, 1964.

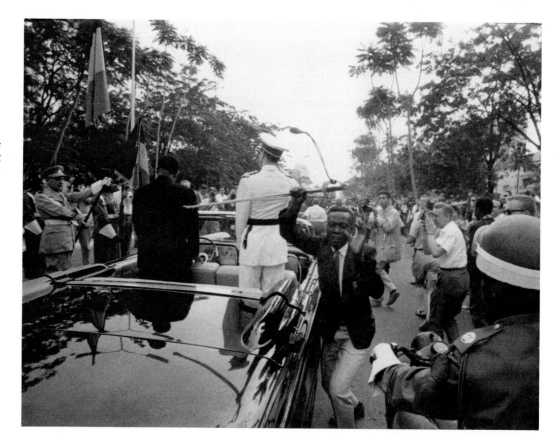

281 Robert Lebeck. The
stolen sword of King
Baudouin of Belgium,
1960.

Colour Photography

(*colour illustrations follow pages 22 and 118*)

Good colour photography demands more of the photographer than simply shooting with colour film. Compared with black and white, colour requires not only a different technique but a different way of seeing. In monochrome the massing of light and shade and the reproduction of texture are of the utmost importance: in colour photography, the imaginative use of colour rather than truth to nature. The average photographer sees in colour only an additional means of bringing greater realism into his picture, and he will invariably consider brightly coloured subjects ideal, since 'colour' and 'bright' seem to him synonymous. The creative photographer, on the other hand, uses colour to add to the significance of the subject. This requires a fine sense for the delicate *nuances* of colour, which he uses to enhance atmosphere, to stress a mood, heighten tension, or increase the decorative effect of his picture; or he may, like a painter, employ colour deliberately as a means of expression. Colour and form—and in reportage, action—have to amalgamate to produce a harmonious composition. Above all, sensitive use of colour calls for good taste and a great deal of experience, which up to now comparatively few photographers seem to have acquired.

Felix H. Man was a pioneer in colour reportage as well as in black and white. His view of the Thames at Chelsea, the first colour photograph of this kind ever attempted successfully (1949), has Whistlerian atmospheric effects [*Ill. i*]. During 1948–51 Man applied the principles of black and white photo-journalism, without additional artificial light sources, to colour film, which then had only about one-quarter of today's's speed. He made for *Picture Post* the first important indoor colour reportage—a canonization in St Peter's—by available light (1950). The following year he produced for *Life* the first colour reportage at night—the Festival of Britain—and the first colour pictures by moonlight, at Monte Carlo. Interviews with leading artists shot in colour in their homes and studios were the subject of Man's book *Eight European Artists* (1954) [*Ill. iii*]. The documentary value of such reportages is greatly increased by the inclusion of the artist's canvases or sculpture.

Improved colour film and greater speed have now solved all practical difficulties in taking colour photographs. The main obstacle to the wider application of colour in the illustration of books and magazines remains today the pro-hibitive cost of printing. The re-creation of the colour photographer's achievement in print makes very high demands on the skill of the blockmaker and printer, who can make or mar the picture. The chief difficulty is that the opaque pigments of the printing ink do not correspond very closely with the translucent dyes used in the colour transparency. For this reason a certain amount of colour-masking and hand correction is necessary to compensate for the shortcomings of the printing colours. This accounts for the high cost of colour printing, and, in turn, for the comparative rarity of books illustrated entirely or largely with colour photographs. Up to now, the finest colour printing comes from the presses of a few Swiss, German, and Italian printing firms.

The many fine colour documentations taken by the Swiss Emil Schulthess in various parts of the world (*USA*, 1955; *Africa*, 1959–61; *The Antarctic*, 1960; *The Amazonas*, 1962; *China*, 1966; *The Soviet Union*, 1971) stand out (like the Eugen Schumacher films on Alaska and the Panamerican Highway) among all similar publications through their superb photographic quality coupled with an informative text, an excellent layout, and perfect printing. To this category also belong the wide range of books by Werner Bischof [*Ill. vii*], Georg Gerster [*Ill. xx*], Erwin Fieger [*Ill. ii*], and the American nature photographer Eliot Porter (*In Wilderness Is the Preservation of the World*, 1962, and *The Antarctic*, 1978). The poetic colour portfolios published by the Austrian Ernst Haas in his albums entitled *The Creation* (1971), *In America* (1975), and *Himalayan Pilgrimage* (1978) have been over-publicized, and neither text (where one exists) nor printing and layout are completely satisfying to the connoisseur.

A stimulating exploration of colour photography in the aesthetic sense, and a perfect demonstration of its creative possibilities, were given by Walter Boje in *Magie der Farbe* (1961) (*Magic with the Colour Camera*) in which a number of German photographers show unusually imaginative use of colour and interpretation. Some of them deliberately depart from realism and use both colour and subject matter expressionistically. The effect is sometimes rather startling, as when the photographer imitates by the use of long-focal lenses the focussing of the human eye, giving greater importance to the main subject of the picture by blurring nearer

and more distant objects [*Ill. ii*]. Blurred representation of movement, too, comes out very dramatically in colour, as Walter Boje shows in his ballet picture [*Ill. iv*] and Brian Blake in his picture of Indian women [*Ill. v*]. A number of contemporary photographers give a highly personal interpretation with an impressionistic effect due partly to selective focussing and partly to slow shutter speeds.

Eliot Elisofon was one of the first to advocate the deliberate alteration of the image's colour values in keeping with the subject, by the use of filters. He was special colour photography consultant in the making of the film 'Moulin Rouge' (1952) in order to re-create Toulouse-Lautrec's colours. Blue and fog filters were used on the camera to create the smoke-filled atmosphere of the Moulin Rouge.

Control of colour, when used with discretion, can also add greatly to the aesthetic pleasure of a picture. The magazine photographer has on the whole more latitude in this respect than the illustrator of topographical or ethnographical books, where any deliberate change of colour would reduce the informative value of the illustrations. Emil Schulthess's *Africa* (1961), Werner Bischof's *Japan* (1954) and other publications [*Ill. vii*], the colour documentations of Eliot Elisofon, Ed van der Elsken's *Bagara* (1961), René Gardi's *Sepik* (1958), and Peter Cornelius's *Paris* (1960) are outstanding examples of this kind.

Erwin Fieger's *London City of Any Dream* (1962) is, on the other hand, intended as a completely personal interpretation. His brilliant ability to handle his theme creatively in colour by zooming in with his telephoto lens on expressive snatches of life [*Ill. ii*] is evident in this and later volumes such as *13 Photo Essays* (1969), *Japan, Sunrise Island* (1971), and *Mexico* (1973). The impact of zoom-lens close-ups is breathtaking, marking a personal style that proved to be a landmark influence on reportage photography.

While fragmentary glimpses of a city and concentration on amusing oddities are not typical of the subject and could just as well have been taken elsewhere, no critic would deny the poetic charm of Bidermanas's (Izis's) very personal viewpoint of Paris (*Paris des rêves*, 1950; *Grand bal du printemps*, 1951; *Paris des poètes*, 1967) and other places (*London*, 1952; *Israel*, 1956). The tender, beautifully conceived impressions of the Lithuanian-born photographer are poems for like-minded philosophers, not for Baedeker-guided information seekers.

Hungarian-born Ferenc Berko, on the other hand, who was making films in Bombay when Moholy-Nagy engaged him as a teacher at the New Bauhaus in Chicago, believes in interpreting realism with an artist's eye. He is equally versatile in rendering fascinating abstractions from nature [*Ill. viii*] and man-made objects, as in his fine colour reportages of many countries [*Ill. vi*]. With Harry Callahan, Aaron Siskind,

and Arthur Siegel, all former teachers at the Institute of Design (formerly New Bauhaus School) at Chicago, Berko was one of the pioneers of abstract design in photography in the early 'fifties which has since found an increasing number of followers both in America (such as Carol Cohen, *Ill. xxii*) and in Europe (such as Raymond Moore, *Ill. xiii*).

Franco Fontana of Modena, Italy, startled visitors to his exhibitions in the early 'seventies with colorful abstractions of landscapes—most of them clearly defined patterns of fields combining in an unexpected geometric design [*Ill. xix*] or of nothing but sea and sky forming a dramatic color blaze with the setting sun. Since then he has applied his vision to buildings which lend themselves to the reduction of planes and the play of colored surfaces [*Ill. ix*].

Swiss Victor Gianella probably goes further in abstraction than most by concentrating on small details that remain hidden to the average passerby. The fragment assumes a life of its own [*Ill. xxi*] the more it is isolated from its context or seen in juxtaposition to another detail normally not associated with it in our minds [*Ill. xviii*].

By surveying the world from the air for magazines and Swissair, the Swiss writer-photographer Dr Georg Gerster discovered the calligraphy of roads, the graphics of planted terrain [*Ill. xx*], and the mosaic of small cultivated fields, or archaeological sites, not revealed to the man on the ground. Shot in colour, his aerial views, published in *Grand Earth from Above*, 1976, and *Bread and Salt*, 1980, have an overpowering beauty of design that frequently comes very close to modern art. Gerster's earlier volumes, documenting the removal of Abu Simbel as official UNESCO photographer, the Ethiopian *Churches in Rock* (1968), and *The Nubians* (1973), are equally outstanding.

Pierre Cordier's Chimigrammes, or chemigrams, could be mistaken for modern art [*Ills. xvi, xvii*], yet they are deliberate metamorphoses of the original image. The Belgian photographer has never revealed exactly what takes place in producing a chimigramme beyond admitting that the process he invented in 1956 'owes its existence to the localized action of chemical substances on a photo-sensitive surface, without the use of a camera, enlarger or darkroom.' The results are very original and beautiful.

Marta Hoepffner, who had studied painting and graphic art under the constructivist painter Willi Baumeister, was, like her pupil Irm Schoffers, fascinated by techniques evolved at the *Bauhaus*. In their quest for more complex forms of photographic art Hoepffner developed colour-solarization [*Ill. xiv*], colour photograms, and vari-coloured light images whilst Schoffers gets fascinating colour variations from metacollage [*Ill. xv*]. Both have also worked in mixed media.

With the demise of most of the illustrated weeklies, whose slow reporting on current events has been taken over by on-the-spot television transmission, people of discernment with a taste for good photography now have to turn to certain monthly magazines such as *National Geographic*, *GEO*, or *ART* if their cultural requirements are tuned to a higher level than that of sensation or sex. Generally speaking, the best of contemporary photography will be found in books rather than in magazines, and a library of picture-books is as vital to visually aware people as a good stereo is to serious music-lovers.

Acknowledgements

The major portion of the illustrations in this book are from the Gernsheim Collection at the University of Texas. The author and publisher wish to express their gratitude to the Chancellor of the University for permission to publish them. Some other items are in the author's private collection. The author and publisher also thank the contemporary photographers as well as museums and institutions for permission to reproduce some of the illustrations. The Roman numerals in the listing below refer to the colour illustrations.

Ferenc Berko: vi, viii.
Walter Boje: iv.
Frau Eva Bollert, Staatliche Kunsthalle, Karlsruhe: 199.
Brassaï: 250, 251.
Camera Press: 212.
Carol Cohen: xxii.
Pierre Cordier: xvi, xvii.
Eric de Maré: 211.
Falk Gallery: 217.
Gertrude Fehr: 219.
Erwin Fieger: ii.
Franco Fontana: ix, xix.
Fox Photos: 244.
George Eastman House, Rochester: 16, 128, 150, 162.
Gernsheim Collection, University of Texas: xxv, xxvi, 1–15, 18–23, 25–42, 44–48, 50, 52–56, 58, 60–67, 69, 70, 72, 74–80, 83–127, 129–140, 142–149, 151–157, 160, 161, 163–184, 186–190, 192–198, 200–208, 210, 214, 215, 218, 221, 225–238, 240–243, 246, 248, 249, 252, 254, 257, 266, 267, 269, 270, 273, 274, 276.
Georg Gerster: xx.
Victor Gianella: xviii, xxi.
Tim Gidal: 247.

Graphis: xxiii.
Philippe Halsman: 216.
Arno Hammacher: xxiii.
Hans Hammarskiöld: 159.
Robert Häusser: 239.
Fritz Henle: 255, 256.
Marta Hoepffner: xiv.
Walde Huth-Schmölz: 220.
Imperial War Museum, London: 265.
André Jammes: 71.
Peter Keetman: 222–224.
Keystone: 278.
Robert Lebeck: 281.
Library of Congress: 81, 258–261.
Life: 268.
Magnum Photos, The John Hillelson Agency: v, vii, xi, 253, 262–264, 272, 279, 280.
Mrs. Felix H. Man: i, iii.
Raymond Moore: xiii.
Museum für Hamburgische Geschichte: 57.
Arnold Newman: 213.
Sir George Pollock: xii.
Paul Popper Ltd: 82.
Radio Times Hulton Picture Library: 271, 275.
Royal Photographic Society of Great Britain: 141, 158.
Sander Gallery: 191.
Mrs. Saul: 245.
Mrs. M. Schinz: 185.
Karl-Hugo Schmölz: xxiv.
Irm Schoffers: xv.
Science Museum, London: 24, 49, 59.
Société Française de Photographie: 51, 68.
Stenger Collection: 73.
Jack Stuler: x.
Wolfgang Suschitzky: 209.
The late Prof. Robert Taft: 43.
United Press International: 277.
Victoria and Albert Museum, London: 6.
Harold White: 17.

List of Illustrations

Plates i–xxvi are in colour:

45 Richard Beard's studio. Wood engraving by George Cruikshank, 1842.

46 Daguerreotype of Sir Henry Bessemer, c. 1848.

47 Daguerreotype of a gentleman, c. 1845.

48 Antoine Claudet. Daguerreotype (tinted) of a lady, c. 1851.

49 Dr A. J. Ellis. Daguerreotype of Temple of Faustina and Antoninus, Rome, June 1841.

50 'La patience est la vertu des ânes'. Caricature by Daumier from *Le Charivari*, July 1840.

51 L.-J.-M. Daguerre. Daguerreotype of still-life in his studio, 1837.

52 L.-J.-M. Daguerre. Daguerreotype of Notre Dame and the Île de la Cité, Paris, 1838.

53 Caricature by Daumier published in *Les bons bourgeois*, 1847.

54 J.-P. Girault de Prangey. Daguerreotype of statue at portal of Genoa Cathedral, 1842.

55 Antoine Claudet. 'The Geography Lesson'. Stereoscopic daguerreotype, 1851.

56 C. F. Stelzner. Daguerreotype group, c. 1842.

57 C. F. Stelzner. Daguerreotype of ruins around the Alster after the great fire of Hamburg, May 1842. The earliest news photograph.

58 Daguerreotype of a Milanese lady, c. 1845.

59 W. H. Fox Talbot's establishment at Reading. Calotype, 1844.

60 N. Henneman. 'The Chess Players' (A. Claudet and W. H. Fox Talbot). Calotype, 1844.

61 W. H. Fox Talbot. Cover of *The Pencil of Nature*, 1844. The first photographically illustrated book.

62 David Octavius Hill and Robert Adamson. James Nasmyth, inventor of the steam hammer. Calotype, c. 1845.

63 David Octavius Hill and Robert Adamson. 'The Birdcage'. Calotype, c. 1843.

64 David Octavius Hill and Robert Adamson. Cottage at Newhaven near Edinburgh. Calotype, c. 1845.

65 Roger Fenton. Domes of the Cathedral of the Resurrection in the Kremlin. Waxed-paper process, 1852.

66 Dr Thomas Keith. Willow trees. Waxed-paper process, c. 1854.

67 John Shaw Smith. Pillars of the Great Hall of the Temple of Karnak, Luxor. Waxed-paper process, 1851.

68 Hippolyte Bayard. The windmills of Montmartre. Calotype, 1842.

69 W. H. Fox Talbot. House in Paris opposite Talbot's hotel. Calotype, 1843.

70 Maxime Du Camp. Statue of Rameses II on the façade of the temple at Abu Simbel, Nubia. Calotype, 1849.

71 Charles Nègre. 'Les Ramoneurs'. Waxed-paper process, 1852.

72 John Whistler. Old farmhouse. Waxed-paper process, 1852.

73 Charles Clifford. Fountain and staircase at Capricho Palace near Guadalajara, Spain, c. 1855.

74 Alois Löcherer. Transport of the colossal statue of 'Bavaria' from the foundry to its present site in Munich. Calotype, 1850.

75 The Egyptian pyramids. Engraving from Joseph Banks's *New and Complete System of Geography* (1790?). It was copied, with slight alterations, from O. Dapper's *Beschreibung Afrikas* (*Description of Africa*), 1670.

76 Francis Frith. Pyramids of Dahshoor, Egypt, 1858.

77 William England. Blondin crossing the Niagara River, 1859.

78 Louis and Auguste Bisson. Mont Blanc and the Mer de Glace, 1860.

79 Samuel Bourne. The Scinde River, 1864.

80 Carleton E. Watkins. Washington Column, Yosemite, 1867.

81 Timothy H. O'Sullivan. The Canyon de Chelle, 1873.

82 Herbert Ponting. The 'Terra Nova' in the Antarctic, 1912.

83 Robert MacPherson. Garden of the Villa d'Este, Tivoli, c. 1857.

84 Henry White. Bramble and ivy, 1857.

85 Gustave Le Gray. 'Brig upon the Water', 1856.

86 James Mudd. Dam-burst at Sheffield, 1864.

87 P. H. Delamotte. Opening ceremony by Queen Victoria of the rebuilt Crystal Palace, Sydenham, 10th June 1854.

88 P. H. Delamotte. Upper gallery of the Crystal Palace, Sydenham, 1854.

89 Robert MacPherson. Relief on Arch of Titus, Rome, c. 1857.

90 James Anderson. Base of Trajan's Column, Rome, c. 1860.

91 Carlo Ponti. Piazza San Marco, Venice, c. 1862.

92 Edouard Baldus. The Pont du Gard near Nîmes, c. 1855.

93 Henry Dixon. The office of the *Daily News*, founded by Charles Dickens, in Fleet Street, shortly before demolition, 1884.

94 Thomas Annan. Glasgow slum, 1868.

95 Cartoon by John Leech in *Punch*, May 1857.

96 J. E. Mayall. Queen Victoria and the Prince Consort, 1861.

97 Camille Silvy. *Carte-de-visite* of an unknown lady, c. 1860.

98 Etienne Carjat. Charles Baudelaire, c. 1862.

99 Antoine Adam-Salomon. Charles Garnier, c. 1865.

100 Nadar. George Sand, 1866.

101 Honoré Daumier. 'Nadar raising photography to the height of Art'. Lithograph, 1862.

102 Julia Margaret Cameron. Sir John Herschel, 1867.

103 Julia Margaret Cameron. Charles Darwin, 1869.

104 Robert Howlett. Isambard Kingdom Brunel, 1857.

105 Paul Nadar. F. T. Nadar interviews the centenarian M.-E. Chevreul, August 1886.

106 Mélandri. Sarah Bernhardt in her studio, 1876.

107 Elliot & Fry. Sir Joseph Wilson Swan, 1904.

108 Adrian Nadar. Portrait of Dr G.-B. Duchenne using his electrization apparatus, 1857.

109 Maull & Polyblank. Robert Stephenson, 1856.

110 Thomas Annan. Dr David Livingstone, 1864.

111 Constant Dutilleux. Camille Corot at Arras, 1871.

112 Paul Sescau. Double portrait of Henri de Toulouse-Lautrec, c. 1892.

113 Lithographic poster for Paul Sescau by Toulouse-Lautrec, c. 1894.

114 Lewis Carroll. Ella Monier-Williams, 1866.

115 Lady Hawarden. At the window, c. 1863.

116 O. G. Rejlander. The milkmaid, c. 1857.

117 Roger Fenton. Crimean War, Balaclava harbour, 1855.

118 Roger Fenton. Crimean War, cantinière and wounded man, 1855.

119 James Robertson. Crimean War, interior of the Redan after withdrawal of the Russians, September 1855.

120 Timothy H. O'Sullivan. 'The Harvest of Death'. The battlefield of Gettysburg, July 1863.

121 Franco-Prussian War, German troop train blown up by the French near Mézières, August 1870.

122 Paris Commune insurrection, the fallen Vendôme Column, 16th May 1871. The bearded man in the second row is Gustave Courbet.

123 Copying pigeon post dispatches during the Siege of Paris, 1870–71.

124 Reinhold Thiele. Boer War, firing 'Joe Chamberlain' at Magersfontein, 1899.

125 John Thomson. 'Ha'penny Ices', Italian ice cream seller in London, 1876.

126 John Thomson. Junkshop in London, 1876.

127 Jacob Riis. 'Bandits' Roost', New York slum, 1888.

128 Lewis W. Hine. Carolina cotton mill, 1908.

129 Sir Benjamin Stone. Ox-roasting at Stratford-on-Avon 'Mop', c. 1898.

130 Nahum Luboshez. Famine in Russia, 1910.

131 Paul Martin. Cab accident in London, 1895.

132 Paul Martin. Piccadilly Circus at night, 1895.

133 Eugène Atget. Basket and broom shop in Paris, c. 1910.

134 G. W. Wilson, Greenwich Pier, 1857.

135 Charles A. Wilson. Oxford Street, London, 1887.

136 Eadweard Muybridge. Galloping horse, 1883–85.

137 Prof. E.-J. Marey. Flying duck, c. 1884 (reproduction).

138 Prof. E.-J. Marey. Jumping man, c. 1884 (reproduction).

139 Prof. Hubert Schardin. Bullet passing through candle flames, and the sound waves caused by it, c. 1950.

140 Harold E. Edgerton. Multiple-flash photograph of the golfer Dennis Shute, c. 1935. 100 flashes per second.

141 O. G. Rejlander. 'The Two Ways of Life', 1857.

142 H. P. Robinson. Study for a composition picture, c. 1860.

143 H. P. Robinson. 'Dawn and Sunset', 1885 (detail).

144 J. Bridson. Picnic, c. 1882.

145 Eiffel Tower and Trocadéro. International Exhibition, Paris, 1889.

146 Oscar van Zel. Skating in Vienna, c. 1887.

147 P. H. Emerson. Gathering waterlilies, 1885.

148 B. Gay Wilkinson. Sand dunes. Original photogravure, c. 1890.

149 Lyddell Sawyer. The Castle Garth, Newcastle. Original photogravure, 1888.

150 George Davison. 'The Onion Field', 1890 (reproduction).

151 Lacroix. Park-sweeper. Photogravure of a gum print, c. 1900.

152 Robert Demachy. 'Behind the Scenes'. Photogravure of a gum print, 1904.

153 Frau E. Nothmann. 'In the Garden'. Photogravure of a gum print, c. 1897.

154 Heinrich Kühn. Venice. Gum print, 1897 (reproduction).

155 Hans Watzek. A peasant. Photogravure of a gum print, 1894.

156 Theodor and Oskar Hofmeister: Great-grandmother, Cuxhafen, August 1897. Photogravure of a gum print.

157 Hugo Erfurth. Lady with hat. Negative print, 1907.

158 Alexander Keighley. The bridge. Photogravure of a bromoil print, 1906.

159 Edward Steichen. Auguste Rodin with his sculpture of Victor Hugo and 'The Thinker'. Gum print, 1902.

160 Title-page of exhibition catalogue, Hamburg Kunsthalle, 1899.

161 J. Craig Annan. The painter and etcher Sir William Strang. Original photogravure, c. 1900.

162 Frederick H. Evans. Aubrey Beardsley. Platinum print, c. 1895.

163 Maurice Bucquet. 'Effet de Pluie'. Paris, c. 1899.

164 Alvin Langdon Coburn. Reflections. Original photogravure, 1908.

165 Clarence White. Lady in black. Original photogravure, c. 1907.

166 Alfred Stieglitz. The terminal. Original photogravure, 1893.

167 Harry C. Rubincam. Circus rider. Original photogravure, 1905.

168 George Bernard Shaw's reply to Helmut Gernsheim, giving his reason for taking up photography, 1949.

169 Richard Polak. Photograph in the style of Pieter de Hoogh, 1914 (reproduction).

170 Alvin Langdon Coburn. 'The Octopus'. New York. Original photogravure, 1912.

171 Edward VII and Queen Alexandra, 28th June 1904.

172 Paul Strand. Shadow pattern, New York. Original photogravure, 1915.

173 Paul Strand. The white fence. Original photogravure, 1915.

174 Alvin Langdon Coburn. 'Vortograph', 1917.

175 László Moholy-Nagy. Photogram, 1922.

176 Early X-ray photograph, c. 1896–97.

177 Advertisement of X-ray exhibition, London, 1896.

178 László Moholy-Nagy. View from radio tower, Berlin, 1928.

179 Man Ray. Solarized portrait, 1931.

180 Cecil Beaton. The actress Diana Wynyard, 1935.

181 Angus McBean. Self-portrait (four exposures), 1946.

182 Angus McBean. Surrealist composition including self-portrait, 1949.

183 Winifred Casson. Surrealist photograph, c. 1935.

184 Winifred Casson. 'Accident', c. 1935.

185 Erwin Blumenfeld. Profile in motion, 1942.

186 André Kertész. Distortion study, 1934 (reproduction).

187 Clarence J. Laughlin. 'Elegy for Moss Land', 1947.

188 Albert Renger-Patzsch. Driving-shaft of a locomotive, 1923.

189 Eugène Atget. Tree roots at St Cloud, c. 1910.

190 Karl Blossfeldt. Young fronds of maiden-hair fern, 1928.

191 August Sander. The pastry-cook, 1928.

192 Helmar Lerski. Metal-worker, 1930.

193 Edward Steichen. Paul Robeson as The Emperor Jones, 1933.

194 Albert Renger-Patzsch. Tower of the Hofkirche in Dresden, 1923.

195 Otto Umbehr (Umbo). Photomontage, 1926, depicting Egon Erwin Kisch as a roving reporter.

196 John Heartfield. Photomontage for a Tucholsky book cover, *Deutschland, Deutschland über Alles*, 1929.

197 John Heartfield. Photomontage, 'We worship the power of the bomb', 1934.

198 Cover of *USSR in Construction*, July 1936.

199 Walter Hege. Ionic capital from the entrance to the Propylaea, 1929.

200 E. O. Hoppé. Brooklyn Bridge, 1919.

201 Herbert Bayer. Einsamer Großstädter (Lonely Big-City Dweller), 1932.

202 Hugo Erfurth. Käthe Kollwitz. Oil pigment print, c. 1925.

203 Howard Coster. G. K. Chesterton, 1928.

204 Edward Weston. Sweet pepper, 1930.

205 Ansel Adams. Pine-cone and eucalyptus leaves, 1933.

206 Ansel Adams. Sand dunes, Oceano, California, 1962.

207 Helmut Gernsheim. Section through a cucumber, 1935.

208 Helmut Gernsheim. Design for a poster, 1935. Not a photomontage: effect was achieved by sandwiching two negatives in the enlarger.

209 Wolfgang Suschitzky. Two camels, 1938.

210 Andreas Feininger. Oil derricks, Signal Hill, California.

211 Eric de Maré. Brighton Pavilion, 1969.

212 Yousuf Karsh. Sir Winston Churchill, 1941.

213 Arnold Newman. Igor Stravinsky, 1946.

214 Ida Kar. William Scott, 1961.

215 Brian Seed. Patrick Heron, 1959.

216 Philippe Halsman. Albert Einstein, 1948.

217 Philippe Halsman. 'Dali Atomicus', 1948.

218 Richard Avedon. Igor Stravinsky, 1958.

219 Gertrude Fehr. Hans Arp, 1965.

220 Walde Huth-Schmölz. Elegance, Paris, 1955.

221 Toni Schneiders. Air bubbles in ice, 1953.

222 Peter Keetman. Oil drops, 1956.

223 Peter Keetman. Pipes, 1958.

224 Peter Keetman. Oscillations, 1950.

Index of Names

The numbers (or letters, for the color illustrations) in italics are illustration numbers, not page numbers.
When known, dates have been given of persons connected with photography.

Abbott, Berenice (b. 1898) 98
Abruzzi, Duke of 50
Académie des Beaux-Arts, Paris 11
Académie des Sciences, Paris 11, 13
Adam-Salomon, Antoine (1811–1881) 57. *99*
Adams, Ansel (1902–1984) 98, 99, 120. *205, 206*
Adamson, Robert (1820–1848) 40–42. *62, 63, 64*
Agee, James 121
Aguado, Comte Olympe 55
Albert, Josef (1825–1886) 61
Albert, Prince Consort 55, 73, 74. *96*
Alexandra, Queen *171*
Alfonso, King 116
Alhazen 3
Alinari, Giuseppe (1836–1890) 52
Alinari, Leopoldo 52
Amboise, Cardinal d' 9. *10*
American Society of Magazine Photographers 132
Anderson, James (1813–1877) 52. *90*
Andriesse, Emmy 133
Angerer, Ludwig (1827–1879) 55
Anglonnes, Prince Giron des 45
Annan, James Craig (1864–1946) 78, 82. *161*
Annan, Thomas (1829–1887) 55, 61. *94, 110*
Anschütz, Ottomar (1846–1907) 71, 72
Anthony, Edward (1818–1888) 32, 70
Arago, François-Jean-Dominique (1786–1853) 11, 13, 14, 35. *14*
Arbeiter Illustrierte Zeitung 96
Arbus, Diane 101, 133
Archer, Frederick Scott (1813–1857) 16, 46, 47
Aristotle 3
Arp, Hans *219*
Art 137
Art Union 40
Associated Press 117
Atget, Eugène (1857–1927) 69, 85, 92, 120. *133, 189*
Athenaeum 35, 73
Auerbach, Erich (b. 1911) 102
Avedon, Richard (b. 1923) 103, 105. *218*

Babbitt, Platt D. 32. *44*
Bacon, Roger 3
Baldus, Edouard (b. 1820) 44, 53–55. *92*
Bandy, Ina 118

Bandy, Nicolas 118
Banks, Joseph 47. *75*
Barbaro, Danielo 4
Bardi, Luigi 52
Barnack, Oskar (1879–1936) 25
Barnett, E. Walter (1862–1934) 61
Barr, Alfred 119
Barraud, Herbert 61
Barrett, Arthur 115. *245*
Barrett, Elizabeth (Browning) 34
Barry, Sir Charles 35
Barton, Mrs 82
Baudelaire, Charles 57. *98*
Bauer, Franz Andreas (Francis) 9
Bauhaus 87, 88, 92, 97, 105, 136
Bauhaus, New (Illinois Institute of Design) 110, 112, 136
Baumeister, Willi 136
Bayard, Hippolyte (1801–1887) 13, 14, 37, 43, 44, 51. *68*
Bayer, Herbert (1900–1985) 94, 97. *201*
Beard, Richard (1801–1885) 33, 34, 37, 67. *45*
Beardsley, Aubrey 61. *162*
Beato, A. 65
Beaton, Cecil (1904–1980) 89, 103, 131. *180, 276*
Beck, R. & J. 23
Bede, Cuthbert *29*
Bedford, Francis (1816–1894) 47, 51
Benham, C. E. 107
Bennett, Charles (1840–1927) 18
Bérardy 65
Berek, Dr Max (b. 1886) 25
Berko, Ferenc 136. *vi, viii*
Berliner Illustrirte Zeitung 115, 117
Berliner Tageblatt 117
Bernhardt, Sarah 59. *106*
Bertall, Felicien (Albert d'Arnoux) 57
Bertsch, Adolphe (d. 1870–1871) 22
Bessemer, Sir Henry *46*
Beutler, Willi 133
Beyers für Alle 117
Biasi, Mario de 127
Bidermanas, Israel ('Izis') (1911–1981) 118, 136
Bingham, Robert J. 16
Biow, Hermann (1804–1850) 38
Bischof, Werner (1916–1954) 98, 127, 135, 136. *vii, 266, 267*
Bisson, Auguste (b. 1826) 37, 48, 53. *78*
Bisson, Louis (b. 1814) 37, 48, 53. *78*
Blake, Brian (b. 1927) 136. *v*
Blake, William 92

Blake, Mrs William *23*
Blanchard, Valentine (1831–1901) 70
Blanquart-Evrard, Louis-Désiré (1802–1872) 17, 43, 45
Blossfeldt, Karl (1865–1932) 93. *190*
Blücher, Adolf von 118
Blumenfeld, Erwin (1897–1969) 90. *185*
Böhm, Hans (1890–1950) 114
Boissonnas, Fred (1858–1947) 82
Boje, Walter (b. 1905) 135, 136. *iv*
Boole, A. & J. 55
Bosshard, Walter 115, 117
Boubat, Edouard 133
Boulanger, General 59
Bourke-White, Margaret (1904–1971) 118, 120, 121
Bourne, Samuel (1834–1912) 48. *79*
Bouton, Charles-Marie 10
Bovier, L. 82
Boys, Charles Vernon (1855–1944) 72
Brady, Mathew B. (1823–1896) 32, 38, 65
Brander, Georg 7
Brandt, Bill (1904–1983) 110, 120. *237, 257*
Brandt, Friedrich (1823–1891) 65
Brassaï (Gyula Halész) (1899–1984) 115, 118, 120. *250, 251*
Braun, Adolphe (1812–1877) 48, 70. *34*
Breuning, Wilhelm 46
Brewster, Sir David (1781–1868) 20, 21, 26, 41
Briand, Aristide 115. *246*
Bridson, J. 75. *144*
Brogi, Giacomo (1822–1881) 52
Browning, Robert 58
Bruguière, Francis (1879–1945) 89
Brunel, Isambard Kingdom 58. *104*
Bucquet, Maurice (d. 1921) 82. *163*
Bull, Dr Lucien 72
Bullock, Wynn (1902–1975) 98
Buonaparte-Gabrielle, Princess *36*
Burgess, John 18
Burns, Robert 40

Caldwell, Erskine 121
Camera 118
Camera Work 85, 86
Cameron, Henry Herschel Hay 61
Cameron, Julia Margaret (1815–1879) 58, 75, 82. *102, 103*
Canaletto (Antonio Canale) 36, 37
Caneva, Giacomo 45